contemporary
voices

contemporary voices

WORKS FROM THE UBS ART COLLECTION

Ann Temkin

THE MUSEUM OF MODERN ART, NEW YORK

Published in conjunction with the exhibition
*Contemporary Voices: Works from The UBS
Art Collection*, at The Museum of Modern Art,
New York, February 4–April 25, 2005, organized by
Ann Temkin, Curator, Department of Painting
and Sculpture

The exhibition and accompanying publication are
made possible by UBS.

Produced by the Department of Publications,
The Museum of Modern Art, New York

Edited by David Frankel
Designed by Barbara Glauber, Sarah Gifford,
and Beverly Joel, Heavy Meta, New York
Production by Elisa Frohlich
Printed and bound by Conti Tipocolor, Florence

This book is typeset in Foundry Monoline
and Documenta. The paper is 150 gsm Larius Matt

Published by The Museum of Modern Art,
11 W. 53 Street, New York, New York 10019

Distributed in the United States and Canada
by D.A.P./Distributed Art Publishers, Inc., New York
Distributed outside the United States and Canada
by Thames & Hudson Ltd, London

Library of Congress Control Number: 2004116182
ISBN: 0-87070-089-8 (cloth)
 0-87070-087-1 (paper)

COVER: Vija Celmins. *Night Sky #5* (detail). 1992.
Oil on canvas mounted on wood panel, 31 x 37½"
(78.7 x 95.3 cm). The Museum of Modern Art, New York.
Partial and promised gift of UBS. See p. 141.
FRONTISPIECE: Sarah Morris. *Midtown-PaineWebber
(with Neon)* (detail). 1998. Gloss household paint
on canvas, 60 x 60" (152.4 x 152.4 cm). The UBS Art
Collection. See p. 197

Printed in Italy

CONTENTS

———————

A financial services firm and an art museum may serve our society in different ways, but UBS, home to one of the finest corporate art collections, and The Museum of Modern Art, the world's premier museum of modern and contemporary art, have much in common. At the heart of our longstanding relationship is a shared commitment to art as a positive, inspiring force that benefits the full range of human endeavor.

That belief in giving back to the communities in which we conduct business is the foundation of UBS's support for this exhibition. We are delighted to support the Museum in presenting *Contemporary Voices: Works from The UBS Art Collection*. This outstanding exhibition features more than seventy contemporary masterworks by American and European artists, including forty-four works that have been given to the Museum by UBS.

Like all fine art, The UBS Art Collection illustrates the integral combination of insight and passion to create something lasting and meaningful. These are the very qualities that enable UBS to be a leader in the financial arena: the passion that inspires us to understand our clients' needs, and the insights we apply in creating proactive solutions to help them pursue their goals.

All of us at UBS congratulate MoMA on its seventy-fifth anniversary and join New Yorkers and art-lovers around the world in welcoming the Museum back to midtown Manhattan. We are especially proud that MoMA has chosen to present the UBS gift and other works from The UBS Art Collection as the first temporary exhibition in the Museum's beautiful new galleries. These modern masterpieces serve as a vivid reminder that creativity and innovation are crucial to success.

JOHN P. COSTAS
Chairman & CEO
UBS Investment Bank

MARK B. SUTTON
Chairman & CEO
UBS Wealth Management USA

———

We are delighted to present *Contemporary Voices: Works from The UBS Art Collection*, a celebration of the financial-services firm UBS's generous gift of forty-four contemporary masterworks to The Museum of Modern Art. Comprising works in the gift plus additional works on loan from The UBS Art Collection, *Contemporary Voices* showcases a cross-section of distinguished artists active within the past four decades.

As the inaugural exhibition in the new International Council of The Museum of Modern Art Gallery, part of Yoshio Taniguchi's stunning sixth-floor suite of René d'Harnoncourt Exhibition Galleries, *Contemporary Voices* begins an important chapter in the history of The Museum of Modern Art. With their eighteen-foot ceilings, skylights, and flexible, open expanses, the new galleries offer optimal space in which to show contemporary art. Their magnificence, however, depends on the art within them, and *Contemporary Voices* includes a breathtaking array of paintings, sculptures, drawings, and photographs by many of our most important contemporary artists. The collection was founded as The PaineWebber Art Collection by Donald B. Marron, the company's former Chairman and Chief Executive Officer and a longstanding friend and Trustee of the Museum. It is now one of the leading corporate collections in the world, and its gift to the Museum is one of the most generous gifts of art ever made by a corporation to a public institution.

Enhancing the Museum's collection of modern art is our primary goal, and the UBS gift is part of a long and distinguished tradition of large-scale gifts to MoMA. Over the past decade we have received an unusually large number of major gifts, and have celebrated all of them with exhibitions, including *The William S. Paley Collection* (1992); *The David and Peggy Rockefeller Collection: Manet to Picasso* (1994), *The Louise Reinhardt Smith Collection* (1995), and *On the Edge: Contemporary Art from the Werner and Elaine Dannheisser Collection* (1997). Such gifts constitute the lifeblood of the Museum, and it is with profound gratitude that we honor UBS's generosity with *Contemporary Voices: Works from The UBS Art Collection*.

Donald Marron has been a dynamic leader at MoMA since March 1975, when he was elected to the Board of Trustees. Since then he has served as Vice President and as President of the Museum, from 1978 to 1985 and from 1985 to 1991 respectively. He became Vice Chairman in 1991, he is currently a member of the Executive Committee, and he chaired the MoMA Nominating Committee from 1993 to 2001. He is an active member of many of the MoMA curatorial and financial committees and has been a leader and major donor in the Museum's current capital campaign. While performing all of these Trustee duties, Don has continued to collect and give works of art to the Museum.

Don first proposed a major gift to the Museum in the 1990s. When PaineWebber merged with UBS, in 2000, Marcel Ospel, Chairman of UBS, steadfastly and enthusiastically honored Don's commitment. Peter Wuffli, Group Chief Executive Officer, UBS; John Costas, Chairman & CEO, UBS Investment Bank; and Mark Sutton, Chairman & CEO, UBS Wealth Management USA, extended the same degree of support, and on behalf of the Museum I thank them and the company they lead.

GLENN D. LOWRY
Director, The Museum of Modern Art

The Museum of Modern Art is delighted and privileged to welcome a generous gift of forty-four works of art from UBS, and to celebrate this gift with the exhibition *Contemporary Voices: Works from The UBS Art Collection*. Contemporary art is the area of the Museum's collection that is most emphatically a work in progress, and gifts such as this one greatly contribute to our ability to represent the art of our time at the highest level of excellence.

What is today The UBS Art Collection was instigated in the late 1960s by Donald B. Marron, who was then the president of the investment firm Mitchell Hutchins, Inc. Mitchell Hutchins merged with PaineWebber in 1977, and PaineWebber merged with UBS in 2000; on both occasions the art collection merged too. Marron, former Chairman and Chief Executive Officer of PaineWebber, is an eminent collector of modern and contemporary art and a longtime friend and steadfast supporter of The Museum of Modern Art. As he relates in this book in his interview with Glenn D. Lowry, the Museum's Director (pp. 17–25), he became a devotee of modern art while he was in his teens and then began his own collection in his early twenties. As his passion for collecting flourished, to begin a collection for his company seemed the logical next step.

Conceived, assembled, and nourished by Marron, the collection began to grow into the large-scale enterprise it is today after Mitchell Hutchins merged with PaineWebber. By the 1990s it had its own full-time curator and an active lending program; it was the subject of the book *The PaineWebber Art Collection*, published by Rizzoli (1995); and on two occasions it toured major museums throughout the United States (1995–97 and 2002–4). In building the collection, Marron was motivated by a personal philosophy that he describes in *The PaineWebber Art Collection* as "the conviction that good contemporary art reflects contemporary needs and trends in society, and that truly outstanding works might even suggest the future—a particular benefit to us since our business tries each day to anticipate tomorrow." While the collection became a valuable financial and cultural asset, it was built on the idealistic principle that art can enrich the minds and spirits of those who live with it, in this case UBS's employees, clients, and associates.

As a collector, Marron has always been both a connoisseur and a risk-taker. Since his earliest days buying art, he has followed the careers of established artists, acquiring works by such luminaries as Willem de Kooning, Jasper Johns, and Lucian Freud, but he has also delighted in supporting new talent. In the 1960s and '70s he amassed significant holdings of works by such artists as Ed Ruscha and Roy Lichtenstein, who were then still early in their careers. In the 1980s, a boom time for the New York art world, Marron was one of the foremost collectors of the new painting. Spending each Saturday scouring the SoHo galleries, he acquired for PaineWebber works by soon-to-be-renowned artists like David Salle, Francesco Clemente, and Kiki Smith. With large-scale photography beginning to emerge as an important force, he was quick to add major works by such artists as Laurie Simmons, Cindy Sherman, Thomas

Struth, and Andreas Gursky. He acquired most works soon after they were made, before the benefit of hindsight would enable safer choices.

While Marron was developing the PaineWebber Art Collection, he was also actively involved in the leadership of The Museum of Modern Art, having joined the Museum's Board of Trustees in 1975 and served in a variety of roles since then. He long envisioned a significant gift from PaineWebber to the Museum, although its exact parameters evolved over time. The company made its inaugural gift, of Susan Rothenberg's *Biker*, in 1986; in 1992 it donated seven more works. Shortly thereafter, Marron asked my predecessor as Chief Curator of Painting and Sculpture, the late Kirk Varnedoe, to create a wish list of works from the collection to go to the Museum. Over the next few years, in consultation with other members of the Museum's curatorial staff, Varnedoe and Marron selected the works for the gift. As part of this project, Varnedoe and Robert Storr, former Curator in the Department of Painting and Sculpture, also began planning an exhibition that would feature both the gifted works and a selection of works on loan from the PaineWebber Collection. Ultimately, it was decided that the optimal time for the show would be in 2005, upon the reopening of the expanded Museum. When PaineWebber and UBS merged, UBS agreed to these plans, and has continued steadfastly to support the project as it has evolved. We at the Museum have greatly appreciated the cooperation of UBS.

Long in development, the exhibition has now been realized by Ann Temkin, Curator in the Department of Painting and Sculpture, who rejoined the Museum in 2003 after working here earlier in her career. *Contemporary Voices* is both the first show she has organized in her new position and the first show in the spacious galleries dedicated to temporary exhibitions in the Museum's new building—aspects of the show that mutually honor each other. Recognizing Ann's role in shaping and ordering the selection of works on view, though, brings me back to Donald Marron, whose intelligence and eye were behind their original assembly into a coherent collection. For this exhibition of a part of that collection and for the particular works that became a gift to the Museum, I would like to extend to Don my warmest personal thanks.

JOHN ELDERFIELD
The Marie-Josée and Henry Kravis Chief Curator,
Department of Painting and Sculpture

————

The exhibition *Contemporary Voices: Works from The UBS Art Collection* has as its core a group of forty-four works of art promised as gifts to The Museum of Modern Art, joined by about thirty additional works that further reflect the depth and breadth of The UBS Art Collection. The exhibition presents paintings, sculpture, drawings, and photographs by a broad range of artists making important work today and during the second half of the twentieth century. They range from the earliest generation of Abstract Expressionists to young artists who have emerged within the last decade. Most of the exhibited works lie somewhere in between, made by artists who rose to prominence in the late 1960s, '70s and '80s. They mostly hail from the United States and Europe, primarily England and Germany. All of the work in the exhibition, and in the collection as a whole, hangs on the wall, even those objects that are considered sculpture. This is explained not by an aesthetic preference or theory but simply by the fact that the collection was formed in order to enrich an office environment that provided many walls on which to display works of art but no vast empty floors available to art rather than to the people who populated a busy workplace.

The great majority of the artists featured in this exhibition are at work today. In accord with The UBS Art Collection's mission as a link between the often narrowly circumscribed art world and a broader public, we have decided to use this catalogue as an opportunity to bring the artist's voice directly to the reader. Eleven of the artists in the exhibition have generously discussed their work with me, in conversations that focused particularly on the paintings and drawings in the exhibition but also touched on topics ranging from childhood to studio routines. The choice of whom to interview rested on a variety of factors: we wished to speak with artists reflecting a cross-section of approaches and generations, those whose works in the show are of particular significance within their own oeuvres, and those who are not the subject either of other recent or upcoming MoMA publications or of many previously published interviews.

Broad generalizations do little to illuminate the works of art under consideration, since each object entered the collection not to illustrate a point or fill in a gap but as an object of compelling interest in its own right. In that spirit, this introduction will offer observations focusing on several individual objects in the exhibition. The brief comments that follow sketch an outline of the chronological and stylistic arcs traced by the exhibition and merely suggest the richness of the material it brings together. The exhibition, like the collection of which it is a micro-cosm, is by no means an exhaustive chronicle of the art of the late twentieth century, nor did it set out to be such. Nevertheless, in both its heterogeneity and its particular depths, it provides an exceptional window onto that world.

Both Philip Guston and Willem de Kooning, the oldest artists in the exhibition, developed distinctly late styles for which they are justly celebrated. Art history has a tendency to address the first breakthrough of an artist, and then leave him or her behind as new decades bring with them younger generations. Guston and de Kooning adamantly refuse such treatment, for their late work commands an independently important status. They were members of a generation of artists who lived notoriously brief lives, but they were more fortunate, and their art evolved richly up to the end. Both artists first became known for their work in the 1940s and contributed to the classic flowering of Abstract Expressionism in the 1950s. By the mid-1960s, Guston had begun to

reconsider what he had achieved, and between 1965 and 1969 he did no painting at all, unable to continue what he had been doing but not ready to know where he was headed instead. In 1969 he astounded friends and colleagues with a new style that resumed the figurative direction he had taken as a young man but invested it with an exaggerated, cartoonlike character. Like many works of this period, *In the Studio* (1975; p. 161) is a wry reflection on the myth of the artist as an inspired and lofty being. Here we confront Guston in the form of a bulbous disembodied head, unattractively wrinkled and unshaven, with an oversized eye. In his one dirty-fingernailed hand he clutches not a paintbrush or palette but a cigarette, ready reinforcement for the one already between his lips. The painting on the easel portrays a clunky red foot, a visual pun on the artist's flatfooted attempts at high art. The painting is almost childlike in its affect, the artist not having bothered to finish sketched-out areas, to modulate passages of color, or to clarify contours.

In de Kooning's final decade of painting he did not make the kind of profound turn-around that Guston did, but his works of this period offer a comparable example of the extraordinary late flowering of a master. *Untitled III* (1982; p. 181) reflects his reduction of a lifelong vocabulary into a language in which color and line merge into one, as do references to the human figure and to landscape. The artist confined his palette to the primary and secondary colors and to white, whose newly dominant presence lends his compositions an airy openness that defies their material nature.

Like all of de Kooning's later work, *Untitled III* operates as much from its perimeters as from its center, possessing an overall balance but no conventional symmetry. The painting might be a luscious magnification of a tiny detail of an earlier work, and during this period de Kooning did indeed keep at his side earlier drawings, and photographs of other earlier works, as catalysts for the new paintings. The effortless appearance of *Untitled III* suggests rapid execution, but the process of building up the canvases of this period actually involved many layers of extremely thin paint and much sanding and scraping. In fact de Kooning's canvases had to be attached to foamcore backings to be able to withstand the physical punishment they would endure on their long road to completion. All this resulted in a surface that seems more glazed than painted, almost transparent in its lightness yet as firmly anchored in the composition as de Kooning was in his five decades at the easel.

The exhibition represents the next generation most beautifully in works on paper, the drawings of such artists as Jasper Johns, Robert Rauschenberg, Cy Twombly, Andy Warhol, and Claes Oldenburg. Ed Ruscha, a pioneer of Pop art in California, is the member of this generation most extensively represented in the collection. Ruscha has lived in Los Angeles since arriving there from Oklahoma in 1956, and the city permeates his sensibility. In one of his great early paintings, *The Los Angeles County Museum on Fire* (1965–68; p. 98), Ruscha took a new cultural landmark in his city and ever so gently set it ablaze. He made several drawings after the painting, including the tiny treasure in the UBS collection (p. 222), drawn like the others in exquisite graphite. In a mood foreshadowed by Surrealist paintings, the drawing has a silent calm that stands in diametric opposition to the calamity it portrays. In his most recent work in the collection, *The End* (1989; pp. 226–27), Ruscha takes his material from film, the industry that defines Los Angeles. One of an extensive series, this painting applies the artist's lifelong interest in the formal behavior of letters (pp. 223, 225) to a literal situation: the conclusion of old movies in the words "The End." The image is marked by illusionistic scratches evoking deteriorated celluloid, and the lettering is divided as if the film were out of sync. As in much of Ruscha's art, the curious power of *The End* derives from the contradiction between the perfectionism applied to the task at hand and the apparent lack of a logical reason for that task. The apocalyptic cast of the words, and the vaguely medieval

lettering, give the picture the same air of quiet doom seen in the picture of the museum aflame.

Parallel to the innovations of Pop art in the early-to-mid 1960s, a group of artists were reinventing the language and purpose of abstract painting and sculpture. Like the Pop artists, artists associated with the movement that later became known as Minimalism were reacting against the overblown image of the angst-ridden Abstract Expressionist artist, his works flaunting brush-work and gesture. Whereas the Pop artists looked at the mass media, appropriating imagery from comics, advertisements, and consumer products, the Minimalists focused on the essential properties of the materials they worked with, and chose rational systems with which to manipulate them. In the end, of course, their works clearly reflect signature styles, despite the artists' dedica-tion to a seemingly impersonal and objective approach.

Donald Judd saw his work as such a departure from tradition that he termed it not "sculpture" but "specific objects." Like his friend Dan Flavin (p. 155), he rejected established parameters for both material and process. Beginning in 1964, Judd no longer made his work himself but had it handled by a commercial fabricator not far from his studio. His galvanized-iron sculpture of 1967 in the UBS collection (untitled, like all of his art; p. 175) belongs to a category of his work known as the "progressions," because of the sequential dimensions that mark both negative and positive elements. In this example, six rounded elements, separated by five intervals, project forward in a horizontal progression. Starting at the left, the first element is five inches long, the interval half that. The elements decrease by one-half inch as they move rightward, while the intervals grow by the same amount. The spangly surface of the galvanized iron is visible through thin layers of red Harley-Davidson paint, chosen for its emphatic contemporaneity. This surface reveals the closet sensualist behind the rigorous artist, who indulged the emotional and retinal joy of rich texture and high color at the same time that he devised strictly mathematical structures.

The innovations of Judd and Flavin paralleled, and inspired, contemporaries such as Robert Ryman, Brice Marden, and Richard Serra. The UBS Art Collection features later works by these artists, who continue to explore the avenues through which they redefined abstract art in the 1960s. Serra's work on paper is a rich and diverse aspect of his primarily sculptural practice. *No Mandatory Patriotism* (1989; pp. 232–33) is made in paintstick on paper, and despite its traditional presentation as a drawing in a frame, it has the monumentality and weight characteristic of his sculpture. Almost eight feet tall and seventeen feet long, it is part of a set of large drawings entitled Weights and Measures. The grainy surface of the paint, its dark color, and the obdurate forms it describes directly evoke Serra's sculptures. The two black shapes, each on its own sheet of paper, stand in precarious balance, the gap between them narrowing as they rise. The title *No Mandatory Patriotism* reflects Serra's outrage after local citizens convinced the court to order the dismantling of his *Tilted Arc*, a site-specific sculpture of 1981 commissioned by the federal government in downtown Manhattan.

Much of The UBS Art Collection was formed during the 1980s, and its focus on painting coincided with a revival of painting in the United States and Europe, after a period in which sculpture, performance, and video had predominated. Certain painters who had been developing under the radar during that time aroused new notice as audiences caught up with them. Chuck Close had been committed since the 1960s not only to painting but to figuration, thought by many to be no longer worthy of serious artists. The UBS collection boasts a rich collection of Close's work from both the 1970s and the 1990s. *Large Mark Pastel* (1978; p. 147), from the earlier period, reflects the reach of Close's otherwise intensely focused explorations into a wide variety of mediums in the fields of prints, drawings, and painting. Two self-portraits (pp. 148, 149), represent

the later period of Close's work. All were made after Polaroid photographs—close-up shots of the head that include virtually no background and few external cues to character or status. Close then superimposes a grid on both the photograph and the canvas or paper to enable the image's transfer from one to the other. These images belong to two important subsets of his work since 1968: work in shades of black, white, and gray (highlighting an essential fact of the photographs he uses as a basis), and self-portraits. Close has painted himself more than any other model. His self-portraits dramatically demonstrate that the uniqueness of a painting lies in the making of it, not in its subject. Like all of Close's later paintings, these particular works replace the warts-and-all topography of the face found in his early work with a fictive landscape of colors and shapes. There is a magical contradiction between the fact of the face he documents and the gregarious assembly of circles, ovals, and other forms that fill in each square of the gridded canvas.

Lucian Freud is another modern artist who, though in an entirely different way from Close, has steadfastly devoted himself to the seemingly antimodern genre of portraiture. He is one of several British artists richly represented in the UBS collection. There is virtually no stylistic linkage among such artists as Freud, Richard Hamilton, Howard Hodgkin, Tony Cragg, and Richard Long, but all exemplify the vibrancy of art made in London long before the headline-grabbing work of the 1990s. Freud pursues an autobiographical project in the sense that he turns to family and friends as subjects and to his studio as the setting for his paintings. Yet as *Double Portrait* (1988–90; p. 157) shows, little is to be learned of this private realm. Freud's portraiture leaves no room for the sentimental or indulgent; here, as often, the titles do not even allow for the sitters' names. Emphasizing physical being rather than social status, psychology, or even state of mind, Freud focuses on people as animal beings. Here the bending legs and arms of woman and dog emphasize that parallel, as does the rhyme of their long lean forms. With its rich passages of paint and elaborately modeled volumes, *Double Portrait* bespeaks an arduous number of sittings. Indeed the woman rests against the wreckage of the painting process: piles of painting rags accumulated during the course of the artist's work. Freud paints without rehearsal in sketches. The fact that this portrait took form only as it was underway is revealed by the fact that it has actually been extended twice at its left side, the seams where the canvases meet largely hidden by the paint. One's awareness of this fact brings one closer to the singular concentration of the artist, intently following where his sitters, and his picture, took him.

In the 1980s, American collectors became keenly attuned to contemporary German painting, some of it new and some of it long ongoing. This interest appears in the UBS collection in strong examples of the work of Gerhard Richter, Sigmar Polke, Georg Baselitz, and Anselm Kiefer. The highly influential Baselitz, Richter, and Polke have been making paintings since the 1960s, Baselitz in Berlin and Richter and Polke (both emigrants from what was then East Gemany) in the Rhine region of Cologne and Düsseldorf. The slightly younger Kiefer, who has made the culture and history of his nation the focus of his art, was the German artist who most strongly captured the attention of Americans in the mid-1980s.

The UBS collection features a particularly important set of objects by Kiefer, ranging in date from 1978 to 1989 and involving three mediums that he has made especially his own: watercolor, woodcut, and lead. The watercolor *To the Unknown Painter* (1982; p. 177), painted on three sheets that are together more than four feet long, belongs to a series of works by that name. In the center of a colonnade that evokes the architecture of the Third Reich, a palette is suspended on a pole. Suggesting the eternal light of a memorial or, conversely, the decapitated head of a martyr, the palette silently salutes the artists exiled or killed by the Nazis in the 1930s and '40s.

Ways of Worldly Wisdom: Arminius's Battle (1978; p. 176) is one of several works fashioned from individual woodcut portraits of figures from German history. The woodcuts, printed on paper, were mounted on canvas and painted over with a skein of black lines linking them all to each other and to the fire burning at the center of the composition. The subtitle refers to the German victory over Roman invaders in 9 A.D., which set the stage for the country's independent history. The fire evokes that battle, but also perhaps the Nazi book-burnings, and the wartime destruction of the German landscape, in the twentieth century. Ultimately *Ways of Worldly Wisdom* is as ambiguous as the question of how to regard great leaders and thinkers whose life and work take on a different cast in the wake of the Nazi regime's use and abuse of historical German culture. The narrative element has lessened in Kiefer's more recent work. *A.D.* (1989; p. 179), named after Albrecht Dürer, collages animal entrails onto a large vertical sheet of heated and shaped lead. The work's evocative power rests principally on the symbolic properties of lead, a pivotal element in the alchemists' attempts to transform base metals into precious ones.

Most of the paintings in The UBS Art Collection were purchased without regard for their ultimate site in the company's offices. The exceptions were a set of six panel paintings by Susan Rothenberg, *1, 2, 3, 4, 5, 6,* (pp. 218–19, and discussed in the interview on pp. 87–95), and two works by Frank Stella, *The Wheelbarrow (B #3, 2X)* (p. 243) and *The Blanket (IRS-8, 1.875X)*, all completed in 1988. That year both artists were invited by Donald Marron to supply paintings for PaineWebber's corporate dining room. Whereas Rothenberg made new works for the architectural columns throughout the room, Stella chose for the long entrance wall two works from his current series on the theme of Herman Melville's novel *Moby-Dick*.

Made while Stella was in his fifties, the Moby-Dick paintings arrived in the middle of a career that was for its first portion adamantly abstract. "What you see is what you see," an endlessly quoted remark of Stella's from the 1960s, banned personal subjectivity and symbolism from the painted subject, and his work was recognized as a forerunner to Minimalism. But during the 1980s Stella's art evolved into a virtuosic and wide-ranging exploration of mediums, techniques, and subject matter. Melville's sprawling novel provided a fitting basis for Stella's own artistic interests and ambitions and his Moby-Dick series came to include almost 300 works, made between 1986 and 1997.

Like most of those works, *The Wheelbarrow* conflates painting and sculpture: though it hangs on the wall and is painted, it is made of independent metal forms and is unremittingly three-dimensional. It takes its name from the chapter in which Melville's hero Ishmael first leaves land in the *Pequod*, and its parenthesis, *B #3, 2X*, indicates that it belongs to a group within the Moby-Dick series, the Beluga group, and that it was cast in aluminum at twice the size of its foamcore maquette. Stella's sources for the imagery are extraordinarily eclectic: the wavy form at the upper left evokes the whale in motion, the round foundation piece is painted with a Chinese lattice pattern, and the lower right form is based on a cast-iron gutter design. More important than these source details are the vivid sense of motion, the exuberant color, and the powerful buoyancy of the final assemblage.

Contemporary photography occupies a significant place in The UBS Art Collection. For more than a century after its invention, photography by and large constituted a separate sphere from the work of painters and sculptors; this is no longer true. The large scale of recent photographs—framed directly, without a traditional mat—is a metaphor for the way they occupy the same space as painting and sculpture.

In the 1970s, many women turned to photography for projects with a conceptual basis. Cindy Sherman is among the best-known of these; for almost three decades she has photographed

herself in scores of guises, yet none of these images could be considered self-portraits. Instead she transforms herself, often unrecognizably, to create photographs that examine our history of images of women, in both fine art and the mass media. Sherman's early work neatly co-opted the hackneyed conventions that have governed the representation of women; *Untitled #122A* (1983; p. 235) belongs to the first of several series that subvert fashion photography. In 1983, retailer Diane Benson commissioned Sherman to make photographs using designer clothes for a spread in *Interview* magazine. As *Untitled #122A* suggests, Sherman's response turned fashion photography on its head: instead of looking glamorous in her tuxedo-cut black dress, the woman is furious, or so it seems from the clenched fists and the bit of face seen through the sweep of uncombed peroxide hair. Her body, though slim and delicate, makes an unwilling partner for the close-fitting dress. Centuries of painting and decades of photography have conditioned us to expect full complicity between artist and model. Sherman explodes that nice fiction, and in so doing alerts the viewer to what fiction it is. By extension, she calls into question all the myths that reinforce established power relations in contemporary society.

As American artists like Sherman were repositioning photography, related developments were unfolding in West Germany. Thomas Struth is one of several artists who studied at the Kunstakademie Düsseldorf in the 1970s and who since then have taken photography in new directions. Like Andreas Gursky (pp. 158–59), Candida Höfer, and Thomas Ruff, Struth was a student of Bernd and Hilla Becher, a husband-and-wife team who create unromantic photographic typologies of domestic and industrial structures, many of them now vestiges of a bygone era. In some ways Struth has continued the documentary practice seen in the Bechers' work. What most clearly sets him and his peers apart is the contemporary technology that allows them to print both large scale and in color, bringing about an utterly new relationship between the viewer and the photograph.

Struth is perhaps best-known for his photographs of museum visitors in galleries, works that implicitly declare the newly realized ambition of photographs to compete in scale and virtuosity with paintings. *National Gallery London I* (p. 245) was made in 1989, the year that the series began. Struth remembers as formative his schoolboy experiences in the great museums of Cologne, and remains captivated by looking at people looking. He passes along to us that experience in the six-by-six-and-a-half-foot National Gallery photograph, which positions us far back in the room behind visitors looking at paintings by Bellini and Cima de Conegliano. The photographic arrangement mimics the stepped, frontal symmetry of Cima's altarpiece, and the frozen quality of the photographic moment strangely parallels that of the *cinquecento* tableau. The photograph sets up a network of startling confrontations: between the painted figures in their biblical robes and Londoners in 1980s winter clothing; between the Londoners and us viewers; between the perspectival space of the painting and that of the photograph.

Struth's photograph reminds us that museums now have become part of everyday life. Contemporary art, even more than that of the old masters, is the subject of unprecedented curiosity on the part of a large and diverse audience. Yet the readings of contemporary works of art remain open to interpretation; the observations they prompt very much depend on what the viewer brings to them. And as the interviews that follow make clear, the concerns and intentions of artists today vary enormously. The gift and exhibition of the works from The UBS Art Collection at The Museum of Modern Art pay tribute to the museum's role at the center of art's public life. At its best, the museum gallery becomes the locus for open-ended conversations between the works of art themselves and the viewers who encounter them.

Donald B. Marron

GLENN D. LOWRY

GLENN LOWRY: Let's start with the obvious: when did you begin collecting personally and why?

DONALD MARRON: I was always excited about art. I still remember visiting The Museum of Modern Art in my late teens and entering a room with Cubist pictures and being so excited. In my middle twenties, when I was just getting married and I didn't have any extra money, I found that Hudson River School paintings were the same price as reproductions in department stores. So that was my first collection, which kept going from there.

GL: How did you move from American art to European art?

DM: I always had an interest in European art, and the pleasure of being a collector is when it comes over you that those marvelous objects you had seen in books and museums, you could acquire examples by the same artist. I started in European art collecting prints of Bonnard, Lautrec, Vuillard, and four or five others. I built a collection of those, and that got me thinking about doing more. Now I've had several different collections, including a collection of American black and white prints. It's really a question of enthusiasm for a particular period, and then whether or not that enthusiasm can be acted on. Part of collecting, I think, is recognizing where you can find things that are exciting and are very good, and also that you can continue to build around. From my point of view, other than perhaps that I limit myself to the twentieth century, there aren't any limitations.

GL: At what point did you start collecting contemporary art?

DM: I have always enjoyed contemporary art. In the '60s and '70s, I used to spend a lot of time in Los Angeles on business. I went on the board of CalArts [the California Institute of the Arts, Valencia] when it started [in 1961]. And Ken Tyler had the now famous print operation Gemini on Melrose Place, and I used to go out there and see him. He was, in the early days, working with Frank Stella and Robert Rauschenberg

and Jasper Johns and Ellsworth Kelly, and a number of others. I saw the works and I was just mesmerized by them, and I got to know the artists. There was a group of California artists, led by Ed Ruscha, whom I also got to see and spend some time with. And that's how it all started.

GL: You built one of the great collections of Ed's work.

DM: Ed was the Oklahoma boy who then had just moved to California, and I was interested in prints then as I am now. Color lithography was kind of reinvented by June Wayne and Tamarind, and I went to see her, and of course Ed did his earliest prints with Tamarind. That's one way I was able to get those marvelous early Hollywood prints and a group of other things.

GL: When you started collecting for PaineWebber, did you make a clear distinction between your personal collection and the corporate collection you were building?

DM: I did at PaineWebber. Our earlier firm was private, so it didn't have the issues of a public corporation. When we merged Mitchell Hutchins into PaineWebber, in 1977, I started to introduce contemporary art into PaineWebber in a very modest way, anticipating that it would be met with a certain amount of resistance. But while it did meet with some resistance, it also met with some interest. In addition to loving contemporary art, I had the strong view that good contemporary art reflects the energy of the society in which it's created, and great contemporary art can sometimes anticipate the future. In addition to being marvelous to live with, it also gives you a subliminal window into the now and maybe the future. And being on Wall Street is all about what's going on in current trends. When I started to add some of the works, enough people were curious and supportive that it encouraged me to keep doing it. I very quickly had to make a decision in my own mind as to whether I was collecting for myself or for the firm, and I made a fairly easy decision: I was very interested in modern art and contemporary art, so I said to myself broadly, If it's before World War II, I'll collect it for myself at home, and after World War II, for the firm.

GL: Was that division fairly easy to maintain?

DM: Yes. The major focus of what we were doing at PaineWebber was buying truly contemporary art—art that was made at the time. One of the facts I'm the proudest of, if you look at when the works in the show were acquired versus when they were made, over half the works were acquired close to the time they were created.

GL: Tell me about how you went about building the PaineWebber collection. Were you out in the galleries every week?

DM: I used to spend a lot of time in the galleries on Saturdays. SoHo was starting to burgeon. I knew Leo Castelli pretty well; I'd go down to 420 West Broadway and hang out in Leo's gallery. Ileanna Sonnabend was on the next floor. I started simply to look at good art that was exciting. It was easier then, but I couldn't always spend that

much time on it, and fairly early on it became clear I had to have some help, so eventually I was helped by a curator. Over time we've had several curators. The last PaineWebber curator was Matthew Armstrong. Another curator was the late Monique Beudert, formerly of the Modern and the Tate. She made a lasting impact.

GL: As the collection grew, did the way you thought about it change?

DM: It changed, because people's reaction to it changed. They began to take it more seriously. When I started, people wondered what all these funny pictures were. But we were then downtown, and some of the people who were sitting in desks near the funny pictures had friends from SoHo who would come up for lunch and say, You know you have a Jasper Johns over your desk? They didn't, but now they did. And when they'd go to a museum and see works by the same artist, they got a kind of excitement. They began to see the works in a different context. I always felt that good art is its own best communicator. We said, We'll hang it up, give it some time to communicate with you, and see how you feel about it; if at the end of three or six months you really don't want it there, we'll move it. In the end, very few works were moved.

There's a great Museum of Modern Art story that goes with this. Years later, after we moved uptown, the Museum asked if they could have docents come over and give tours, I think to people on committees at the Modern. We said fine. And eventually an assistant who was sitting in front of one of our pictures came to me and said, "Mr. Marron, may I ask you something?" I said, "Sure." She said, "We've had five of these tours, and the docents come and describe the picture enthusiastically and they bring different groups. There have been five docents and five different explanations and descriptions of the same picture." And I said, "Well, that's contemporary art."

GL: Were you surprised by the way the collection developed?

DM: I knew I wanted to look for interesting and exciting examples of the art that was being done at the time. I was surprised at how many works we wound up with in the collection. I was excited by how many people were supportive; that didn't surprise me, but it encouraged me to keep going.

GL: What are the changes you see in the art world today as opposed to the late '60s and '70s, when you started the collection?

DM: I suppose one of the biggest changes is that there are many more artists and certainly many more galleries. The issue of schools—AbEx, then Pop, and then the next generation of people, to the degree that there are schools—is a little less clear; it's harder to categorize artists, because there's a much broader range of artists to work with. Second, many more people and institutions are collecting. Europe has so many institutions collecting contemporary art, all backed by the state; we have a very different way of looking at things. Third, in those earlier years, the art we saw was predominantly from the United States and in particular from New York. That made it easy; you got to see everything you had to see by going downtown. Then of course it moved to Europe, and to Latin America. I think the final difference, which is

harder to assess, is the financial commitment involved, and how that affects collecting. It just takes a lot more resources now to accomplish the same thing.

> GL: Did you ever think about the appropriateness of the works you were buying to an office environment?

DM: I like to think we were just looking at the quality of the art we were buying, but the reality was we were hanging art in our office, a public place where people spend close to a third of their time. About twenty or twenty-five years ago I got very excited about collecting Lucian Freud. We started by collecting his prints, and eventually wound up with an encyclopedic collection. But a few of Freud's prints, and several of his paintings, you just wouldn't want to hang in an office.

> GL: Did you ever pass on a work of art because you thought it might not be appropriate?

DM: Yes, but I hope not often.

> GL: Did you ever sell work from the collection?

DM: Since this was a public company, we didn't set rigid guidelines, but we told dealers and artists that we were building a collection, we had no intention of selling anything. And if we did, it would be for the purpose of acquiring something else by the same artist or in a similar vein. We pretty much stayed with that.

> GL: Did you ever think about the value of the collection as it was being assembled?

DM: When we were collecting these things originally, art wasn't the hot commodity it's become. So it wasn't a big issue. It began to be an issue when some of the works on the walls increased dramatically in value. But I don't think it influenced anything.

> GL: Did you have a budget?

DM: No, we just kept looking for good works. At the beginning, we'd buy things for $2,000 or under, so it wasn't a big issue. When we started acquiring major works we'd have a discussion, but we never spent that much money in any given year relative to the size of the business.

> GL: As the collection became more valuable, did that change the way you thought about it within the business?

DM: The collection certainly increased in value substantially, but it still wasn't a big asset relative to the size of the business.

> GL: Why do you think it's so difficult for corporations to build meaningful collections?

DM: I think the answer is embodied in the way I've described this collection: it's not a corporate collection, it's a collection that hangs in a corporation. An art collection has to have an advocate, someone who feels strongly about it and is willing to make the decisions and take the risks that go with them. There are a few corporations

where that has happened—with David Rockefeller at Chase, and John Bryan at Sara Lee—but that advocate is not present in most entities. A corporate collection then becomes something that gets built by a committee, which in my view is unlikely to wind up collecting the kind of aggressive, look-at-the-future works of art that are needed to create a contemporary collection.

GL: Would it be possible to build a collection similar to this one today?

DM: Absolutely. You'd need an advocate. You'd need some professional help, more so than before because there are so many more artists, you have to move much faster, and you have to go more places. Going to Chelsea isn't enough anymore. But though it would take more money and more resources, yes, I think you could do it.

GL: Has the competition changed with the number of people now in the market?

DM: There's been a big socioeconomic change that isn't limited to art. In the past, buyers were limited because there weren't that many people who had the resources and the interest and the time. Now you have a much broader range of people with substantial resources. This new generation of collectors is willing to take the time, and they have curators, or are getting advice at various levels. So yes, it's very different today, and there's much more competition.

GL: I'm interested in your opinions about some of the artists in the collection.

DM: I like artists who gain reputations from a certain body of work but are able to continue to be provocative and strong and to evolve over a long period of time. You will see that in our collection with some artists, like Ed Ruscha and Roy Lichtenstein, and obviously Jasper Johns. Susan Rothenberg has continued to do important work since her seminal horses and other works. The most interesting artists for me have been those who I've started with and grown with.

GL: You commissioned relatively few works at PaineWebber. Were there special problems in commissioning works?

DM: Well, I felt that commissioning art was a big event, so we never actively considered it. But on the top floor of our building was a set of dining rooms and conference rooms with high ceilings. That space was so outsized, I said, Here's a chance to do something interesting. I asked three artists: Richard Diebenkorn, who said no, Frank Stella, and Susan Rothenberg. The space was great for Frank because it was so big, but in the end we purchased two works from his studio so it really wasn't a commission. I took Susan up to the space one day and I said, There's all these conference rooms, there's a couple of public walls, pick whatever you like and we'll talk about it. Well, she thought about it and of course didn't pick any of these areas: she picked the piers between the windows in the dining room, which you never would've thought of at all. We gulped, and said, Okay, so what do you want to do? These piers were ten feet high. She went back to her studio in Sag Harbor and turned out six works. Then the day came when they were going to be delivered, and of course the wood panels

wouldn't fold, and they wouldn't fit on the elevators. Much crisis for a long time, which was finally solved by putting them on top of the elevators and transporting them up to the floor that way. I don't know what the journey was like up thirty-eight floors in a high-speed elevator with art on the top, but that's how they got there and they looked great.

> GL: Are there certain themes or issues or ideas that have emerged in the collection that give it definition from your perspective?

DM: I'd say the biggest issue is the division between abstraction and imagery. What was interesting to me about that was that while abstraction was exciting in itself, when you started to see large numbers of pictures hung up, it made you long for imagery. We had a policy that no space was to be built specifically for the collection; there were no spotlights, no special accommodations. I said, This is a business—the art has to hang on its own terms and see if it works. But back in the '70s it was interesting and somewhat surprising to me how strong imagery looked at a time when abstraction was given very high marks. Gerhard Richter is a very good example: beautiful abstract work, there's no question, and we have a fabulous work by him, but the representational ones came through in an astonishing way.

The other issue in collecting in a corporate space is scale. You're limited by height, and also because you don't have that many floors, ceilings, or walls to work with. There are other things going on in the space, people are working there all the time. The challenge was how to have an artist well represented by medium-size pictures. Out of that came a focus—not a total focus, but an important one—on major works on paper by significant artists.

> GL: Who figured out where to hang the works? Was that something you took an active role in?

DM: I did early on, when we had a small number of pictures and a small number of walls. But as it got going that was one of the roles of a curator.

> GL: Do you think collecting has changed the way you think or approach life?

DM: I think collecting has certainly given me a link to other aspects of what goes on in our city, in our country, and now the world. Certainly in my case it has gotten me very much involved in The Museum of Modern Art, which has been a great and rich experience for me. I think the biggest issue is, When you're collecting, what do you feel? I don't think anybody can explain it for anyone else. For me, it's really a continuous exhilaration, and a feeling of, I don't want to say joy, as not all these works are joyful, but involvement when you're surrounded by good art.

What's interesting about that, too, is that people would ask me how I knew that employees liked any of the art. I was the CEO—was I really going to hear anybody say something negative? Well, we always had a policy that if a museum wanted to borrow a work, we would lend it. No matter where it was, we'd take it off the wall and off it would go. And we found over time that people would really miss the art that left

their offices. I thought that was a marvelous endorsement of what was going on.

> GL: Do you think it's possible in a kind of quantitative way to determine
> whether or not a meaningful collection, like the PaineWebber Collection, is
> an active element in enhancing not just the pleasure of working in a
> corporation, but actually the way the employees feel, think, react to the world?

DM: That's a marvelous question. If you could quantify that, wouldn't that do something for the art world? I think it works on different levels. The simplest level is there's got to be something on the walls, and isn't this collection much more satisfying, more interesting, and more involving than the typical framed prints? Most people who have been involved would agree with that. I think it's also a question of pride when people realize that what you have is respected by others. And then I think the third level is there's a value and a power in being linked with creative activity. Someone who works in the office may to go to a museum, see work by the same artist, recognize it for maybe the first time, and say, Oh, we have one of those. Its presence in a museum says, Respect me, I've been picked by institutions as being timeless. There's no such pressure when it's sitting in the office. Maybe more the reverse: Hey, why is that stuff there? When those two things come together, I think it adds to people's feeling of being involved with something that works, having some pride in the organization, and feeling in touch with what's happening. Recent contemporary art has had a much bigger impact on life than any art form in prior years. You see it in design, everywhere.

> GL: When you began collecting, was there resistance within the firm
> or among your peers?

DM: Well, it was kind of stealth in the beginning, we just had a few things. There was some resistance. I remember Bob Rauschenberg doing a set of prints with Gemini called *Cardbirds* [1971]—structures made of cardboard that maybe looked like birds in two dimensions. And when I was out at lunch one day, *Cardbirds* had arrived at the firm. I'll never forget this: when I came back from lunch, my assistant went up to me white and said, Look what they've done to *Cardbirds*! Well, someone had unwrapped the prints and decided the whole thing was a mistake and why would anybody send us a piece of cardboard, and was in the process of folding it up and throwing it in the trash. Ever since, *Cardbirds* has had a kind of legendary quality to me. So sure there was resistance, and there's still resistance.

> GL: There must be acquisitions that you're particularly proud of, the
> culmination of months or years of effort on your part. Are there any that
> come to mind?

DM: Certainly there are acquisitions I'm especially proud of. I have always felt that terrific artists make a range of pictures, so I would look at artists, particularly ones who worked very slowly, show after show, and I would never see the work I wanted. It often tried the patience of artists, and then finally I'd see the one I wanted. An exam-

ple that comes to mind is Chuck Close, who has always done marvelous things but who, as you know, works slowly. One day, after I'd been seeing his works for years, his dealer called and said, Chuck wants to show you something. I went to his studio and there was this self-portrait, which is part of the show. I looked at that and said, That was really worth waiting for. Then there was Brice Marden. I'd been to many, many shows, and one day his dealer called and said, Come to the studio. I walked up the stairs, and I could see in his look—he didn't say it but I could see it: If you don't like this one, it's all over. And it was a fantastic picture.

GL: Are there any acquisitions you regret getting away from you?

DM: Oh yes. I still remember sitting in Angela Westwater's gallery and her saying, You must get this, Don. It was a candle painting by Richter. I remember looking at it and saying, Angela, I just don't know. That's certainly one. I look back at a couple of works by Jasper Johns; they always looked too expensive for the corporation, and then of course you look back on it and you realize that they were actually great value.

GL: The hunt for a great work of art, the willingness to focus on this for years at a time without being satisfied until you find that last work—is there an obsessional quality to that?

DM: Obsession to me is something that's unreasonable and out of your control. I think what you need to have a good collection is time. You can't build a good collection without time, and patience. I have both those things when it comes to collecting. That's probably what distinguishes a collector from someone else, who would get distracted. On the other hand, we collectors aren't just waiting for that one artist, that one picture; we're looking at thousands of works as we go. If you're building a collection, you always have opportunities. You always have things to see and places to go. The real problem is you never have enough time. In my case, my priorities are my family, my business, then The Museum of Modern Art, and collecting. So it's important and exciting but it has its place.

GL: Through the generosity of UBS, a considerable part of the PaineWebber collection has come to The Museum of Modern Art. What was involved in the decision to give these works to the Museum, and how does a public entity transfer works out of its collection this way?

DM: It was a big decision. What triggered our thinking was that once we'd had exhibitions from the collection in museums around the country, the logical question was, Shouldn't we be showing in a New York museum as well? To anyone in the firm who asked that, and I was asked by many people, I responded, Well, to show these works in The Museum of Modern Art, which to my knowledge has never done a show of a corporate collection, one would have to think that some of these works would eventually be going to The Museum of Modern Art. That wasn't a bad thing, it was a good thing. New York was our home base. There were lots of values to that idea beyond the obvious ones, and we had to think that through. There was a growing endorse-

ment of the idea, which wouldn't have happened five years earlier. It wouldn't have happened without people seeing that getting the name of the business exposed in this way was very positive.

The next question was, What would you give? Well, we had 700 works of art, and in the end we gave 44. Obviously these were good works, and they were picked by The Museum of Modern Art. That seemed to be all right in proportion. The final question was, When would you do it? Well, you'd want to do it at a time when it wasn't a material issue for the firm. Our business is driven by the stock market, which goes through cycles, and not all cycles are up; you would want to make such a gift in a time of enthusiasm. As a result, although PaineWebber had come to a verbal understanding with the museum, we hadn't actually made the gift by the time we did our deal with UBS, because we didn't think the timing was right. When we were done with our deal, I said to the Chairman of UBS, Marcel Ospel, "Marcel, we have this plan to have a show at the Modern, but there's no legal commitment at all, there's a promise to do it." And he said, "If you promised, we'll do it." That carried right through, and we formalized the commitment after PaineWebber was acquired by UBS.

> GL: Under the current regulatory climate governing financial institutions and other businesses, do you think it will be as easy to give away such an important asset?

DM: Well, I hope it will have a positive impact. Part of the responsibility of a large corporation is to be involved in the community and its quality of life. I think every corporation ought to give away a certain percentage of its profits every year; I think that's good corporate governance. In fact a growing number of corporations have foundations. All this corporate governance is more about understanding what corporations do, and ensuring transparency about what they do, than about restricting them from doing it.

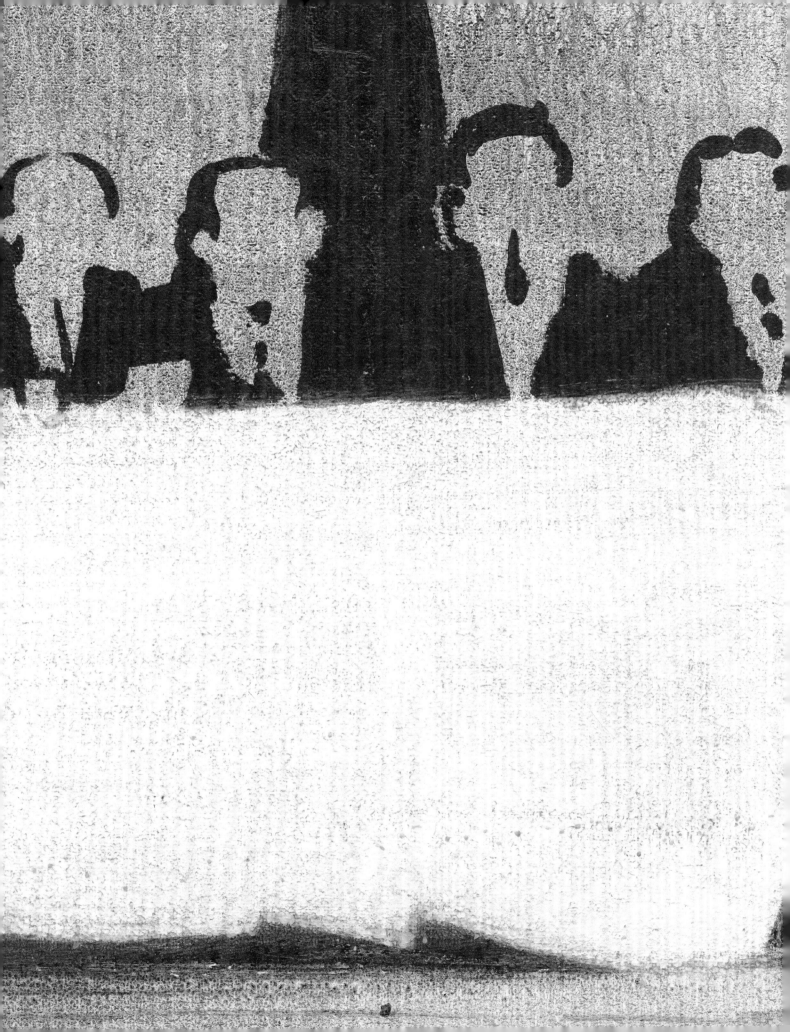

Richard Artschwager

ANN TEMKIN: What was your formal training as an artist?

RICHARD ARTSCHWAGER: Well, I fought in World War II and did the GI Bill, which took me to Cornell to finish my degree, in 1948. That last semester at Cornell, I took whatever art I could, but I couldn't change my major, which was chemistry and math directed toward biology. That would have put me on the cutting edge of biology—I'd like another lifetime, or a parallel lifetime, to do that stuff. Art was a choice to build on quicksand instead of on granite, and not know what was going to come out. But you know, knowing me, that I still overlay some kind of structure in my art. Then I also studied with Amedée Ozenfant from 1949 to 1950, at his studio school in New York.

AT: What was Ozenfant's reaction to the paintings you were making?

RA: Oh, he was cool. He didn't hand you premises. He had a cluster of imitators and he didn't bother them about being imitators, if that was what they wanted to do. Ozenfant relied a lot on cosmology. People in the art world can put a cosmology together, but it was so unscientific; I'd been trained in science so I didn't have much respect for that. I couldn't take the cosmology stuff seriously, although I was interested in it around the time of my first dip into the New York art world.

I wouldn't say I had a whole lot of respect for the art world then, the Abstract Expressionists. Three of them is sufficient; you don't need a school of Abstract Expressionists. There's an oxymoron built in there that should scare anybody away. My experience of the art world then was pretty negative. I wondered, How did I get mixed up with this pack of fools? I was a real snot. Then, down the line, I just went for the thing that would support my art, that would let me make a living, and that was making furniture. It was hard to make a living, and then have prime time for art—forget about it. But I got in with a fellow who had majored in economics at Columbia, and he and I worked out a way to make a chest of drawers in four hours. I made furniture for something like ten years, and I got good at it. I'd lowered my horizons. But Mark Di Suvero's first show at the Green Gallery [1960] made a huge impression on me: I realized that you can do anything, that you can use the chaos,

that there are no rules in art. It was liberating.

> AT: Your images from the early '60s were little landscape paintings. In light of what you're doing now, it's all the more interesting to me to look at those.

RA: They communicate a passion, or affinity, for landscape—to be up on the mesa east of Las Cruces in New Mexico and see as far as you can see. There are places where there's no sign of any human other than oneself. It's really oneself and the context: you set aside everything but yourself and the space you're in, the body you're in, because there's so much room just for that, the I/Thou, the thou being the life—

> AT: That comes across in those paintings.

RA: I would think. Nothing really painful, but a virginal romanticism. It could be in stripped-down terms, but there's a lot of stuff in those paintings.

> AT: Yes.

RA: And then I went on a search for originality, using Lefrak City as the subject of a painting, for example. That painting wasn't social commentary, as it has been described so many times. But I've quit getting pissed about that.

> AT: How did you make *Lefrak City* [1962] and the other pictures, like *Seated Group* [1962; p. 135], based on existing images?

RA: *Seated Group* was made freehand, just referring to the photo as I drew. But *Lefrak City* was drawn on a gridded canvas. The original image was, oh, about the size of the mouse for a computer. I blew it up to eight feet wide.

> AT: Did you project it to enlarge it?

RA: No, I blocked the original, small image into one-eighth-inch squares, then divided the new, large canvas into three-inch squares. And I transferred it using the grid, filling in each of the squares.

> AT: Freehand?

RA: Yes, I drew it. It's finding a formula for being creative. You look into each little square and you compose within it—you're given 10 percent of the information and you have to fill in 90 percent. You've got that 10 percent as your only guide, along with the four sides and the shape hovering there, being helpful. There are elements in there that make you wonder, What the hell is that? But then you just draw it. The idea of enlarging was first; it's not that I was clevering out on all of this. You bump into things when you do something drastic like eighth-of-an-inch to three inches. It's all in a vague, cheerful hope that something is going to pop out. Accidents, one hopes,

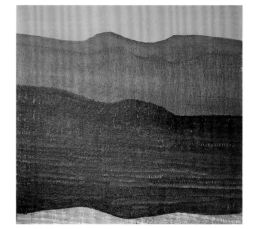

RICHARD ARTSCHWAGER.
Untitled. 1962.
Acrylic on Celotex, 47 5/8 x
49 5/8" (121 x 126 cm).
Private collection

RICHARD ARTSCHWAGER.
Lefrak City. 1962.
Acrylic on Celotex, 44 1/2" x
8' 1 1/2" (111.25 x 243.75
cm). Collection Irma and
Norman Braman

will happen. When you're making something, it's often pretty brainless at the start. Like the painted chest of drawers [*Portrait I*, 1962], it's just a dumb thing to do. Fools rush in where angels fear to tread—well, be the fool and you'll find new territory.

AT: You proved it.

RA: There's invention there, so that formula for making oneself inventive seems to have worked out. The way to get something bad is to put an image in a projector. Then you draw the projection and you get what you deserve.

AT: And when you're drawing your squares, is that with pencil?

RA: Could be. Some of my paintings have some pencil or charcoal in them. *Seated Group* had charcoal in it, but mainly paint. Whatever you grab and whatever is working. I have it written down: I told Bonnie Clearwater [in *Richard Artschwager: "Painting" Then and Now*, 2004] that I was looking to make something with the particular fetch of drawing but on a big scale.

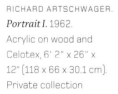

AT: She quotes you as saying you wanted "the intimacy of drawing even at a distance, the authority of a photo, and the juiciness and depth of a painting."

RA: Yes, that was a notion I had. There are conventions in drawing and they're all good for something. You can work between them, or work with two out of three....

AT: Does that explain your use of Celotex as a support?

RA: I wanted drawing on a big scale, an ambitious scale. But I wanted to change one variable—*a lot*—and see what came out.

AT: So paper wouldn't do.

RA: The difference between generic paper and canvas is that canvas has a pattern that's north, south, east, west—in other words it's a grid. But the surface of paper, even newsprint, is random. You have ridges and valleys but the landscape is random. That really defines paper for me, in a useful way. So, you make it or you find it. Around that time, in Chicago, I saw four Franz Kline paintings on Celotex and I thought, This is it, just what I need. I'm not sure of the timing, whether I'd thought of Celotex first, but I probably owe it to Kline—or at least he waved it under my nose. But he didn't use the aspect of it that interested me.

AT: Right, that was irrelevant to his aims.

RA: Good painter.

AT: Is it true that *Seated Group* was the first painting that you based on a photograph?

RA: *Woman with a Ball* [1962] was around the same time, and that was also based on a photograph. I worked on those pictures simultaneously. I'd done a picture of a bather before, an oil painting, so I was ready to do another. That oil painting was sort

RICHARD ARTSCHWAGER.
Portrait I. 1962.
Acrylic on wood and
Celotex, 6' 2" x 26" x
12" (118 x 66 x 30.1 cm).
Private collection

of the first painting, but my assistant at the time did a little editing and got rid of that thing. It was in a roll, not on a stretcher, and it wasn't that great—it wasn't even particularly good—but it was interesting. The idea behind it was to do a painting with the same theme as a '30s painting by Paul Cadmus, who did paintings of girls and sailors and treated no one with any respect. I wanted to do a Cadmus kind of theme, but without the spite, just the people. I think the intent was relatable to *Lefrak City*, which wasn't commentary but just this little illustration that people lived there—that behind each of these windows there were people living.

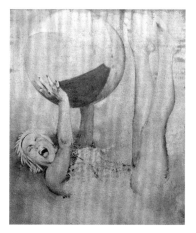

 AT: Can you talk a bit more about *Woman with a Ball?*

RA: I can make a connection. Take a photograph of someone winning, breaking the tape on the hundred-yard dash, and there's an expression of agony on the face. It isn't really agony, it's just somebody having run a hundred yards like hell and trying to breathe, trying to get some air into their system, which makes for a Greek-mask expression. That image might have a duration of five-hundredths of a second, but in the photograph the expression on the face would be in place as a condition as much as in a figure in the Elgin marbles. Stop-motion, but the stop would have some dynamic, some sense of time. Maybe like Lucy's footprints, preserved some three million years ago in the Olduvai Gorge. You see Lucy turning. So the face of the *Woman with a Ball*, it's a five-hundredth of a second, but it also wanted some classic quality. I don't know if it ever got that but that was the intent.

 AT: Did it occur to you to use color in any of these works?

RA: That's been the agony. See, I started with drawing and I never really left. I did some big interiors where I planned to get a color in there. It would be the color of a chrysanthemum, and also the same color as a fire in a fireplace. There would be two blotches of color. I guess I liked the false logic—a bowl of peaches where one peach is painted peach color and the rest are black and white. That does a good number on the black and white; there's a little bit of a hologram effect. The image hovers a little bit in front of the patterned surface.

 I wanted an ambitious scale, so I had to enlarge everything. If I'm enlarging the square footage of the surface, then along with that I have to enlarge everything else. If you look at newsprint under magnification, you see hills and valleys, so you have to enlarge the hills and valleys also. That's the general idea. Usually when you enlarge, you only change one variable and that's size. But then you can bump everything else up and see what happens.

 AT: But the variable of a color was one too many variables?

RA: I didn't know how to fit it in. When I put in color I lost the dichotomy…you really give up something important. You can keep it and you can even enhance it if you have

one arbitrary debt to color in there. These ideas are probably also the source of the blp: again, it's experimenting with drawing, and then ending up with just a single mark that activates and is activated by whatever the context is.

AT: When you were working from these photographs, were you thinking, This is a good way to not be expressive, to go against Abstract Expressionism—to make work that won't be about me, Richard Artschwager?

RA: I wasn't worried about that. I figured the Abstract Expressionists could take care of themselves. I wasn't going to be "school of" because one doesn't do that.

AT: Well, *you* don't.

RA: If you're a biologist you don't join a school, you find new territory. If you copy somebody else's idea, you get fired, and deservedly.

AT: Where did you find the photo for *Seated Group?* I've read that it was from *El Diario La Prensa.* Were you reading that paper?

RA: Yes, I used to get it from time to time. A couple of kids working for me in the furniture workshop were Spanish-speaking. I really learned Spanish that way—I had high school Spanish, and then Spanish was spoken in the workshop everyday.

AT: So one of the kids in the studio would have bought *El Diario?*

RA: Or I could have bought it too. Not every day, but sometimes.

AT: To try to improve your Spanish?

RA: Yes. I'm always in school. I got a couple of images from there, for example the man in *Portrait I* and the one for *Seated Group.* That's a wonderful image.

AT: These people around this long table.

RA: Some other parts of the scheme there I came up with in the process of extreme enlargement. That's the creative part. But working from an existing photograph allowed me to set myself up for creativity.

AT: It gave you a certain structure to build off?

RA: Yes. But also, the photograph I used for *Seated Group* had something electrifying about it. It wasn't a stop-motion thing; it was in the pages of this Puerto Rican newspaper, and it was a kind of event that probably happened a lot, an archetypal event: people meeting to work on something.

AT: It could be the most powerful people in the world or it could be a little community group.

RA: Yes. I found that photograph really powerful. In 2002 I did a remake of *Seated Group* in green, *Green Closure,* but it was much less instinctive, more studied. First I blocked in the table, and it just sat there for a while. The original *Seated Group* has a woman, but she's off on the left end; I wanted to keep her, but for some reason I put her on the right end—actually at the end of the table, which was ambiguous in

the old *Seated Group*. That fit the flavor of the old newspaper photograph, which is a black and white. It lent itself to being translated into a rough painting.

I really like the color in the green one, I call it baleful green—I was waiting for a chance to use it. It's not all that baleful, it's actually kind of nice, but with the green reflection on the floor, it's something definite. You can't do anything about its credibility; the thing takes over and you believe it. There's never any question in your mind about not believing it, because it would be silly not to believe it. I drew the woman unclothed first so that I could get the anatomy correct. It's just easier for me to do that. I thought it was really nice the way she came out—and in that placement, too, at the head of the table.

AT: You say you intentionally remade *Seated Group* as *Green Closure*. Was that prompted by your memory of *Seated Group*, or had you seen the picture recently?

RA: I don't know, I may have—I may have caught it in a catalogue. But it was another idea that I had, and I pretty much got right on it. You have to get on it before the newness is gone.

AT: Were you doing a set of paintings that looked back at early paintings?

RA: No.

AT: It was really a one-shot occasion.

RA: There's always the hope that you can start a new day and come up with something new. I've picked up on the appeal of the generic whenever possible—having something generic be something you can pick up and cut with a pair of scissors, sell, improve. A physical presence. It's souvenirs. For example, when I've collected I've collected the generic. In the war, for instance, I collected paper. I also collected guns, you know, we all had guns. They were popular and very wonderful for trading. Those odd-looking guns, they just radiate Germanic-Nazi dynamic.

RICHARD ARTSCHWAGER. *Green Closure.* 2002. Acrylic and fiber panel on Celotex in artist's frame, 49⅞" x 6' 2⅝" (126.7 x 189.5 cm). Private collection

AT: But *paper?*

RA: Yes, I saved every one of my intelligence reports. They were all classified, and I sent them home because I wanted them.

AT: The packages weren't opened?

RA: No, because I sent them on through. I was the one who censored my unit's mail. That was a job that the lieutenant got. I used the blacker-outer, something like a pen.

AT: That gives me a new way of looking at your blps.

RA: Well, black will do that, you know. Braque used that in his Cubist paintings. You take the f-holes in the middle of a violin in a still life, and it's always black, and it jumps out, but it goes in. It does both.

AT: What happened to the first *Seated Group* after you painted it?

RA: I don't think it was ever shown. I remember that when I decided to find a gallery, I made a dozen or eighteen sets of black and white snapshots and sent one to each gallery—there weren't many—and to all the museums, with a cover letter. And I think eighteen was enough to do it at that time. I only got two responses, one actually a card from someone at The Museum of Modern Art, and then I got a note from Ivan Karp at Leo Castelli. I responded to that right away. He told me to come by in the fall—this was 1963—which I did, and then he shoehorned me into group shows. There was actually a group show in November of that same year. My first solo show at Castelli was in 1965.

AT: Of the other things going on at this time, in the early '60s, was there anything else you felt had an important impact on your work?

RA: Oh, my epiphany—I was coming up to forty and it got me going. I realized that shortly I wouldn't be a kid anymore. I realized that I was letting things go by, and I became consumed by the notion that everything counts. That made me do a kind of gerrymandering of priorities, or jailhouse lawyering. I realized that you're here in this place every day, you work with so-and-so, you spend eight hours a day with them, and that day-to-day stuff is essential. Everything counts; these people I work with— they're my friends, they're my associates. A fact. I got to know them better; I could speak to them in their native tongue anyway, in Spanish. It didn't go a whole lot beyond that, but the notion stayed with me. That's why I have the chutzpah to call it an epiphany.

AT: I know what you're saying: pay attention to everything.

RA: Yes. There's all this stuff going on in your life, and you don't have to edit it out or throw it away, as if it's of no significance. Don't think that there are important relationships and relationships of no importance, such as a relationship with somebody working for you. They are all important. The furniture workshop (which was also my painting studio) was where I spent my time, and that's not nothing. I could feel bad about it and say, Oh, this is wasted time. But no, it wasn't.

AT: Right. Use this. Embrace it.

RA: "Embrace it" is better. Realizing that was an absolute turn-around for me.

AT: How lucky.

RA: And it had consequences in the art: it opened doors.

AT: And as far as you know, it came from nowhere?

RA: Just turning forty.

Vija Celmins

———

ANN TEMKIN: Can you explain how you decided to be an artist?

VIJA CELMINS: I can't remember when I didn't want to be an artist. When I was really little I had a sense of wonder about drawing things, that you could then have them, you know—you want a dog, you draw a dog. There was a kind of a magic there. And then I guess to be able to go to your room and draw was a refuge from grownups. A lot of kids draw, but usually they stop when they're somewhere about eight or nine, and they start going into other things. I kept drawing.

When I got into looking at art, it was like this world had opened to me, like when I started reading when I was seven. I just ran from one artist to another, like having a love affair—trying to paint like them and to see everything they had done. And then I was beginning to sense different ways of forming the work. I read all about that period at the turn of the century from the nineteenth to the twentieth— it's the most exciting period. I read van Gogh's letters, I couldn't believe it—the man was fantastic, so rational, so poetic. I read about Picasso, his various women, and how he changed his style when he got a new woman; it seems hokey now, but it's part of it. Toulouse-Lautrec and his model…then Duchamp…I loved it. These people became like friends for a kid who wanted to do that. It seems to me like that whole gang is way back there still, in those rooms, with the lights on, drinking and talking all night, and painting.

That was in Europe, and then the excitement jumped over here. I was never into Marsden Hartley or Georgia O'Keeffe, even though there was a Georgia O'Keeffe painting in the Indianapolis Museum of Art. (I grew up in Indianapolis and went to school at the John Herron Institute, which was connected to the museum.) But I looked at the O'Keeffe because it was a woman painting. I thought, If she could do it, I can do it. But I was never into that group. I was into de Kooning, maybe because he was an immigrant, and because he started in a dopier way, with those very academic drawings and so forth, and you can actually see his struggles. (Of course I tend not to show *my* struggles.) Same thing for Arshile Gorky, another wonderful artist I just

loved. So anyway, I thought, This is a world for me. I really moved into it. And my parents knew nothing about painting; I don't think they've ever been to a museum, except in Latvia. (I'm Latvian, you know—I'm American really, but my family's Latvian and I was born there.) They have a tradition of looking up to the artist—you're not a bum if you're going to be an artist, like people might say over here. So that helped, but they didn't know anything about art. This was my way of veering off into my own world.

AT: Creating your own world.

vc: Maybe making my own world as I went along. And then of course I was a student, always the student, darn it. I don't think I really faced the fact that I had to come to terms with what I was going to do in this field until I was in graduate school. I went to UCLA, because they gave me money. But they had no room at the school for an art department, so you had to find a studio in the city, which meant you were basically on your own and then the teachers would come to visit you every two weeks. It was good. You had to face some things in yourself. When I put together the work for my first retrospective, at the Newport Harbor Art Museum in 1979, I started with the lamp painting [*Lamp #1*, 1964], which I made when I was in school. I thought that was one of the more important works. First of all, they're like two eyes. I'm a great fan of looking. The sensations in painting come through the eyes.

AT: Can you talk a bit more about your early work?

vc: I had a couple of breaks. One was I started working with an image, and not with just gestures and color. That was a big break, and it came somewhere in about '64. Then I decided I was going to paint all these objects, which I did. I was trying to think about the painting space and whether you could put anything into it. I had another little break where I decided, No, you can't. I'd been collecting photographs, as I'm sure you've read, so in a way I really had a subject, a subject outside of myself, which freed up certain things. I think it freed up a certain kind of touch for me, and maybe quieted my little active mind, which was always thinking of things to do. So I started painting these photographs, which were already flat but still kept an image in there.

The early work is pretty autobiographical really. I went over my childhood images, war images—then I started painting all the things around me, as a way of trying to maybe personalize and get away from certain ideas and looks that I didn't think were mine, and that were beginning to feel decorative to me, and not meaningful in any way (although now I'm not sure what *anything* means). So then at a certain point I stopped painting and went to just graphite. I really think the night sky works came out of the pencil, because I like graphite. I was doing these allover ocean things in different pencils, they had grades to them and got darker and darker. I used to go rummaging around L.A. looking for images that I responded to and that would fit my

criteria of activating the whole surface. It was a way of composing.

AT: But am I wrong that the oceans were from photos that *you* took?

VC: They were, but I also had images I collected—all the war images were photos I found in magazines and books. I like the cold image, the found image that doesn't have too much in it. Then when you make it, you make it specific. So it turns emotional and comes to life in the materials.

AT: And that's why you went back to painting, right?

VC: Yes, well, first I went into drawing because I was so in love with the lead, the graphite. I did that for about ten years; I pushed it so far I couldn't go any farther. I didn't start painting again until the early '80s. And I started rather tentatively. I think the paintings were, and maybe still are, a little bit like graphite: they're quite hard and quite dry. But painting has a much more spatial quality, and the painting can be built up. That's one thing I decided to try. If I wasn't manipulating the image, if I wasn't really working with color, how would I make the painting have emotional power? I thought: Not easy. So I started layering the painting so that it became what I some-times think of as fat, instead of thin: it gets fat, dense, but not with brushstrokes. I take those down: I paint the image, I lay it down, and I take it down to the two-dimen-sional plane—I sand it. I paint it again, and then I sand it again, so that nothing jumps out. I paint it again, I sand it again very lightly.

AT: When you sand it, the image doesn't disappear?

VC: No, I don't sand it that hard. I just knock down any edges to even it out.

The image is just one of the things in the painting. The paint itself begins to have a tactile quality, even when it's knocked down. Hopefully. So you begin to see an object that has been really manipulated and built, not unlike building a house. When I started doing the night sky paintings, most of the images projected out. They were very clear, very strong works, and when they were balanced just right and the proportion was just right, they tended to work like little sirens and project out into the room. When I started doing the darker drawings, I noticed that from across the room you could only see the proportion, and they brought you in so that you could inspect their making. But you can't go too far in; you're pushed back out again a lit-tle. I like that double thing.

AT: You've said that you never want frames on them—that has a lot to do with that quality, right?

VC: Right. I want you to be able to see that there's a structure, and that the surface has been worked with in the most rigorous way. I want you to have a complicated experience where the image and the making have a kind of a tension between them, and where an ambiguous spatial thing draws you in and pushes you out at the same time. The more abstract the works became, the more ambiguous the experience seemed to be. You think: well, this looks like a night sky. At the same time, it doesn't

look like anything when you're far away; and when you get closer, maybe it's a night sky, but maybe it's just little marks, or a kind of wall, a barrier. That's very hard to see in reproductions; the work has to be experienced. And the experience is just the experience—I'm not sure what it means, except it's from one person to another. I'm the one—unfortunately, I sometimes think—who has made these, who has *had* to make these. I've put you through a spatial experience of painting. You could get that with any other painting, of course, but I think I've sort of herded you there.

> AT: You make the point especially clear by doing something like the night sky, which one could find in a photograph if all one was after was the image.

VC: Yes, but the image for me is like a net that catches the viewer. It catches you, and then when you come close to the image, you see that maybe it's not really what you thought—it's not really an image, it's a painting. Maybe then you get involved. Of course these paintings are so compressed that sometimes they look almost like Formica, but hopefully you get a feeling from them—though I don't know what the word for the feeling would be…. I don't know, you get a kick from them. When it all comes together you begin to feel that there's something more there.

> AT: But the work isn't easy. Many people walking by one of these might not get to the point you're talking about.

VC: You have to have an openness. You stand and say, Well, she didn't draw this, did she? What *did* she do? Intuitively you know you have to begin to ask, What is this person bringing to me?

> AT: But you're setting the price of admission quite high. It's not necessarily so easy to understand your project as you describe it. You make it a little harder to understand why these paintings are so skilled, as opposed to a flashily virtuosic thing that one can instantly appreciate.

VC: It's something that opens up. If you begin to open up to looking at art, it's an adventure, a passion…a way of living, really. If people see a Jasper Johns, do they run right up to it and say, Oh yes, I respect it perfectly?

> AT: He's hardly a model of easiness.

VC: I love Jasper Johns. He's a convoluted person. I love the way he gets his life in there and regurgitates it. He's brave…I'm a much more restrained sort of artist. He's always making these giant leaps. I make a few leaps, into sculpture sometimes. And now I feel like I'm ready for another leap for myself.

> AT: And if someone said to you, I don't get it?

VC: I wouldn't say there's anything to get. It's an experience. People have different kinds of experiences, but to try to go back and forth and find some place where there's a moment where you say "Ah!" or "Wow!"—just "Ah!" is good enough. You find an "Ah!" place, which would depend on the painting. There's a place where the painting begins to sing a little bit.

Then you can always look at it different ways, and you can see it has millions of coats on it, and it has a kind of a depth.

AT: Because the different stars, or dots, that you see are in many layers?

VC: They aren't, though. Take this painting I'm working on now, for example. I blocked out with rubber the—let's call it a star. And then I painted the painting again, and then I took the rubber off and I repainted the star so it could be up on the same level with the others. Just as a mechanics of making it.

AT: And when you do your second or third go-round, are they all on the same plane?

VC: There's always a tiny bit of adjusting because I like to keep the plane even, so that you're always aware that you're looking at an object. Yet you have the slight illusion that it may be like the night sky—but maybe just a night sky in your brain.

AT: When you say you block out in rubber, what does that mean? Something like rubber cement?

VC: Yes, rubber, but not rubber cement. I block out this little white spot so I don't have to paint the whole thing around it. Later I take it off—it's like a stencil.

AT: But how can you block out something so tiny?

VC: I use a tiny brush!
The painting is built, it has layers. It takes an incredible amount of stamina. And then toward the end…

AT: There's a transformation.

VC: Well, hopefully. I try to get to the point where the painting begins not to want me anymore.

AT: When were the first night sky paintings made?

VC: The first drawing was '73; the first paintings were in the mid-'80s. The last graphite drawings I did were very heavy, and I said to myself, OK Vija, this lead can't hold anymore, you're going to have to go to a more pliable material that you can build off. That was in '83. Then I got a new studio—somebody was redoing a building and they let me have a studio that was big. I started doing some paintings, and then I started doing some bigger paintings.

AT: Earlier you called the night sky paintings strange.

VC: I think they are a little strange. First of all, it's very difficult to make a black painting, and to find a context that's right for it.

AT: You've been doing them for over fifteen years?

VC: This has been a very concentrated thing. I thought, it doesn't have any meaning, nothing, but maybe something will get across if I make one painting after another. But I do think there's an emotional quality to the work. It's cold, in a way, and austere,

but when you come close to it, it begins to warm up. It's like a little eye exercise, but it's not just the eye: there's a little bit of a tug. You feel, This is something that's been cared for and constructed over a period of time.

AT: The paintings of oceans, night skies, and deserts—none of these has a central image.

vc: No. But the work itself, because it's small, isn't really an atmosphere that you can roam around in. It's a concentrated work that stays itself. You have to confront it with your body. I'm trying to make a painting that grabs you when you walk by and says "Take a look at this." Different artists' paintings do different things; some painters aren't even interested in the space of painting, they're interested in images or color. To me it seems like you have to be interested in the space of painting because it's part of the thing, but people are interested in different things. I happen to have fallen into this funnel that took me this way, because I'm interested in illusion and space in painting—in no space, space, flat space, fat space, flat, projected…. It's a way of engaging a person. I don't do portraits or landscapes.

AT: It's a form of communication.

vc: Like all art, right? We'll see where it goes from here. I've been thinking my work has become kind of dry. I was at the Met once looking at Memling and those northern painters, with those beautiful surfaces where everything is crystal clear, but a little bit, I wouldn't say amateurish—

AT: Stiff?

vc: —because they're trying so hard to make space.

AT: It's so endearing.

vc: Right, very endearing in a way. My work lately has had that hard look. So now I've been getting interested in doing lighter paintings, where the space is much more ambiguous—it's like a fog, you can't really tell where you're at. I like that. I'm also interested in doing bigger work, though it would have to be done in a different way.

AT: Because the tension we were talking about wouldn't be there.

vc: These works are in a funny way very overworked, but you can grasp them instantaneously. They're overworked but not overworked: a very simple image has been highly compressed.

AT: Well, it's almost like you sculpt the painting.

vc: Right. I've done paintings that I thought were overly finished. They sometimes get a little fetishy. When the light isn't right or something they just look like some fetishy object. I could see people throwing them out with the garbage because

VIJA CELMINS. *Night Sky #18.* 2000–2001. Oil on linen mounted on wood, 31 x 18" (78.7 x 96.5 cm). Private collection

they don't look like a painting. I'm trying to back away from that a little, and make sure it doesn't happen. And now I have this relationship with leaving a touch, but a very subtle touch—

AT: Showing just a little.

VC: So it almost looks like painting has just *appeared*. Then only on close inspection you think, My God, this has been made in some complicated way! Now I'm thinking maybe I'll let some of this stuff show, and shift away from this…

AT: Deadpan surface?

VC: Right. Though I've always liked painting that laid back and needed to be approached. I don't like work that's in your face all the time.

When I was growing up, the most exciting art was Abstract Expressionism. That's what turned all of us on—we were trying to paint like de Kooning, Rothko, Pollock. I think that's what everybody was doing all over the country. It was a very exciting concept that you could make an abstract painting. I was really young, and I thought Wow, my goodness, these are grownup people doing this fantastic painting—I want to do it! But even though I liked those terrific abstract painters, and wanted to become like one of them, there weren't that many women that were terrific. Somebody told me once that those guys never let the women paint. The women had to keep the men painting—sobering them up in the morning, stuff like that.

Anyway, the Abstract Expressionists collected a whole series of small strokes, and made them, we used to call it "plastic." They really made the painting space a tough painting space. And then the painting itself was the invention, it wasn't like it was the background on which you scribbled a few things—the whole thing was the work of art, and in the best painters it was built quite strongly.

AT: Most of your night sky works are oil on canvas mounted on a wood or aluminum panel.

VC: Yes, because I beat the canvas so much. I sand it, lean on it, work on it….

AT: So it's a literal, physical support.

VC: And then of course there's so much paint on it that if you didn't have a backing, it would crack. Even though it is alkyd, which makes a tough, rubbery kind of surface.

AT: And also one where, if I'm not mistaken, the brushstroke is less apparent.

VC: Right. I was into brushstrokes when I was young, but I did a total flip, like a barrel in the water, and said to myself in a moment of denial, No more—they're gross. Now I sometimes think, Gee, do I still have a little brushstroke in there? Maybe I'll take a look at the brushstroke and see where it can take me—not a gross brushstroke but a little one.

AT: Did each night sky painting start from a particular photograph?

VC: Yes, I have tons of photographs that I've gotten from laboratories and so forth—

the Jet Propulsion Laboratory in Pasadena, a lot of different places. Look at these, these are like my old pets. This photo became a painting. You see, I work from a very tiny thing.

AT: And crop them as you wish?

VC: When your mind is focused on a very tiny area, you get a freedom when you translate it up to a painting. It isn't like I'm cropping every detail.

AT: How does the transfer to the painting happen? Here on this painting you're just beginning, I see a grid.

VC: Usually I grid them. I'm still looking at the photograph and I put down the grid so I don't lose my place.

AT: So there's no projection, you're just translating visually.

VC: Right. I do have an opaque projector, and I used to use it a long time ago, I think on the airplane paintings, but I really haven't been projecting. I find it's much easier to do it this way.

AT: Are you concerned to make them exactly like the source? Or no?

VC: I was at the beginning, but not now.

AT: The photograph is just a taking-off point.

VC: When I first started, the photographs were a major subject. Now I think I'm more interested in what happens when you have the painting in front of you. I'm playing more with the kind of space and aura that the painting has.

AT: I'm also interested in talking to you about the drawings *Eight Saturns*, from 1982 [p. 140]. That's gorgeous.

VC: In 1985 I did a little book with May Castleberry for the Whitney Library Fellows. I was looking through things and I thought, Well, that's an interesting spatial problem: how to draw Saturn? How do you make that little circle that goes around it? Sometimes they look like a coffee cup and saucer, sometimes they look like eyes. So I did a little mezzotint, I tried a whole bunch to make it feel just right. And then I did a little print for the book, it's one of the first little prints. And then I made a couple of paintings. I was trying out different Saturns. It's just like a little exercise, how to make that loop seem to loop around. And I like the planet. It's a gorgeous planet, isn't it? And it's a giant planet, over nine times bigger than the earth.

AT: But there's something weird about the drawing repeating it in rows.

VC: Yes, but I didn't even think of that. I just lined them up, trying to draw them. I had a lot of little Saturns that I'd cut out of various things.

AT: Photographs.

VC: Yes, and each one was slightly different. It's a unique piece.

AT: Usually, looking at your drawings or paintings, one cannot identify the exact stars.

VC: No, they're really only descriptive of the photograph. But we're still tuned in, we still recognize the image. Then some of them are getting a little more—I don't know what you'd say—hard-edge, or abstract, so that it's a little bit harder to immediately identify as a night sky.

AT: There's a funny thing about them, and I know this has been said before: they're not romantic.

VC: They're romantic. The gesture of making art is romantic, don't you think?

AT: Yes, I agree, but they're not capital-R romantic. And the subjects you choose—the ocean, the sky—certainly *could* be made like that.

VC: I know. I tend to neutralize them right off the bat, whip them into shape, flatten them out, and make them very rigorous, so that the romance is something that bounces in your hand but doesn't ever really actualize. I make them strong and resistant to that interpretation.

AT: How do you know when a painting is done?

VC: When my dealer calls and says I have to have a painting or this is it! [*laughter*] Well, seriously, it builds. You have a relationship with the painting when you're working on it, and at a certain point you say Ugh! Or you come in in the morning and it's beginning to feel like it's gelled. I get a little hit. And then I think, Ok, that's it. You know you can't continue it. It begins to have something itself that it gives back to you.

AT: You don't want to fuss with that.

VC: Of course you never know whether anybody else is going to see that thing happening. But the way human beings are, it seems like no matter what you do, other people get glimpses of it. I think you have to push yourself where you want to go, and then somebody else either takes it or leaves it.

Francesco Clemente

ANN TEMKIN: Am I correct that *Perseverance* [1981; p. 143] is the first painting you made in New York City?

FRANCESCO CLEMENTE: Yes.

AT: And it precedes The Fourteen Stations [1981–82; named after the Fourteen Stations of the Cross], but you see it as part of that group.

FC: Yes, *Perseverance* is one of The Fourteen Stations. It and another painting called *Fortune* [1981] were the first of the fourteen to be made. The paintings called *Stations I–XII* were made after *Perseverance* and *Fortune*. Maybe the two titles, *Fortune* and *Perseverance,* somehow establish a sort of compass that you need to enter the Stations, and I think maybe the two are complementary: one is black and one is white.

AT: Do you remember which of the two came first? And do you remember the dream that inspired *Perseverance,* or do you now remember the dream only because art historians have written about it? The story goes that in 1981, during your first night in your first loft on Broadway, you dreamed that you were naked in the New York streets and it was raining excrement.

FC: *Perseverance* came first. And I do remember the dream. I'm generally not very fond of dreams, in the sense that I consider them a mechanical function of our psyche. I find it's always a little bit of a sign of innocence for a viewer to ask whether what I do comes from dreams. To me, dreams aren't signs—they're not signals of freedom, they're signals of slavery. So they're actually the opposite pole of my activity as a painter. But there's a particular kind of dream that has a healing function—not the function of balancing the mechanism, but the function of opening a transitory gate of freedom for a few days or moments. I believe in that, and this was that kind of dream.

AT: Exceptionally.

FC: Yes, and you end up remembering dreams of that type, because they're very rare in your lifetime. Also, we associate dreams with night, and to me The Fourteen Stations are night paintings. They were painted at night and they came out of the dark. The images come out of a dark material that's more than a background. So it makes sense that there's this connection.

AT: Had you decided to make The Fourteen Stations before coming to New York?

FRANCESCO CLEMENTE.
Fortune. 1981.
Encaustic on canvas,
6' 6" x 7' 9" (198 x 236 cm). Private collection

FC: No. The strategy of my work is an itinerant strategy: what I do is collect fragments of discourse from different places. I've always believed in the *genius loci,* the spirit of the place. And until I came to New York, I didn't have much interest in oil painting; it seemed to me too solid a medium for our time. I thought our time needed a more ephemeral kind of medium, so I was more concerned with paper and with more fragile things. I guess when I came to New York, I saw it as a Dutch city, and a city where gold is stored. And with the gold, you also store the oil [*laughter*].

AT: And also, I imagine, the '50s tradition of New York School oil painting?

FC: Well, not so much. Actually, up to that point my relation with American painting was more with the generation before mine, the generation of the '60s, than with the generation of the '50s, because the generation of the '60s really developed their work on a European stage. The '50s remained more remote to people growing up in Europe; they became history very quickly. Whereas the '60s were a living thing for me.

AT: Right. But when I think about '60s painting, I don't think as much about material as I do about subject matter and approach.

FC: Well, I never think in terms of materials anyway. Materials to me are just another decoy. There's a layering of decoys in painting—not because you don't want to say what you say clearly, but because to say something clearly, you have to unravel all the layers that make what you say opaque. I don't really believe in any objectivity of materials, but I do believe that craft is attached to the imagination of a place. And even if craft is extinct in our time, you can revive an imagining of the craft, and an imagining of the voice of the place. That you can do. But you need a sense of irony to do it.

AT: And when you came to New York and bought oil paints in the neighborhood, did that feel like a strange thing or a liberating thing to be doing?

FC: Well... It was just another item in my catalogue of materials. I would impersonate. My best friend was a performance artist, so-called, and to me, to be painting again was also a form of performance.

AT: You were almost one step removed from it?

FC: Yes. Again, to me, to travel meant not only to move physically from one geographic context to another, but also to move from one persona to another. I had no interest in the idea of appropriating a stylistic signature and going on with that, so that would be my little language. I had an interest in fragmentation, in vulnerability. I'm interested in twentieth-century poetry—people like Ezra Pound—more than in painting. He confronted the broken language of the time.

AT: Yes. And precedents in painting, for you, almost ignored that brokenness, or tried to pretend it wasn't there?

FC: Yes.

AT: In that sense, the decision to paint in oil wasn't so dramatic.

FC: It wasn't. Painting in oil was another relative value on a table of relative values. Its radicality lay in establishing a physical obstacle to the assimilation of everything that started back then, and that we're now seeing the full triumph of—the flattening, the homogenization of every single value on the planet. I thought, Any object that can create a bit of attrition in this process will be welcome. I didn't think I could stop my time from being my time, but I thought I could make my time stumble lightly for a second [*laughter*].

AT: It was an act of resistance, in a fashion.

FC: Yes. And to go back to another poet, Rilke, all you have to do is resist. But when I mentioned that in a lecture at a college once, the students asked, "Resist what?" [*laughter*].

AT: Did you begin *Perseverance* the day after your dream?

FC: No, I painted it later.

AT: As you were saying about the innocent idea of dreams, we would have the idea that you jumped out of bed and—

FC: No, what I make is eminently sober. It's what you do after the hallucination, not during it. Again, I think as much as I have objections to the time I live in, I know that I belong to it, and that I need a sense of irony and distance to be able to communicate.

AT: Are you the character in the painting?

FC: I am. But for me, the notion of the self-portrait has to do not with the continuity of self but with the discontinuity of self. It has to do with the fact that every discourse is a relative discourse in a relative dynamic of facts. At the same time, I find it reassuring to know who is speaking. That's almost the most you can aspire to today, I think—to know who is speaking. Or who *thinks* he's speaking.

AT: Unfortunately that's asking a lot.

FC: It's asking a lot. And I imagine a number of people would even dispute that.

AT: The painting represents you in movement. You're so much an artist of itinerant habit: is the simple interpretation, "Here you are coming to America, bringing with you the culture of Europe," a distortion of that?

FC: It has nothing to do with culture, it has to do with affection. Objects carry some of our feelings. I mean, the painting has nothing to do with where it comes from; it has to do with the landscape of my affections. That's all.

AT: Yes. And the rain is New York, somehow?

FC: I think it's also paint itself, as a matrix of chaos and disorder. That divide is in most of what I make—the divide between what's visual and what's self-referential. It's a way for me to stay close to what I feel is the temperature of the mind. You never know what's outside of yourself and what's inside of yourself, you know? I think that's really the theme of what I make, this blurred line between what's outside of you and what's inside of you, and your perception playing in this field.

AT: Right, from where are you ever able to see that distinction, or lack of distinction? I'm interested in how textured that white background is. It's quite thickly built up.

FC: Yes, like almost everything I do. There's a lot of detail to these pictures. Well, The Fourteen Stations are an exception, but *Fortune* and *Perseverance* were made in a very immediate way.

AT: You didn't make a sketch for *Perseverance* at some point?

FC: No, not in this case. In this case I thought that the image would appear out of the material, the paint, instead of the material being determined by the image. So no, there were no preparatory sketches. Not even a note. Nothing.

AT: You did these two and then you did the other twelve, but these are part of that set. Did you know that when you made them?

FC: Again, I always have this question of establishing a voice or a view. So I guess these two were the generating paintings. There are always generating works, which are modest works that establish a ground, a pitch, a field. Then you work within that zone. I never thought about it before, but there are complementary movements in the two paintings: lifting and carrying on the one hand, digging and falling on the other. It's almost like establishing directions. That's what makes working with your hands a good way to grow old: the morality of objects and things takes over your good intentions.

AT: It covers them.

FC: Yes. You start out hopeful of being the master, and you end up under the laws of the objects.

AT: When you think of this painting now, twenty years later, is it something you're entirely detached from?

FC: No. It takes a long time to exit from your physicality, from your body. Also, when I look at objects that I didn't make, I have the same relation with them. I mean, the painting has nothing at all to do with my making it. These objects have their own life. I sew them up, I have a commerce with them, but they're not a matter of my opinions or biography.

AT: No, now this painting is something in the world.

FC: Our familiarity with it, the fact that we are talking about it, means that it is in the world. It wasn't in the world before I made it, but in a way it was, because the kind of familiarity we have with it comes from something that's already there. Is that going too far? Basically there's a necessity to objects. They make a big family, and there's a necessity to this family. Someone in my position just has the capacity to accept the necessity of these things.

AT: But you invented it, would you admit that?

FC: No, that's too active a proposition. Inventing is too much an active thing. I accepted it, yes.

AT: And transmitted it.

FC: I just accepted it. To accept it is a big step [*laughter*].

AT: To me that's a non-Western point of view. The attitude of an American painter would be, I have given birth to something that otherwise would never have been born. I have somehow created something new, something that never existed before, and that without me never would.

FC: No, it's not like that. To talk about acceptance is to talk, in a way, about a personal religion. And that's a purely American invention. I mean, when you think about what America is about, America is about its prophets. Forget America's material success; the material success is just the accidental function, the byproduct, of the illumination of the American prophets. And their illumination was really to accept the personal view and context in life as a world experience, a world reality. Emerson and Thoreau, and painters like those of the New York School: that's what they were doing. So this is not at all foreign to the American experience, not at all.

AT: You're right, that's a different way of thinking about Emerson, who is so often blamed for our materialism and self-advertising. But that's, in a sense, a distortion.

FC: Well, that's the history of humanity: whenever you have a great poet or prophet, you have a masking and twisting of the prophecy. This is the nature of prophecy—otherwise the world would be an easier place to live in. And the more fulfilling, the more clear-minded the prophecy, the more the reaction and the twisting and the masking, and this is the law [*laughter*]. I feel very strongly about this truth of America,

because I think my friendship with American poets like Allen Ginsberg has to do with that spirit. My admiration for American painting has to do with it too.

AT: It's the best we have to offer?

FC: It's not the best, but it's something real. Everything else comes and goes.

AT: It was there a hundred years before Emerson, I suppose?

FC: Well, Emerson articulates it in a very clear and wonderful way. Carlyle speaks about these issues in a very obscure way—and when we touch Carlyle, we go back to Blake. There's a lineage there that I'm really fond of: Blake, Carlyle, Emerson, and then ultimately Whitman and Ginsberg.

AT: What comes between Emerson and his generation and Ginsberg and our own time?

FC: Well, there's a back and forth, East and West. Thoreau read the Bhagavad Gita. And we know that Tolstoy read Thoreau. Gandhi read Tolstoy. And when Krishnamurti was in America, Pollock went to listen to him. Krishnamurti has this wonderful notion about contemplation: he says it should be an effortless effort. "Effortless effort" is a wonderful way to think about Pollock. These connections are there; they're not that fanciful.

AT: The title *Perseverance?*

FC: Maybe that suggests another lineage. When we say Krishnamurti, we say theosophy and Annie Besant, who thought she was the reincarnation of Giordano Bruno. So we go back to a lineage of Western contemplative tradition, which was persecuted by the Catholic and Protestant churches, but which left behind a great constellation of images and emblematic structures. *Perseverance* and *Fortune* want to be part of that. They refer to early Renaissance discourse. I guess somewhere on those Renaissance wheels, you need both perseverance and fortune to complete your journey.

AT: Let's talk about *Salvation* [1987; p. 144–45]. My notes say it's pigment on linen, which means nothing, of course. We weren't precise.

FC: No, that's me [*laughter*]. Strangely enough, this painting bears the same relation to The Funerary Paintings [1987] as *Perseverance* does to The Fourteen Stations: it's the second of The Funerary Paintings, and it's part of a group of five that bear individual titles, and that were dispersed from the series. In a way, this painting, just like the other one, is a marker in the story of my relation to New York. This is near the end of that period. Probably more than any other work I've made, The Funerary Paintings relate to my imagining of painting as a form of ritual. My radical lack of interest in formal solutions and concerns has to do with that—with the fact that I've always thought of painting as the relic of a ritual. Basically, painting is a catalogue, a collection, of actions, memories, and stories that have been

told and forgotten and told again, and that happen to be finally codified, briefly, in this way. I think The Funerary Paintings have that character more than any other work from that time.

AT: Were they done in reaction to something particular?

FC: Yes. A painting is always a meeting point, a field where different concerns and images of thinking and experience come together. As far as the chronicle of New York goes, we are in 1987, when all of the great protagonists of that time had just died. As far as my own emotional temperature goes, I'd just come back from my first trip to Egypt and had just seen the Valley of the Kings for the first time. That's where the palette and format come from. Even the treatment of the surface, the fact that it's so matte and so dry—that comes from imagining the painting as the wall of a funerary chamber.

AT: As with the Stations, did you do the titled ones before the numbered ones?

FC: Yes. In this case, actually, the numbered ones also have titles. It's a process where you establish a format and then make variations on it, and usually the variations take you somewhere else, if you're lucky. They were made over the arc of maybe eighteen months in which I don't think I made anything else. It was an extremely—

AT: Focused period.

FC: Yes, and also there are emotional rules: it didn't seem appropriate to do anything else than this.

AT: Is the boat from Egyptian iconography? Or is the connection less literal?

FC: No, it's never like that—there are no dogmatic cues for anything. The painting is always an ephemeral, transitory operation, and things permute into something else. The reduction of the palette, on the other hand—that comes straight from the Valley of the Kings. The whole series is painted in the four earth colors—you have umber, green earth, pozzuoli red, and ocher yellow. I'd been using these colors in frescoes, they're colors that don't mutate with water and lime. If you look at frescoes, the colors that are really in the plaster are the earth colors. When you see a bright color like blue, it's *a secco,* not *a fresco*—painted when the plaster is dry, not when it's wet, because bright colors like blue would oxidize with the lime in the plaster, they'd be burned and changed. Yellow would turn red, blue would turn black….

AT: So you applied the rule of fresco to these paintings, even though they're on linen.

FC: That gave me the range, or the limitation, for the backgrounds. Then I painted on it with a limited palette, a palette of oxides and I guess a lot of black.

AT: The format of a background that's almost like a carpet is new in these paintings.

FC: Yes, I'm wondering what that's about. Not only are the paintings the walls of the chamber, there are also cenotaphs, something buried in the middle of something else. Often the central part has a densely deep black background. So they're walls that open into darkness, I guess. Around it the background stays…a lot of the ground shows. The ground, and earth colors, are very important in these paintings.

AT: Now I go back to my question about the pigment.

FC: Yes, it's water-based. Let's call it a tempera, maybe. Water-based earth colors. Very thin, so the paint sits on the grain of the canvas, almost like a pastel surface.

AT: As if you could blow it away. And you painted The Funerary Paintings in New York too?

FC: They were all painted on the glorious ninth floor of the Chelsea Hotel. One by one, because there was no room for more than one in the room I had there. In fact I built a diagonal wall across the room to accommodate the paintings' length, which wouldn't fit on the room's own walls.

AT: Why were you working in the Chelsea Hotel, not here in your studio?

FC: It was part of the geographical misplacement that I seem to need to be able to think properly. I feel besieged by false consciousness, so there's a permanent struggle to displace myself, to make room for some clarity of mind. That's the way I do it. I don't take drugs, I don't drink, so… [*laughter*].

The other thing about The Funerary Paintings is that they all have these impersonal pencil outlines. That's really important. Don't ask me why it's important, but it is.

AT: Underneath the paint?

FC: Yes, but you see it.

AT: And there are drawings after The Funerary Paintings, right?

FC: I made a suite of drawings after the set. I kept those together. In the past, before photography, artists had books of etchings reproducing their most popular works. I always liked that idea, so I thought of making my own record of these paintings, and I thought that photography wouldn't be the most eloquent medium to give an idea of what they were about—that maybe drawing would do better. The drawings are very accurate. They feel like accurate reproductions.

AT: *Salvation* obviously is no longer with the other Funerary Paintings. Are the rest in one collection?

FC: They're still together in a private collection.

AT: You didn't mind splitting up the group?

FC: In the group that I kept together, I didn't need to see a variation of certain images. They were like a collection of amulets, if you like, and it so happens that I made a few variations on certain ones, but for the collection of amulets to have its power, all I needed to have was one of each.

Damien Hirst

ANN TEMKIN: How did the Spot Paintings begin?

DAMIEN HIRST: I painted the first ones directly on the wall. I bought empty tins, mixed paint in them, put them in a grid on the floor, and then just painted from the tins.

I'd always done collages when I was a student at Goldsmiths; then I realized I'd always used color to solve formal problems, so I'd ended up with very colorful things that looked more like curtains than collages or paintings. I'd been weak formally, and in every other way—metaphorically, in terms of content—because I'd always solved problems with color. So I started doing things that had no color in them—I tried to separate color out. Then the Spot Paintings *just* dealt with color. They questioned the emotional decisions that people make about color, how they respond differently to paintings in reds and oranges than to paintings in browns and purples. I think I'd been looking at photographs of space, or of the moon, where they put little crosses on the photograph—the grid over the landscape. It's this unknowable landscape, but the crosses give you the false feeling that you have some understanding of it. I was thinking about a system like that in terms of color, so I tentatively chose this grid. I made the spots and the gaps between them the same size. Also, at first I experimented with putting two spots of the same color quite far apart in the painting, but they would jump out at you like a chord; so I decided that no two colors would be the same, to stop you from picking out chords of color. I wanted it to be like the moon landscape: you'd be at sea.

AT: The grid of tins on the floor—was that on a one-to-one scale to what was going to be on the wall?

DH: I just laid the tins out to look at. They were circles as well. I don't think I left any gaps; they were touching. I was basically trying to create something random. I toyed around with how to do that for a while, and then I realized that random is random—that the best random was when I just laid them out. Sometimes I got four yellows in a row; that's just what happens.

AT: But then would you stick to that, or not?

DH: In the beginning, no, but now I do.

AT: What kind of wall did you work on? Were the paintings ephemeral?

DH: I would paint them on anything. I've done them on brick walls, which is very difficult—the paint gets into the cracks. But I quite like that, it's like nail varnish or a skin or something. I sold those paintings, they exist as a certificate and tins of paint. With the first ones I did on a wall, you got no paint, you just got a certificate that said "Use any colors."

AT: Really do-it-yourself.

DH: I think it says "by an authorized representative" on the certificate. I wasn't thinking of selling those first Spot Paintings, shown at the *Freeze* show [which Hirst organized as a student in London in 1988], but then somebody said, Do you want to sell it? I made the certificates out of the back of the catalogue to the show—I just hacked it up, wrote something out, and did a little drawing on it.

AT: That made them a sort of conceptual art: you could own one without getting the physical thing.

DH: Yes, but it was the people who bought them who came up with idea of the certificates. I said, How are you going to buy these? And they went, You can give me a certificate. So I said OK. They were each about £500.

AT: Then the buyers could make them any colors they wanted?

DH: Yes. I put "Dimensions variable, colors variable," though "No two colors the same."

AT: Do you still do any on the wall?

DH: I haven't been asked to paint one on a wall recently. When I was doing them on the wall I never thought they'd work on canvas, I thought that was the beauty of them, but then I tried one on canvas and thought it looked quite brilliant. Once I started painting them on canvas, I forgot about the ones on the wall. I wanted to do an endless series of spots.

AT: I've read in a few places that you've ended the series.

DH: I haven't but I'm trying to. I keep thinking of other nice ways to do them, though. In 2000 I did an edition of fifteen in a do-it-yourself box: we made boxes holding paints, brushes, a compass, everything in a set. I've always wanted to do a show of just the Spot Paintings. I think that would make me feel that I'd put the whole thing to bed.

AT: Would it be important to include every Spot Painting you've done?

DH: No, but maybe 300 of them or so. I think I need to get the feeling of what the Spots are about, which is a breaking down of scale. I want the viewer to get lost in

this intense focus. It can be like either a microcosm or a macrocosm: are you standing a long way away, or are you close up? I want to create a really strong sense of vertigo in a show of the Spots, which, in my mind, I can't have until I present the series that way. I think otherwise it won't be finished.

AT: So an exhibition could be the funeral.

DH: Yes, that could be the funeral. Art's not life, you know: with an endless series, you don't have to actually *do* an endless series for it to *be* an endless series. Plus it would be nice for me to be able to move the people who make them onto working on new works.

AT: In the beginning, did you make them all yourself?

DH: I think I did about five on canvas. But I hated doing them, it was tedious, so I got people to do them for me.

AT: But you painted the ones you did at school, and those from shortly after you graduated, in '89?

DH: Yes. I used household paint, because I didn't want to use artist's painting materials; I wanted the paintings on canvas to be like the ones on the wall, like a machine had come along and done them. I always liked the idea of the robot-artist, a machine instead of an artist. The backgrounds cracked on those five I did, because they were done with household paint, ordinary eggshell, which isn't flexible. Then as we went along, I changed the paint. I started getting into the essence of the process.

AT: So then you used acrylic for the backgrounds?

DH: Yes. Once they were part of an endless series, I accepted that they were paintings. Actually I realized that they were *good* paintings, although they'd started off as a denial of painting, or a way to avoid painting.

AT: You've said many times that you always wanted to be a painter.

DH: Yes, but I think the Spot Paintings are like sculptures. They're almost like a sculptural version of what a painting should be like.

AT: How would a viewer know that? That seems like a conceptual idea that isn't really part of the work.

DH: I think the same is true of a lot of painting: you look at the edge, you look at the surface. With a Turner or a Goya, you don't look at the edge to see how it's stretched; you look at the image first, not the object. But you look at the edges of a de Kooning or a Brice Marden. My paintings have always been about the painting as object, not really about the seductive quality of paint. Or maybe just a little bit.

AT: A Gerhard Richter color chart—is that sculpture? Don't you think of that as painting?

DH: I think Richter's into the painting as object as well, the denial of illusion. There's definitely a feeling in a Richter that the painting's being made by machines, there's something robotic about it. The painter has stopped being this hairy guy with paint all over him. He became a guy in a suit, or a lab coat probably. I think that happened every-where: when the Beatles were recording at Apple, there were guys in white coats saying, Excuse me Mr. Lennon, I think you might need a bit of treble there. They were like scientists who happened to be into music. There was that machine ideal. That's where painting's gone, but I don't think it will stay there. At the end of the day, painting is always about illusion.

GERHARD RICHTER.
256 Colors. 1974.
Synthetic polymer paint on canvas, 7' 3" x 14' 5" (221 x 439.4 cm).
Private collection

AT: Were you aware of Richter's and Ellsworth Kelly's paintings when you started the Spot Paintings?

DH: Yes, and also of Bridget Riley, Larry Poons even—this complete area. At Goldsmiths we'd also seen the Neo-Geo stuff—Jeff Koons, Ashley Bickerton, and friends. I think the Spot Paintings, which I began in '87, '88, were probably done in reaction to that.

AT: Was art history in your mind when you started them?

DH: When I came into the art world, the angle we came from was that the influence of other people wasn't a problem. It was a problem when I was younger, but at a certain point everyone at Goldsmiths believed that rather than avoiding taking directly, we could take from everybody. Even in my fly-killer piece [*A Thousand Years*, 1990], the lights were like Dan Flavin and the box was like Sol LeWitt. I put all that in knowingly. It was just getting all these influences and piling them together into our own thing.

When I made the first Spot Paintings, I was really surprised at how seduc-tive they were, how nice they looked. I got the idea of this struggling painter trying to express really depressed emotions, but using a kind of scientific formula that would never let him express himself. All the Spot Paintings created a really dumb, optimistic mood.

AT: No matter what the color combinations?

DH: No matter what the color combinations. My mother had said to me, Well, why can't you do happy paintings? Suddenly I had happy paintings.

AT: She got what she wanted!

DH: No, I think she was thinking more of paintings of flowers.

AT: When you were a boy, I've read, the doors on your house were spotted.

DH: Yes, my dad painted them. He drew pencil lines around a bowl, then he painted

them all blue. My mum got him to do it really. When I was telling people where I lived, I'd say, It's the house with the blue dots.

AT: Did you have those dots in mind when you started these paintings?

DH: No, I try to do everything instinctively.

AT: When you decided to have other people make Spot Paintings, whom did you pick? Were they painters necessarily?

DH: No, my girlfriend Maia Norman did some. But I usually employ artists, or anyway pretty creative people, like the painter Rachel Howard. They were much better than me. They painted them flat, on a tabletop, because then the paint wouldn't drip.

AT: Are the color combinations up to the painter?

DH: Yes. I might go in and change something, but very rarely.

AT: How many people have made them over the years?

DH: I don't know. Probably twenty people.

AT: Is there any way that you or the other makers of the paintings know which ones they've made?

DH: No, because they move from painting to painting.

AT: Oh. Each person does a certain color on several different paintings?

DH: Yes, you may be working on seven at the same time. You'll go from painting to painting putting in one color, and then you start again. So you get five people working on five paintings.

AT: Would that go on for days, or weeks?

DH: There's one painting I've been working on for three years solid, with a team of five people. It's forty feet by ten feet with one-inch spots, and it's got 18,000 different colors on it. The paintings that I sell are the medium-size ones, but I do much bigger ones and much smaller ones, like one-inch dots. I've done half ones as well. The smallest we've done is half a dot.

AT: What color was it?

DH: Yellow.

AT: If you look at a Spot Painting, do you know when it was painted?

DH: Roughly. I remember what studio it was painted in.

AT: Where were these, over the years?

DH: I had studios in Brixton, Leyton, Tower Bridge, and Gloucestershire.

AT: How did you decide on the works' format?

DH: I just chose some sizes I liked. The first were ten by fifteen. I like odd sizes, odd

shapes—nine feet by ten, ten by eleven. Ten by eleven, eleven by ten, they were my favorites. Twelve by thirteen.... I love thirteen because it's an unlucky number. I hate squares—though I've done them a few times, just as gifts—because they don't lead anywhere. The odd sizes imply a bigger dimension.

AT: We often compliment a painting by saying it has to be the size it is. You do the opposite: the painting doesn't look like it necessarily must be that size.

DH: Yes, it's like a section of something done by a machine, as if you could put any-size blank canvas in and it would go "bzzz bzzz." But I did decide that the only cut-off points were going to be at the edge of a spot, a half spot, or a gap—not just randomly throughout the spots.

AT: Have you done any other shapes besides rectangles?

DH: I've deviated a few times, but we'd always come back to the same formula. I did a parallelogram once, and I've done circles. The round ones were a separate thing from the pharmaceutical paintings, although I think they look good in their own right. They're not in this grid format. They're taken from a different shape, from the holes on a stereo speaker.

AT: Is there a relationship between the size of the spots and the size of the canvas? Some paintings seem dense, others much less so.

DH: I've done one-inch, two-inch, three-inch, and four-inch spots. I usually do a one-inch, a two-inch, a three-inch, and a four-inch on every size of canvas. In any one size I'll probably reverse the dimensions as well: one landscape format, one portrait.

AT: Are there any colors you exclude?

DH: No. There are colors I don't like, but I haven't rejected any. My mum's got one on the wall with a color in it that I'd love to change. Every time I see it, I want to change it. But because I'm working randomly, I never do.

AT: So that's a principle—what happened, happened. Has your palette changed over the years?

DH: I have a set of colors that I've been adding white to slowly, so that the spots get fainter and fainter. I thought of that as one way to end the series—working until they fade away. But I keep going back to it.

AT: I'm curious about the origin of the title *Albumin, Human, Glycated* [1992; p. 164].

DH: I've got a book that I named the Spot Paintings from, published by the Sigma Chemical Company, listing all the drugs doctors can buy. Everything's arranged in terms of color and look. There's no mathematical formula to it. *Biochemicals, Organic Compounds for Research and Diagnostic Reagents*—I found the book somewhere. I loved the layout of it. I was trying to find the titles of Spot Paintings and I had an endless series of drugs.

AT: You liked the pharmaceutical connection?

DH: I quite like the illusion of something with very little intellectual underpinning looking supremely confident. We started with "A"—I was going to go through the whole book, that was the idea. I tried to do anything to not have to make a decision myself. With the book, I was faced with the decision of what to use, so I decided to use everything. But then I'd have to make another decision: Where am I going to start? I'm going to start at the beginning. So I was always having to do things like that in trying not to make a decision. For example, I wanted to work out the size of the spots, and I thought, Well, how am I going to do that? I'm going to do it just like the first spot. Then I thought, How big are the gaps going to be? Same size as the spots. Absolutely anything to not make a decision. With the book, we started with "A" but we didn't go all the way through it. We eventually just picked them out.

DAMIEN HIRST.
No Feelings. 1989.
Glass, steel, MDF
(medium-density
fiberboard), aluminum,
and drug packaging,
53¹⁵/₁₆ x 40³/₁₆ x 9¹/₁₆"
(137 x 102 x 23 cm).
Private collection

AT: You've talked before about an analogy between the spots and pills. Does the title have to do with that?

DH: Not really. It's just that the spots look small and round, and they're color-coded. There are loads of analogies that I like—art that's easy to swallow, for example.

AT: Eye candy.

DH: Visual candy, yes. That's what I called another series of paintings.

AT: You don't feel that people misunderstand them by thinking of them as visual candy? You don't want them to have some sense of being *about* something? Or are you happy with them just seeming decorative?

DH: I think they're actually quite uncomfortable things: they give you a feeling of empty happiness, one with no basis, no root. So they make you uncomfortable. The fact that you can't focus on a particular point in the painting makes you uncomfortable as well: I think you look at them and go, Wow, that's great, but then your eye can't rest anywhere. After a while of looking at them, you can actually start to feel a bit ill. They do look great, but if you actually think about them, they're not comforting. You get comforted when your shoes match your jacket, or when the chairs match the sofa—there's this confident feeling you get from chords of color. There are no chords of color in these paintings, you're left at sea with them.

AT: So it's the opposite of Matisse's famous remark about his paintings being comfortable armchairs.

DH: I suppose they could be comfortable if you got to know them. But if I get too com-

fortable, or bored, with mine, I turn it upside-down. It only gets decided which way is up when the label goes on. And I often get the gallery to decide which way up they go.

AT: You've said that your work in general is about the fragility of existence. I wonder how much that applies to these paintings.

DH: I think you can talk about them forever, but at the end of the day, they are what they are. You can get lost talking about art, and I don't think you really should. You may get a little glimpse of something but in the end you're left with nothing. The best thing is the painting, not what you say about it. Sure, there's a lot of circular movement in the world; it's the way the planets move, the way atoms move, the way the parts of an atom move around the nucleus. That in itself is a reason for the paintings to work: connected, circular motion. But where do you stop? You don't.

I always liked the idea that to work out if a painting is any good or not, you just leave it in the street. If it's still there in the morning it's no good. Otherwise somebody walking by would have said, That'll look great in my flat. I'd rather think like that about things than think, What does it mean? You don't really need to know what it means; you just need to know whether it would be there in the morning if you left it in the street.

AT: The Spin Painting in the show has a totally different kind of title from *Albumin, Human, Glycated:* it's called *Beautiful Cyclonic Bleeding Slashing Hurricane Dippy Cowards Painting* [1992; p. 165].

DH: The only thing I specified on the Spin Paintings was that the title has to begin with "Beautiful" and end with "Painting."

AT: There are fewer Spin than Spot Paintings, right?

DH: We don't make as many, but that's an endless series too, in a way. The idea for them came to me because I had a little spin-painting machine at [high] school, and I used to love doing them. So I just thought about making the machine big enough to produce huge paintings, giving you the kind of wonder you had when you were small and the spin paintings were small. At our age we need them to be big to have the same effect.

The idea also came from Max Beckmann's remark that he'd always primed his canvases black, instead of white, so that he could contemplate them as the void. All the areas he painted worked like an object that he put between himself and the void. There was that idea going on with the Spin Paintings. The void of a painting used to be so vast, I'd never know what to paint in it. With all the possibilities, what the hell am I going to paint? I realized that the idea of waiting for inspiration was always the background to my painting. Then with the Spins, I thought that if you got something moving between you and it—whatever *it* is—then you don't have to wait for inspiration, it just happens anyway. It was as if somebody was trying to do a normal paint-

ing and the paint was flying off in every direction. I was always looking for some kind of process to make painting easier, and the simplest thing was that circular motion we were talking about in the Spots, that motion that goes on everywhere. I thought, You'll never need inspiration again.

In the butterfly paintings, I always had an idea of a guy trying to paint in monochrome, and having insects land in the paint and ruin it. Although I kind of don't like the Spin Paintings when they're finished. They capture a movement, but it's almost like the movement, when it's actually happening, is more…

AT: Wonderful.

DH: Arrested movement is always a bit sad. It's like death. In a Spin Painting you get a lot of arrested movement, and when you first see it you go Wow! But then you realize that it's not going anywhere. It almost becomes like looking at a corpse.

AT: That doesn't bother you?

DH: Not really. You just turn it the other way up. You can do that a few times. I've done ones that turn as well.

AT: The Spin Paintings relate to the Spot Paintings in the sense that they're one giant spot.

DH: I suppose, one giant colored spot. But a circle's a circle. A simple shape like that can't really go wrong.

AT: Well, it's the perfect thing. But unlike the Spot Paintings, the Spin Paintings almost wreck the perfect thing.

DH: Yes, in a way they're the antithesis of it. But it's about expression as well, you know. At the same time, whatever you do, you express yourself. So try to do something else.

AT: It's redundant.

DH: But then, you know, you get in funny situations. I remember wanting to be an abstract painter. An abstract *expressionist* painter. But you can't go that route either…. Paint itself is fantastic stuff, but it's very self-indulgent to be making paintings that are just about paint. You just have to find a way to do it. You have to find a way to do all those things you want to do—make gestural marks, throw things around—in such a way that somehow in the end result it's denied, which means it's able to comment on today. Because if it's *not* denied, you're talking about the '50s.

AT: Yet the urge to be an abstract painter, to make gestural marks, has not gone away. So you never think of just stopping painting and only making sculpture?

DH: No, paint is delicious. You want to cover people in it. You want to eat it. I can't see any point to stopping when you've got a toy like that. I think I'll still make them. You'd

never get bored of it, really. If people come to the studio, I let them make their own.

AT: But you said you kind of don't like the Spin Paintings.

DH: I don't like them as much as the Spot Paintings. Actually I think they're irresistible, but in a very simplistic way. I like things that are a bit more complicated than that. Also, I think they're a little psychedelic, a '70s kind of thing…and I don't really like that kind of painting. They look kind of like Yes albums.

AT: But they're fun to make. And that's the opposite of the Spot Paintings, which *aren't* fun to make.

DH: Yes. I'd say that the Spot Paintings can compete with a Richter color chart painting, but the Spin Paintings can't. They're great on a different level, though: I think there's a need for them. The world's an ugly place; you need to brighten it up whenever you can.

AT: Your sculpture seems to evolve through the years—there are phases. Whereas the paintings are like steady background noise.

DH: I don't know. As I said, you borrow from other artists—a bit of Richter, a bit of Bridget Riley, a bit of Sol LeWitt, Dan Graham, Jeff Koons. You put them all into the pot. There's a history of artists working in series: On Kawara and many others. That's in the mix as well. You have to do that to get security in life, or to become confident. Yes, there are Ming vases or the Mona Lisa as opposed to Coca-Cola cans. I've just always had to have both. I've always got to have the comfort of mass production. I think things have to be pretty special, or pretty personal, to only make one of.

AT: I've read that you consider your sculptures conceptual, and if someone had to get a new animal or a new case it wouldn't bother you.

DH: Yes, I don't mind that personally. But people won't do it.

AT: We still believe in the aura of the original.

DH: Yes, unfortunately we live in a world where the object the artist created is more important than the artist's original idea. I think the idea is more important. I get comfort from the story of my grandfather's axe: it says, If my grandfather had an axe and he gave it to my father, and my father replaced the handle, and he gave it to me, and I replaced the head, is it still my grandfather's axe? Things do change like that, and eventually you end up with a completely new axe, but for me it's still my grandfather's axe. I think artworks should work like that, but they don't. You lose sight of the original intentions, and you get the worship of the object—a relic, or an icon. There's a constant battle between conserving the idea and conserving the object.

AT: Yes, though I'd say, Even if Hirst denies it, something about his choice—even if it was a choice at a certain remove, like how thick that glass

pane should be, or what exact shark it was—is important to me. I admit
to the fetishistic aspect of that, but....

DH: Yes, I'd say I'm totally responsible for the final look of whatever I make. I get there by making as few decisions as possible, but at the end of the day, I'm totally responsible for everything I make.

Howard Hodgkin

In Bed in Venice (detail).
1984–88
Oil on wood in artist's
frame, 38 ⅝ x 48 ⅞"
(98.1 x 124.1 cm). The
UBS Art Collection

ANN TEMKIN: A long stream of your paintings—more than a dozen—
have "Venice" in the title. The series seems to have sprung from a visit to the
Venice Biennale in 1984, when you represented Great Britain.

HOWARD HODGKIN: Absolutely right. I went with my friend Antony Peattie; we were there for at least two months.

AT: Including the opening of the Biennale?

HH: Yes.

AT: You had been there before, though?

HH: Often.

AT: When you were in Venice, did you know that this set of paintings would
come out of your visit?

HH: No, I didn't. And that's very much _not_ the way I work. Unlike many artists now, I've got no kind of historical overview. So almost anything can happen.

AT: Were you sketching while you were there, or making notes?

HH: No, I wasn't. I do make drawings, but not of the kind that anticipate paintings. A very bad early picture I painted of some musicians in the Piazza San Marco is the most literal thing I ever did, and almost the only one based on a drawing. What I do is sit and think.

AT: When you were in Venice for the Biennale, it must have been an extremely
busy time, not a leisurely period of wandering the city's empty streets.

HH: Far from it—in fact I was going through all sorts of emotional turmoil. It was extremely busy, and there were far too many people I knew there [_laughter_]. I think the subject matter of _In Bed in Venice_ [1984–88; p. 167] is probably one of the rare occasions of calm, of separation from all of that. In general, being an artist is very isolating. I've never had any real artist colleagues as a painter. My artist colleagues are writers.

AT: Why do you think that is?

HH: I don't know. These patterns were made in spite of themselves.

AT: The Biennale show was a great success.

HH: An incredible success.

AT: Did you know it would be before it happened?

HH: I'm always reluctant to do a show like that. I remember my dealer Larry Rubin saying to me before the Biennale, It's far away, it's in a foreign country. That shows you how long ago this was—Larry is very sophisticated, but he said, If it's a failure, no one will know about it, it doesn't matter. Today that seems amazing.

AT: How long after you came home did you begin the paintings? The starting date on most of them is '84. Does that signify actually picking up a canvas, or does it mean the beginning of the image?

HH: It means the beginning of the image.

AT: In your head?

HH: Yes.

AT: So it doesn't necessarily mean that paint was put down.

HH: Well, it probably was put down, but just a bit.

AT: You began them as early as that summer?

HH: Yes, I began this one that very summer. But it says "to '88," and that, I think, is absolutely correct.

AT: Remarkably [*laughter*].

HH: Well, I'd say "remarkably" because it's usually the starting date that might be wrong on some of my later pictures. Because I took so long (I still do, very often), I'd lie about their age.

AT: To shorten it?

HH: Yes.

AT: How do you remember how long a painting has taken?

HH: Well, I often write down when I started it. I once thought I'd stop double-dating, I'd just date the picture from when the image was finished. But that's enormously misleading, so I stuck to it.

AT: It's extremely unusual.

HH: Well, I'm very relieved when I see other artists do it from time to time. And I

thought of not doing it. But having started I didn't quite see how I could stop, because it would falsely separate the work.

AT: Am I correct that it was during the 1970s that you began to attribute several years to a given painting?

HH: Yes. And when I started the double-dating, I didn't realize, I think, what an important decision it was.

AT: Even knowing more about that practice wouldn't answer the most intriguing, and rude, question, which is, What takes so long?

HH: That's not a rude question at all, that's very reasonable. What takes so long is making up my mind. When I begin a picture—I think this is true of other painters—I begin it, and the next steps are reactions to what is already there, as well as reactions to the subject. So I'm going backwards all the time. And that does take a long time.

AT: As we sit here in the expansive space of your studio, there are about eight paintings on the walls. Most are hidden behind fabric panels, presumably so they won't distract you from what you're focusing on. But it suggests to me that you work on a good many paintings during any given period.

HH: Indeed I do. And that's very difficult, because the way I work, I can't go on and off from the same picture. To make the painting physically as straightforward as possible, I do it once and then go through endless alterations. I try to do that in my head, which means I'm more in control of what happens.

AT: Are you looking at the painting as you're thinking? Or not necessarily.

HH: Well, I often come in here in the morning and I sit. I'm just thinking about the work, because it has two lives: there's a physical life on the wall and another life in my head. I often have pictures for a long time, even when I've finished them, because I have to talk myself into it.

AT: You know they're finished yet you're not convinced they're what you want?

HH: I'm convinced, but I want to see what I've done. Once the picture's finished, with few exceptions it's inalterable. If I do alter it, it's a complete change—I can't bear to look at the picture anymore as it is, so I rethink the idea.

AT: How much does what's going on with the other pictures around the painting you're working on affect it?

HH: Well, I can't see them when I'm working. They're always covered up. Normally there's never anything uncovered except what I'm working on.

AT: But the others are there in your head, of course.

HH: Yes, they're in my head. It seems I can think of two or three pictures at once if I

want to. It's all an elaborate way of managing to keep the emotional commitment there in each case.

AT: Yes, which is the challenge you're setting yourself. So if you're not in the mood to work on a certain painting, that's almost more the issue than a technical point that you happen to be at.

HH: Yes, it is. I always try to be in the mood to paint it.

AT: Yet you're in here every day. Can you train yourself to be in the mood?

HH: Yes, I think it's essential.

AT: On a given day, will you go from painting to painting?

HH: Perhaps two pictures, but not more.

AT: And when you begin a picture like *In Bed in Venice,* do you begin a few simultaneously, like letting the horses out of the gate?

HH: No. I remember that picture very well. I remember I've got a handsome antique frame on it, and I remember thinking of the frame and the picture that I was going to paint in it totally as a one-off. I think they're always one-offs. And I always begin one at a time.

AT: When you picked out the frame, did you know it would be the setting for this picture? Even though you had no idea what the painting was going to look like?

HH: Yes, I did.

AT: In general, when you select a frame, am I correct that the panel for a painting is made to fit it?

HH: Yes, or the frame is modified. It can be either way.

AT: Did you buy the frames for your Venice paintings in Venice?

HH: I have bought frames in Venice; I used to know a very helpful framer there. I love the sentimental idea of buying a frame in Venice to paint the picture in. Mostly, though, I didn't. I'm trying to remember where I bought this one, but it wasn't in Venice, it's too big; I used to buy frames I could carry. I can't remember where I bought this—probably from an antique frame shop I know.

AT: Do you always buy used frames? And if so, is the prior life of the frame an important element for you?

HH: Not particularly. I know this sounds affected but it's just a fact: I can't tell shapes from numbers very easily, it doesn't come naturally, so it's very difficult for me to order a frame. But when I look at a frame, I know whether it's the right proportion for a painting. I've also taken to turning frames over, because I love the back. I do like signs of former lives.

AT: So the selection of the frame often happens with a specific painting in mind?

HH: Oh yes, absolutely. Not always but often.

AT: And do you have an inventory of frames you've bought?

HH: No, not really.

AT: Are you yourself the shopper for the frames? Your assistant, Andy Barker, doesn't do it?

HH: I do it.

AT: It's very romantic in a way, this idea of going into a shop and knowing that a frame is a match for something you're thinking about. You have an intuition that it's what you need for this particular occasion.

HH: Yes, exactly.

AT: And then you have the wood cut to that size, and Andy puts it in the frame. So from the moment you start work, you're looking at the entire object, not a panel without a frame.

ANTONIO ALLEGRI
CORREGGIO.
Jupiter and Io. c. 1530.
Oil on canvas, 64 ⅜ x
29⅛" (163.5 x 74 cm).
Kunsthistorisches
Museum, Vienna

HH: I do sometimes paint panels without a frame.

AT: And in *In Bed in Venice* you do a double framing: you have the frame and you also paint a curtain. So you're looking through that as well as through the physical frame of the painting.

HH: Yes, correct.

AT: Do you remember the impulse for the work?

HH: Yes, very well. It's two people in bed in Venice, and I'm one of them. I think that's as far as I'm willing to go.

AT: Okay, that's far.

HH: It is quite far.

AT: What I really love about the painting is that there's a certain air of abandon.

HH: That's absolutely right.

AT: And that's a treat when it comes up in your work, because it doesn't happen often.

HH: No, but more now.

AT: Thinking about this painting, one thinks of the figure of Jupiter in Correggio's *Jupiter and Io* [c. 1530]. It has that luscious puffiness.

HH: I'm delighted you think of that.

AT: Also its eroticism is so undefined.

HH: Yes, nonspecific. I've always thought it was erotic *because* it's undefined. It's describing something that's entirely a feeling. And how do you do that?

71

AT: The minute you do, it's compromised.

HH: Very much so. Even in literature. I mean dirty books don't really work—

AT: When you look at those old movies where the couple walks into the bedroom and the light goes out, that's far more marvelous.…

HH: [*laughter*] Because there's room for the spectator.

AT: The spectator becomes a partner in a sense. But that brings me back to the idea of making these paintings after you'd been in Venice. It was a daunting thing to do, in the sense that Venice as a locale is so charged in the history of both art and literature.

HH: It's completely charged, and in a way that completely ruins it for you when you go there. And yet, of course, it all comes rushing back. Still does. I went off to Venice again just last year, and it was very good that I did, because I immediately started more pictures of it.

AT: Do you have art history more in mind when painting Venice?

HH: No, I never think of Venice in that way. I can't. It's hard enough to think about what you're doing.

AT: Do you feel that your paintings of Venice have more to do with your feelings as you were painting them during the years after your visits, or were you always trying to capture the feeling of the memory?

HH: Always that.

AT: Nothing to do with today.

HH: No, in that sense I could be an escapist, because I'm rushing back to that moment. The only skill I really have is visual memory.

AT: Visual memory but also emotional memory—

HH: Of course, emotional memory.

AT: Travel does lend itself to that. In the studio, would a year go by without your making a mark on a specific painting?

HH: Easily. But it's so variable. Sometimes there I am in the studio and I try very hard *not* to think of the things you're asking about, so that I'm not really watching myself. Once I was being interviewed and somebody said, Is this the first time you did this? And I said to the person asking, who was someone I admired and respected, You would know that better than I.

AT: [*laughter*] So true.

HH: Yes, but it's good that you asked because it makes me think of these things that otherwise I wouldn't. The curious thing is that I can sit and look or not look at a picture, but I'm thinking about it all the time. There's no way of knowing when I'm going to make that mark. I just have to be there and ready.

AT: Time is in many ways your art's subject, one of its components. You can't say how those years appear on the canvas, but without them you couldn't have that painting.

HH: That's absolutely right. There's no way, I think, that one can isolate the effect of time from the depiction of time.

AT: Right, and we're back to the question of when it started taking you so long to paint. Because that meant a change in the physicality of the painting.

HH: Yes, it's a change in practice, which I'm finding it rather hard to isolate. The change came when I decided to keep as much of the, for want of a better word, pentimenti in my mind rather than in the painting. I grew very suspicious of the changes of mind and so on becoming a rite of their own.

AT: It's a whole other way of working. And your paintings aren't particularly thickly built up.

HH: Not physically, no. If they were, I think they would lose a lot of clarity. It may sound silly to talk about clarity in terms of my painting, but it's essential.

AT: You say they'd lose clarity but maybe they'd also lose their paradox— the paradox of the seeming straightforwardness and at the same time that slowness, that invisible evolution. Then also the paradox of private and public. There's so much in your work about the collapsing of the public into the private, and vice versa, without ever being the one or the other.

HH: Yes, I think that's fair.

AT: As I think about that, it seems like the most difficult thing.

HH: Well, it often seems like that, doesn't it. But what amazes *me* about my pictures is how long they take to unfold to people.

AT: Yes, it's not about a glance.

HH: No, they don't function that way.

AT: I see these big thick brushes on your table. Do they have to do with your working on a larger scale these days?

HH: No, I've always used those brushes. I'm extremely wasteful and I have someone part-time who washes them for me, which is essential.

AT: When you're working on a specific painting, do you use a couple of handfuls of different brushes?

HH: Easily, I just throw them down. I'm immensely extravagant with paint as well.

AT: Over the years, have the paints you use changed? Or has that been constant?

HH: Absolutely constant. It has to be. And since the very beginning, I've always used the best, most expensive paint there is—it's now made by Michael Harding.

AT: Because of the sense of it lasting? Or just the lusciousness of working with it.

HH: The lusciousness of working with it. And I've always felt the least I owed the next owner of the picture was that it stand up by itself in every sense. I've always been concerned with this.

AT: You haven't financed a whole generation of conservators, as some of your peers have. What about your titles—they're unabashedly straightforward. It would have been characteristic of someone of your generation to just say, This is painting no. 22.

HH: Yes, I was attacked for not doing that, but that's not at all how I see painting. Any sort of painting, let alone my own. Whenever I'm asked about the titles, I always say, That's what the subject is. When my large show in the '90s [*Howard Hodgkin: Paintings 1975 to 1995,* organized by the Modern Art Museum of Fort Worth, 1995] was at the Hayward Gallery, I had the titles put on the floor, so people could look at the pictures without them. That pleased me greatly: having the titles on the floor, people would have to go very near and look. But then they'd say, Yes, of course, exactly.

AT: When there's a label, people focus on that.

HH: Yes, more and more. Verbal explanations often make people feel more secure.

AT: Yet you're extending a hand to them, in a way, by offering them a title.

HH: Well, one wants to.

AT: The critic Andrew Graham Dixon talks about your Venice pictures as melancholy. I didn't find that to be true; there's nothing like that joining them together for me.

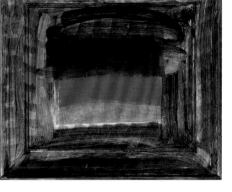

HH: No, there isn't. And there's nothing that joins Venice together. Once a writer asked me, What do you think is the most important thing for you about Venice? What a question. And I didn't think, I just said, The space. I realized I'd said exactly what I meant. It's one of the most extraordinary spaces on earth.

AT: Well, because it's an impossible space, right?

HH: Yes. And so unbelievably varied.

AT: One can get so lost there so fast—so there's a sense of the infinite even though it's so small.

HH: It's like a maze. And you're *not* stuck in history.

AT: When you look back at *In Bed in Venice,* do you think more about the subject it depicts or more about the making of the painting?

HH: I can't really separate them out.

AT: Yet I couldn't tell you much about your life from the painting. I wouldn't

HOWARD HODGKIN.
Venice in the Autumn.
1986–89.
Oil on wood, 19⅛ x 21"
(48.5 x 55.5 cm).
Private collection

call your art an autobiographical art.

HH: No, it isn't in the way some people's is. It is to the extent that it's all about situations I find myself in.

> AT: You wrote a series of letters to John Elderfield, which were published [in Michael Auping et al., *Howard Hodgkin: Paintings*, 1995]. They have a wonderful P.S.: after a great deal of very erudite talk, you say at the end, "Alone in my studio, working on my pictures, more than anything, I long to share my feelings."

HH: Yes, that's absolutely true.

Richard Long

ANN TEMKIN: Work on paper, like this drawing in River Avon mud [p. 191], is an important part of your practice, yet it's relatively little discussed.

RICHARD LONG: Well, the most important part, obviously, is the walking and the works in the landscape. But yes, it's a part of the whole, and I think my work is holistic.

AT: You've been eloquent on the coexistence of your work in the landscape and your work in the galleries, saying that you couldn't have one without the other.

RL: A lot of my work in the landscape is drawing with water or leaving footprints. Sometimes the works on paper are just another way of making marks, but more permanent, more domestic. They're just another way of putting my work in the world. I can make a temporary work in the landscape that might be blown away in the wind, so I record it with a photograph, which might then be used in a book or exhibition. I'm fascinated by the different ways of putting the work out.

AT: You work on a sliding scale from impermanence to permanence.

RL: I use the whole range. I think it helps if you understand the whole picture of my work. Anyone seeing a piece of mine who doesn't know anything about me should be able to get something from it, but if you know my work in total, I think the different ways I work complement each other.

AT: You've remarked how little it bothers you, though, if people pass an outdoor piece of yours without noting that it's a work of art.

RL: Yes. What is a clear image? That's fascinating to me. I might have made work, and a local person walking by won't see it as art, or may not see it at all. The work is often more recognizable in a photograph than in the actual place. There are so many possibilities of making work. For example, all the ways I've used water: I've used rivers as footpaths. I've used mouths and sources of rivers as starting or end points of walks. Some years ago I did a walk in a beautiful canyon in the Sierra Madre mountains in Mexico. Because the canyons were cut by rivers, following the river at the bottom of

the canyon was the only way to be in the landscape. The river provided the course of the walk, so it was appropriate that it also provided the material to make drawings: it was rocky country, so the best way to make work was to draw with water down the rock faces. And that's an example of the best way to record those works being photographs, because the drawings dried in the sun almost instantaneously,

AT: Their lives could be measured in seconds?

RL: Well, minutes. And I guess that's where mud comes in: I could do the same thing in a gallery, but if I just used water I wouldn't make an image, so I started mixing mud into the water. In 1984 I did a show at the Anthony d'Offay Gallery in London where I mixed up I think fifteen buckets of muddy water, and I threw each bucket at the gallery wall. So there were fifteen images of a big mud splash coming down the wall. Mud gave the splash permanence and an image.

I think my first mud work was in Gian Enzo Sperone's gallery in Turin in 1971. That one was a floor work—I made patterns with my hands on the floor with watery mud. I always saw my mud works in galleries as two-dimensional sculptures. It was only about ten years later that I realized I could do the same thing on the wall.

AT: Conversely, you've talked about using mud as almost three-dimensional drawing.

RL: Yes, that's right. In general my work deals with the different ways one can mark the world, make marks of passing. It's all about different ways of making marks with the raw materials of the place. When all is said and done, water is the world's most important material. It's the lifeblood of the planet.

I suppose the starting point of all this was that I was born and grew up near the Avon, a beautiful tidal river with amazing mud banks of a dark greenish brown. The river runs through a gorge, then opens into the Bristol Channel, a big estuary that leads out to the sea. As well as being fascinated by the river, I was fascinated by the tides, the mud, the limestone cliffs with caves I used to play in. My childhood had an incredible adventure-playground aspect—even though I spent it in the city, there were all these woods and screes and caves that we used to discover.

AT: So as a boy, you were a nature type?

RL: Yes, I was. Actually, one of the first things I remember making was a mud pie, scooping out the middle so it was like a volcano, then pouring water in.

AT: When was this?

RL: When I was about three, on my front path, in the sunshine. I think I got my love of nature from both my parents, it was in my blood. My father, who was a schoolteacher, was a keen cyclist, and I used to go on cycling holidays with him. My grandparents on my mother's side lived in the country, in Devon, which is a beautiful part of England. I was born in Bristol and was basically a city kid, but we always had holidays with my grandparents on the moors, in the deep countryside.

AT: When you were little, did you think about becoming an artist?

RL: I never thought about it, I just did it. People often ask when I decided to become an artist, but I never did decide; art was just my language from the beginning. I was always drawing and painting. My parents encouraged me—they let me draw all over my bedroom walls. When we went on holidays, they encouraged me to make little books, like diaries. Even in my infant school, when I was five or six, I had an agreement with the headmistress that if I got in early I could miss the morning service and instead do an hour of painting. Even when I was really young, making art was part of who I was.

A lot of young boys like making model airplanes. I had no interest in that, but I do remember making a model of the river out of plaster of Paris. I made it in a baking tray of my mother's, with little creeks going into the sides, and an oxbow, all the winding bits. I could fill the model with water to make the tide go in and out.

AT: Did you do it from a map?

RL: No, it was my imagined version of the river. I think I even painted it realistically.

AT: How close was the river to your house?

RL: About half a mile, very close.

AT: The books you did on holiday—you recorded nature walks and things like that?

RICHARD LONG.
A SNOWBALL TRACK.
BRISTOL 1964

RL: I described what I did every day. Actually these child's journals were my first artist's books. I'd do everything—make the book, bind it, draw lines for writing, write the words, the story, make the drawings. I still have a couple of those books.

AT: The illustrations were of nature?

RL: Generally, because I'd be either at the seaside or in the country. There were some people in them too.

AT: Do you remember thinking of yourself as a good draftsman?

RL: Oh yes, I was proud of that. I was fascinated by drawing. I was even fascinated by handwriting. I was fascinated by making a mark on a piece of white paper.

AT: When did you start drawing not on paper but in the landscape?

RL: In 1964 we had a beautiful heavy snowfall in Bristol. I lived close to the Downs, which is like a huge park but a bit more wild. I had the idea of making a drawing there by rolling a snowball.

AT: How big was the snowball, and how far did you roll it?

RL: It was quite big, and going by what you can see in the photograph, probably about twenty yards or so. I sometimes call the piece *Snowball Track* and sometimes *Snowball Drawing*. I knew it was a work of art, but I don't think I gave any of my work titles in those days.

AT: When did you start making drawings with your body? Because that, in a way, is what happened.

RL: When I was at art school in London, at St. Martin's. I made *A Line Made by Walking* in 1967. I had the idea, and I took the train out southwest of the city. I waited until the train had gotten outside London and was going through the countryside; then I got out at the next station, found a field, and walked my straight line up and down. I had a ridiculously primitive little box camera to take the one photograph I took of it. In the early landscape works, I didn't realize that one should take lots of photographs of the same thing, in case one negative gets destroyed. In fact, it never really occurred to me that my photographs of the works would themselves have the status of works of art.

AT: You made the photograph just as a record.

RL: As a record for myself, but also to show other people. I was very conscious that what I was doing was to be shared—I mean, the fundamental thing about art is that it's something one does to communicate something.

AT: Did you think about being sure the line would be visible enough for the photograph while you were making it?

RL: I wanted to make the line as something in its own right; I knew it wouldn't be worthless. But it wouldn't be significant if I couldn't show somebody what I'd done.

AT: How did you make the line visible? It was simply the imprint of your body and feet, and no other medium?

RL: I just walked in a straight line, up and down, until I could see the line. Straight lines are easy to do: one aligns two things at a distance in one's field of vision and just keeps the two things in line as one walks. I was interested in alignment at the time. In another work from that period [*ENGLAND*, 1967] I aligned a vertical black frame with a white circle on a distant hillside. Or, rather, the frame and the circle only became aligned because of the position of the person looking at it.

AT: Your work is quiet about what it requires of the viewer, but it's often about the viewer.

RL: The viewer's position, yes. Sometimes I take the place of the viewer; in any case I play the role of the viewer, in that I take the photograph. In many later works I've aligned, say, a line of stones with a distant mountain. So the work isn't just the sculpture itself; it's pointing at something seen on the horizon.

AT: I'm interested in your thinking about drawing, because in a sense you've taken drawing back to the most elementary principles.

RL: Yes, back to cave painting: I make drawings with my hands using mud on walls. I very much like that primitive aspect of my work. I like to think that even though my work is part of late-twentieth-century-sophisticated-avant-garde modernism, it connects with the making of cave paintings.

AT: It transcends cultures.

RL: Exactly. Working like all the artists in different cultures of the world who use their hands and the mud of their environment to make their work. Like Aborigines, or Eskimos carving stones or whalebone.

AT: Today we recognize that work as extremely sophisticated, in a way that we wouldn't have, say, 100 years ago. But one could still say that your work is very knowing about this context and that people working in those cultures work in a different way.

RL: I wouldn't deny that at all. They work in the context of a society and a culture, or maybe a religious system. Everything has its context, and obviously mine is the context of a modern artist living in the twenty-first century.

AT: And yet with universality as an ideal.

RL: Well, I'd say universality is nature. That's what's universal—water, or stones, or mud.

AT: These ideas have been criticized as romantic.

RL: That's a very misunderstood word, I think. Anyway, I think of myself as a realist, in a way, because my work is—

AT: Absolutely concrete.

RL: Yes. It's only romantic from the perspective of some intellectual art writer who lives in a big city. And obviously, compared to Andy Warhol, for example, a Pop artist, or Carl Andre, a Minimalist, an artist who makes stone circles up in the Andes is sort of romantic. But when I say I'm a realist, the arena for my work is the landscape of what the world really looks like. Most of the world is still covered by the landscapes I make my work in. It so happens that most of the art world lives in big cities, but most of the world is not city. My work connects with all those great things like getting cold, getting wet, sleeping under the stars, wading through rivers, bouncing stones across rivers, making prints in the snow, kicking leaves. It connects with all that stuff, which I think is basic, fundamental, and childlike.

AT: Have you had to defend your work against the charge that it's something a child could do?

RL: I take that as a compliment. One of the great definitions of an artist is that he does the things most people stop doing when they grow up. The artist is the person who continues his childhood pleasures. I'll drink to that any day.

AT: And when you present your work in a sophisticated context like an art gallery, do you feel that childhood quality is neutralized? Or is it one way you measure a work's success—how well it withstands that setting?

RL: It's not enough just to do the work; one has to have a context, and the art gallery or museum is the frame. It's what we have. I'm not against that, because I like to think that even though I show my work within the frame of an art gallery or a museum, the work's content actually takes one away from that. Looking at my photographs in an art gallery, one can realize that I make my work in many different landscapes around the world. The exhibition may be in an art gallery in the city, but in the work one can travel anywhere.

AT: This makes me wonder about your work in the context of the collector. How was your work first collected?

RL: Well, it was very surprising. My first week at St. Martin's, I made a big earthenware pot and painted a landscape on it. Then I made a three-dimensional plaster model of a landscape to fill the open top, a pond with some vegetation. And after I painted the pot, I took it into the landscape and took photographs. I was playing around with inside, outside, naturalism, reality—it was obviously my attempt to be sophisticated. Anyway, the girl on the next desk immediately said, That's great, can I buy it? So I sold it to her for £5. That was my first sale. It was great.

AT: Perfect! And what were your subsequent experiences with collectors?

RL: When I finished at St. Martin's, my first show was at Galerie Konrad Fischer in Düsseldorf, in 1968. I went over with these sticks collected from the woods beside the Avon Gorge—a little suitcase of like 300 sticks. Much to my surprise, somebody bought it. So one of the first things I learned (one of the many things I learned from Konrad Fischer) was that if you're doing something interesting, and you connect with the right people to show it, then somebody will buy it. Somebody out there will find it interesting as well, and will want to own it, regardless of what it looks like or how difficult it is.

AT: The mud drawings on paper, which you began in the '80s—the UBS drawing is an example—were these a response to a suggestion from someone?

RICHARD LONG.
Untitled. AUSTELLUNG
BEI KONRAD FISCHER,
DÜSSELDORF 1968

RL: Probably. I've never made drawings for my sculptures, it's neither interesting nor appropriate. At some point, though, I started making drawings by dipping paper—A4 pages—into a big bucket of muddy water, then letting the mud run off. I would work in my shed, and I'd have all these lines of string going across the rafters, like washing lines. I couldn't touch the paper where the drawing would be, but I had to have something to hold onto, so I would dip the paper right up to one inch from the top. And then I would very carefully hang it up with a clothespin, so it would dry hanging on the washing line. The drawing made

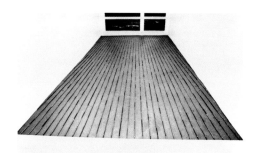

itself without me touching the paper.

AT: Does River Avon mud have any quality particular to it?

RL: Yes, it's the best mud I've ever come across.

AT: In texture? In color?

RL: The estuary of the Avon has the second-highest tide in the world—the rise and fall of the Avon in Bristol is about thirty feet. You have this big negative river half the time, and then the other half the time it's full. So the mud is fantastic. It's academic to say, but mud is the action of enormous lunar forces on stone and water. The moon makes my mud. Millions of years ago, the tides were maybe ten times what they are now—they were these great scouring forces on the planet, thundering up and down. The moon was nearer the earth then; probably as it gets slightly farther away, the tides are decreasing, because they're made by the gravitational pull of the moon.

Years ago, I was usually measuring my walks by days and nights, the solar cycle. But then it occurred to me: why not use the moon as a measurement? So I made some lovely walks where I measured the lengths of the walk by the cycle of the tides, for example. In a roundabout way, the muddy footprints that you see in the drawing we're talking about have all this other stuff linked into them.

AT: What were the specific circumstances of making this drawing?

RL: I made this group of drawings with Lorcan O'Neill, who worked at the Anthony d'Offay Gallery. We made them at a big empty shop we hired, near New Bond Street in London.

I suppose these mud drawings are the closest I get to proper drawing because I have to do them very carefully: I have to have one dry foot to stand on, and I have to have one muddy foot. So I'm not walking: it's all my right foot. Strangely enough, because I'm right-handed, if I were making the drawing with my left foot I would have no balance. So I have the most control with my right foot.

AT: So when you're standing, your left foot is on the page?

RL: It is, yes. I have to work out carefully where my left foot goes so that I don't stand in the wet mud of the drawing.

AT: Like painting yourself into a corner. Is this drawing one continuous walk? It looks as if it were.

RL: It is. Obviously I have to start in the middle and work outward.

AT: As you're doing that, how are you renewing the mud on your foot?

RL: I'm putting it into a washing-up bowl alongside me.

AT: On the page?

RL: Sometimes it's on the page. If it is, I have to be careful that it's clean, that I don't smash into it and make it muddy itself. Otherwise it will leave a mark.

AT: Do you need a second person, then, to move it out of the way?

RL: Not necessarily, my hands are clean, so I can bend down and move it strategically as I go along. I can make these drawings on my own, but I have to concentrate. It takes surprisingly little mud to make one of these drawings; I only need maybe half an inch of muddy water in the bowl. Because the mud is so dense, all the mud works are 85 percent water. There's just enough mud to give the drawing color and imagery.

AT: Does the mud in the bowl stay the same consistency as you work?

RL: It does, yes. Tidal mud is completely different from river silt or muddy earth that you might find in a field. It's actually molecularly different, if you see it under a microscope. The viscosity of tidal mud is absolutely wonderful, because it suspends in water. If you took a clot of earth from a field and mixed it with water, it would be muddy water, but after five minutes the mud would settle down to the bottom; tidal mud actually suspends. Obviously it would separate over a day or so, but it makes a wonderful viscous liquid. Potters call it "slip."

AT: Does it have any odor?

RL: It just smells a bit muddy.

AT: But not distinct from normal mud?

RL: It smells river-y. The drawings smell of rivers, don't they?

AT: Do they all have the same smell?

RL: Different rivers smell different.

AT: If a drawing didn't work out, would you reject it? There's no way to correct them.

RL: No, there isn't. In the mud works I can't make mistakes. If they don't work, I throw them away.

AT: That's easier than when you're working directly on a wall, where you'd have to do the whole thing again. Has that ever happened?

RL: Not really. But every wall is different, so until I actually slap on the first handful of mud, I never know exactly how it's going to splash and drip.

AT: Are you interested in chance, in a theoretical way or as a practical operation?

RL: I don't follow the I Ching, but chance plays a big part in my work. Nature is unpredictable, and the natural world reveals itself in a lot of my works. There's a beautiful work I made in Ireland, [HALF-TIDE, 1971]. I was camping by this stony beach and I made a cross of seaweedy stones. When I woke up in the morning, magically the work had transformed itself: the tide had come in and seaweed was floating up to the surface of the water, but where the cross of stones was under the water, the seaweed did not float up, so it made a negative shape on the surface. That's an example of chance—I couldn't have predicted that.

Then every footprint in this drawing is cosmically different from the last one. They're like fingerprints or snowflakes: I could make a million footprints and they'd all be different. Each image, in its micro detail, is completely different, and that's sort of an action of chance.

AT: And irreproducible.

RL: Yes.

AT: Do the splash marks on the paper signify that you were stepping pretty hard?

RL: Yes, I can control, to some extent, how hard I step.

AT: Do different drawings have different intensities in that way?

RL: They do. And over the years I've learned to control the wateriness of the mud. Quite often it interests me to make really splashy mud works.

Once mud is dry on the wall, it will last as long as the wall lasts. It will not crack or fade. It's as permanent as a fresco. The only condition is that the wall has to be dust-free. If it's dirty or dusty, the mud doesn't stick to it and could flake off.

AT: The same with paper?

RL: Yes, if the paper is clean and dust-free, the mud will stick to it forever.

I mentioned fresco, but I never call the wall works paintings. Somehow I always think of a painting as something you'd make with a brush.

AT: But these, on paper, you call drawings.

RL: I guess they are drawings, yes.

AT: Thinking back, then, to the works where you'd take a walk, write a text describing it, and show that along with a photograph—that's a drawing?

RL: No, that's not a drawing at all. Or rather, it depends on how you define drawing. Some people think of the text works as poems, you know, and to me they're patently not poems, even though I'm using words. It's just art using words instead of mud, a pencil, paint, or stones. I've often said that a text work can be a line of words, and that sculpture can be a line of stones.

Susan Rothenberg

Dogs Killing Rabbit
(detail). 1991–92
Oil on canvas, 7' 3" x 11' 9"
(221 x 358.1 cm). The
Museum of Modern
Art, New York. Partial
and promised gift of UBS

ANN TEMKIN: How did the commissioning of *1, 2, 3, 4, 5, 6* [1988; pp. 218–19] come about? Did you and Donald Marron know each other?

SUSAN ROTHENBERG: Slightly. He was a supporter early on—in fact he was involved in buying a painting, *Axes*, a horse picture from 1976, for MoMA. This was in 1977, my first museum sale. So he knew my work from the very beginning. But we never had a close personal contact. Then many years later he bought *Biker* [1985; p. 217] for the PaineWebber Collection.

AT: Yes, in 1986.

SR: And then, instead of just buying another painting, he asked me if I would be interested in doing something onsite at the PaineWebber office. He said, Why don't you come up and have a little tour.

AT: I've read that you already had in mind the idea of a public art project.

SR: Yes, I'd been wanting to get off a gallery wall into a space where people other than an art audience could react to the work. I dreamed of doing something in the New York Public Library on Forty-second Street—a mural for a reading room, that kind of thing. And it was impossible, the rooms there are as they are. So the idea became doing something in a local library, and I looked at libraries in Staten Island and Queens, and they were filled with children's drawings—as I felt they should be. So I dropped the idea, it lost its appeal.

AT: The idea had more to do with a new audience than with anything centered on your practice, like a desire to paint large-scale?

SR: I wanted to see if I could connect with a different kind of audience. It was a public-service idea. But it died on the vine. Soon after, though, I took the PaineWebber tour, and I decided that I could try for it there. Again I had the public idea: I thought about making art for where people ate together. Also, it was interesting to think about painting the pillars between the incredible views out these huge windows in the dining room.

87

AT: A daunting challenge, actually. You were giving yourself the toughest assignment you could.

SR: Yes, rather than painting a wall in a room. I wanted people to be able to interact with the space.

Anyway, I spent a good many months out in my studio in Sag Harbor, getting the panels built, conceiving the piece, and executing it.

AT: Why did you work on wood panels?

SR: I wasn't going to be able to paint on the pillars directly—I would have been there in my painting clothes during lunch. I'm not a performance artist; I would have been much too nervous to paint in public. The paintings had to be made at my studio. We figured out that the wood could be attached to the pillars.

SUSAN ROTHENBERG.
Studies for 1, 2, 3, 4, 5, 6.
1988.
Graphite, charcoal, and
oil on paper, 60 x 20"
(152.4 x 50.8 cm) each.
The UBS Art Collection

AT: Had you painted on wood before?

SR: Yes, in college, and I'd also painted on Masonite. That wasn't a problem.

AT: When you were working on these panels, was that about all you did? Did they monopolize your time?

SR: Yes.

AT: And you decided on six because that's how many pillars there were? It had nothing to do with anything but the space?

SR: Yes, it was about the architecture of the space.

AT: What about the subject choice? Was that somewhat of a collaboration between you and PaineWebber?

SR: I made a drawing and said, This is what I think I would do. Mr. Marron approved it.

AT: I understand that you gave him the choice of dancers or Buddhas as a theme?

SR: Yes, at the time I was looking at images of folding Buddhas, figures in movement. After years of trying to make things static, I was involved in making them move.

SUSAN ROTHENBERG.
*Untitled (Proposal for
38th Floor Commission).*
1987.
Crayon and graphite
on paper, 42 x 60"
(106.7 x 152.4 cm). The
UBS Art Collection

AT: I think that *Biker,* also in the UBS gift, was one of the first paintings in which you did that.

SR: Yes, *Biker* was a couple of years earlier.

AT: With the dancing figures in *1, 2, 3, 4, 5, 6*, there is an obvious comparison to the Matisse mural at the Barnes Foundation.

SR: You know, I never thought of that.

AT: That's why it's good you're not an art historian [*laughter*]. Was there a deadline for your murals?

HENRI MATISSE.
The Dance. 1932–33.
Oil on canvas, left
panel: 9' 5¾" x 14' 5¾"
(339.7 x 441.3 cm),
middle panel: 11' 8⅛"
x 16' 6⅛" (355.9 x 503.2
cm), right panel: 11'
1⅜" x 14' 5" (338 x
439.4 cm). The Barnes
Foundation, Merion, Pa.

SR: Eventually, yes. I well remember working on the paintings in sweltering heat out on the Island. I must have had to finish them by the end of the summer, before my daughter went back to school—because my loft in the city wouldn't have accommodated them. Whereas my space in Sag Harbor was big enough for all six panels to go on the walls at the same time.

AT: So the deadline wasn't for PaineWebber's sake but for your own. You worked on them all at once?

SR: Yes, I did. I'd think, Which one do I need to work on today, and if I got stuck on that one, I'd move to another.

AT: When you were working on them, did you have sense of which would go where? Was there a one-through-six sequence?

SR: Yes, as I made them I placed them as I wanted them to be.

AT: I don't feel a narrative progression.

SR: No, but they torque: one leans out, one leans in, one flies up, one presses down, one stands, one relaxes. To me they make sense.

AT: In terms of a dance?

SR: A possible dancing movement.

AT: Does your sense of that come from your experience as a dancer?

SR: I tried to feel in my body what the movements would be like. I have some sense of body and dance that helped me picture how moving in space might occur.

AT: When you were dancing with Joan Jonas—

SR: —Well, I was performing. I took dance as a youngster but I was never a dancer. I never performed in a company. I was just a prop for Joan. I also took classes with Deborah Hay. I loved dancing but I wasn't a dancer.

SUSAN ROTHENBERG.
1, 2, 3, 4, 5, 6. 1988.
Installation view
in thirty-eighth-floor
dining room,
PaineWebber Group,
Inc., New York, c. 1988

AT: The figures look quite androgynous.

SR: They look quite male to me, actually.

AT: To me they're ambiguous.

SR: I like the ambiguity. I mean, I dislike thinking of them as bodies, but if I were pinned down, they're male for me.

AT: The limited palette, red, white, blue, and black—did you have that in mind from the start?

SR: I don't think I can answer that, I don't know how that evolved. I think I was thinking of the spaces during the day, and then how they might look at night, so dark and light. I was trying to take that into account; I don't know how to explain it better. But dark and light, and then I guess the flesh of the figure, and then blue popped up.

AT: When you were working on them, did you ever send one or two in as a test? Or did you not see them in the space until the end?

SR: No, not until all of them were done. But I saw that they were going to work as an installation, or I felt they did. I also felt they wouldn't interfere with anything going on there, and that they'd make the room jazzy. I thought they were good images for placing in the sky, against the New York skyline.

AT: Yes, it's almost like they were uplifted by the fact of being on the thirty-eighth floor. In that sense the theme of the dancer is appropriate.

SR: Yes, there's an idea of antigravity—the desire to pursue weightlessness.

AT: Are you a painter for whom it's hard to measure exactly when work on a specific painting stops?

SR: Well, early on, when I showed at the Willard Gallery in New York, I used to go there at night, after the installation but before the opening, and change things. I don't do that anymore; now I make sure the paintings are as good as they can get in my studio. But yes, it's hard for me to let go of a painting. There are incidents of correction—but not, I think, in the last five or seven years. And I never worked on the dancers in the PaineWebber space.

AT: Given that the paintings were originally site-specific, I want to know your thoughts about installing them elsewhere. How do you imagine you'd be most pleased with them?

SR: I've thought of this question since I knew they were coming to the Museum. And you know, I'd have to be there to say what pleased me most. I would think they could exist abutted right up against one another, but I may be wrong. I may want a foot or so between them. I don't see them taking over a room, as they did in the dining room. I see them in a linear row.

AT: How did you come to paint *Dogs Killing Rabbit,* of 1991–92 [p. 221]?

SR: That was an observed event, in the snow. The faces are [my husband] Bruce [Nauman] and me hollering at the dogs. We didn't know if the rabbit was dead, or what was going on, but we were trying to stop the event. It's a little story that happened. The positioning and so on are invented, but there was a moment when the dogs killed a rabbit.

AT: These dogs were your pets?

SR: Yes, I always have a bunch of dogs. I think at that point we had five; two were old, and weren't involved. There are three dogs in the painting.

AT: You were just out for a walk?

SR: Yes. I think we were actually quite near the house.

AT: So if you look at the painting, the horse's legs are in the upper left, with the red hoofs.

SR: The horses were nowhere near this event. There was some fictional intervention on my part.

AT: Thinking of the two faces as you and Bruce trying to stop the dogs gives me such a different take on the work.

SR: How had you read them before?

AT: I didn't know how to read them, but I didn't read them anecdotally. I just read them as more forms in the painting, like the horse's legs.

SR: Well, that's good.

AT: But the horse's legs are shown from a different perspective than the dogs and the rabbit, which you see with a bird's-eye view.

SR: Yes, since I moved to New Mexico I've used shifting perspectives. You see things from different heights here, the topography changes—sometimes you're looking down on the land, sometimes you're climbing up the land. So a different kind of shifting perspective came into my work.

AT: And *Dogs Killing Rabbit* dates from very soon after the move?

SR: Yes, I moved here in 1990.

AT: And in a new environment, how did you choose your subjects?

SR: I started taking small things from what was around me.

AT: Because the landscape seemed so large?

SR: Material events in my life were all I could think of to paint. I was adjusting to all kinds of new things here.

AT: It was new territory.

SR: Oh yeah. Six hundred acres of cactus.

AT: You don't paint quickly, right?

SR: No, I'm not superproductive…eight, ten paintings a year?

AT: And what's your routine?

SR: I'm in the studio most of the day.

AT: Monday through Friday?

SR: The names of the days make no difference.

AT: When you bring the paintings to be looked at in New York, do they look different to you from out in New Mexico?

SR: Yes, they look better. When I see them at my gallery, for the most part I feel they look quite different from in my studio. I guess it's because the work is over—I'm looking at them as finished now. Looking at them without the urge to get at them again, they look more complete than I'd imagined. Whereas when I see them in the studio I'm looking for problems.

AT: How does the difference in the light affect them? Or is that not a factor, because your studio approximates a New York gallery?

SR: The gallery has better lighting than I do. I don't try anything fancy with lighting; sometimes I even work with the lights out, so it's dim—that helps me get away from detail and deal with the whole painting more. So the paintings are much better lit in New York than they are here, and therefore the color is sometimes more resonant in the gallery space. Also I work with the canvases unstretched and stapled to the wall—they always clean up a lot on stretchers.

AT: And does that happen in New Mexico or New York?

SR: New Mexico. I would say the last quarter of the actual painting is done after the canvases are stretched. So then the edges are clean. While they're still stapled to the wall, the edges are wobbly, and different colors show through from different layers of paint, but that folds around the sides once they're on the stretcher. When that happens, my vision of them changes. What edge should that arm be? Do I need to paint it sooner or later? How do I want that to play against the edge of the stretcher bar? The final decisions about what touches what is done after the stretch.

AT: The paintings of your first, say, fifteen years were resolutely impersonal.

SR: Yes, they were. Now my personal life has entered my paintings much more. Which is not to say they're narrative, but they're dependent on where I live and what I see around me.

AT: Your 1982 painting *Self-Portrait*, with paper-doll tabs, couldn't be less revealing.

SR: I think a lot of my thinking in those years was, Keep it flat, don't be too literal. I gave myself a lot of do's and don'ts. I grew up in the Minimalist era, and I was very aware of how *not* Minimalist I was. I tried

SUSAN ROTHENBERG. *Self-Portrait.* 1982. Oil on canvas, 15 ¼ x 21" (38.7 x 53.3 cm). Private collection

to conform to certain tenets of contemporary painting in the '70s and '80s. But now I just do what I feel like doing.

AT: That brings me to ask about your sense of yourself in relation to the tradition of abstraction.

SR: I have a hard time with that question. I think I'd like my work to be more abstract, but at the moment I'm working on three paintings that couldn't be more literal, and I seem determined to minimize their painterliness so as to allow their subjects to be. I'm doing exactly what I don't wish to be doing. These are strange paintings, and I don't know if I'll extend them into a series. They're inventive dramas; the camera is painted into them, and there's an actor—they're like home movies about meaning-less gestures. They're not in the least bit abstract. Every element is extremely defined.

AT: So when you say you're doing exactly what you don't want to be doing, does that mean that in the studio you're almost an observer?

SR: Well, I started them, and now I have to follow them. Scumbling them up, making their different elements less clear, would seem to be falsifying what I'm trying to say. But I can't wait until these three paintings are done. I would like to be in a looser arena than I've given myself at the moment. I don't think I'm capable of making a purely abstract painting, it just wouldn't satisfy, but I can see these paintings becoming less literal. I guess in order to define the idea to myself, though, I've had to make them extremely literal.

AT: So once you've gone a certain distance, you are where you are, and you're following the painting.

SR: Yes, and I would rather start over again with a different set of images than force the painting I'm doing. So I'm working on each of these paintings every day, and at a certain point I'm going to say—

AT: —These are what these are.

SR: Yes, and I can't work on them anymore, and get them out of sight.

AT: When you think back to your earlier work—like *Biker,* say, which you made almost twenty years ago now—can you put yourself in the head of the person who made it?

SR: Oh yes. Though I always wondered why that painting is kind of a loner. I haven't done anything quite like it.

AT: No, the only thing that comes close is *Night Ride* [1987].

SR: Sometimes I think a painting is the beginning of something. *The Chase* [1999], say, is a big painting of animals and rabbits. The empty center of that painting, and the spiraling movement—I thought that was brand new territory, and I tried two or three paintings to extend it—but I was unable to and I had to drop it. It was a one-timer. So was *Biker.*

AT: What's one-timer about *Biker* is perhaps its extreme sense of speed.

SR: Yes, and there's landscape in there, which is unusual. Water, tree.

AT: The white puddle splashings are fantastic.

SR: It's both more abstract and more literal than many of my paintings.

AT: Were you the biker?

SR: Perhaps. I haven't asked myself that. I mean, I'm not a serious biker, I hadn't actually ridden a bike in a long time. But it was a way of moving through space other than spinning and dancing.

AT: As an observer, you feel that the bike is coming out of the painting. You think, Oops, I'd better move.

SR: I'm glad it has that effect.

AT: On the questionnaire that MoMA sent you almost twenty years ago on *Biker,* all of your answers are "Yes," "No," "Fine," "No comment." Then we ask "Is there any special significance?" And you write, "Probably."

SR: I don't think I can elaborate on that. For me *Biker* has to do with what I said about moving through space. It was another vehicle, both for moving the body and for moving my painting along.

AT: Yes, in almost the opposite way you worked when you began as a painter.

SR: Exactly, in the '70s everything was quite still, matter-of-fact, and flat. We didn't want illusion and we were trying to throw off art-historical premises. Of course nobody succeeds in doing that. Now my painting is much more static again than it was in *Biker.* I'm energizing the painting through the methodology of applying the paint, rather than trying to nail the spinner or biker.

AT: Is it a coincidence that your first paintings were made after your gave birth to your daughter?

SR: Well, I was breaking up clay, and mixing it with linseed oil and all this stuff. Rubbing it into paper and painting on canvas, like earthwork. But I had to change mediums because I was breastfeeding. I couldn't have all that material: for example, if the baby was crying, I literally would have to spend five minutes washing my hands off with turpentine. So I went to a paint called Flashe, and mixed it with an acrylic medium, a water-based paint. It was a practical, motherly concern.

AT: Had you always wanted to be a painter?

SR: I started out in sculpture at Cornell, but I flunked out of the department. I think that what flunked me out was that I was casting Baby Ben alarm clocks with cement, with spikes coming out of them. My influence was Lucas Samaras. Then after a while I went back to being a painter.

AT: But when you arrived in New York City in 1969, you were performing?

SR: Yes, I was performing and I was working for Nancy Graves, working with Joan Jonas, taking dance classes with Deborah Hay. I remember something that really got me going was Richard Serra's lead-throw pieces. They were the natural evolution of sculpture, but also of Jackson Pollock. His steel plate things, and then his throwing lead around the room making molds, almost like painting—that kind of thing started to open things up for me. Robert Morris's box that took up the whole room floored me. But I couldn't be those guys.

AT: Right. But you weren't even painting then.

SR: No, I was ripping up cloth and tearing up paper, trying to do process art, I guess we called it then. I was ripping holes out of paper and gluing them back on next to the hole, and I was working with wire and string. I was very influenced by Alan Saret's work, he's a wonderful artist.

AT: When you were ripping up paper, it was about collage, not sculpture, wasn't it?

SR: It wasn't about sculpture—I was trying to find my way back into pigment, texture, and material. Then I started doing pattern paintings; I did about eight of them and threw them all out. I thought I had to go more abstract. Then, you know, all these experiments, and finally I came up with the horse. I did a show of that work, and that was the beginning of me and the horse and the whole—

AT: You were a painter whether you liked it or not.

SR: Yes. I liked it.

Edward Ruscha

ANN TEMKIN: How does the drawing *Museum on Fire* [p. 222] relate to the painting *The Los Angeles County Museum on Fire?* The dates suggest that the painting preceded the drawing, since the painting is dated '65–68 and the drawing is dated '68.

EDWARD RUSCHA: I worked on the painting for something like three years. I'd paint on it for a few weeks and then put it away—I once put it away for almost a year—and then I'd work on it some more. I think the drawing is an exercise. I did five or six of these studies, all the same size; I stepped in with them after the main painting was begun. They're probably a light moment where I thought, I want to expand on this thing and make some little drawings, see what they look like.

AT: The drawing and the painting are so different—it's clear you weren't trying to work out something in the painting.

ER: No, most of my drawings are made as drawings, not as preparations or sketches for a bigger work. I've always treated them as an end in themselves.

AT: The museum is much more on fire in the drawing than in the painting.

ER: It is, isn't it? And it's probably the most developed of these drawings.

AT: How did you get that grain? Did you use erasure?

ER: I bet I did. The medium is powdered graphite, and I probably blocked off certain parts with stencils and worked it and reworked it, and then took the stencils away and reworked it further. It's probably done with Q-tips. It looks to me like I put down the graphite and then erased it for these columns here.

AT: The stencils would block out a building form or section?

ER: A section. Or I could have used tape to block it out. I probably made a background first and then went back and detailed the whole thing.

AT: Did you make the stencils?

ER: Yes, I'd have made a tracing-paper pattern of the building's outlines. Then, after

making the background, I probably removed the stencil and worked the building with more patterns, block-outs, and that sort of thing.

AT: You blocked out the border too? You made it really clean.

ER: Yes, I wanted to make a picture within an area.

AT: You've said that you'd been flying over LACMA in a helicopter with Charles Cowles and Joe Goode.

ER: We were just taking a ride. We left from somewhere in the San Fernando Valley, and I was stunned how fast you could see all of Los Angeles—in a half-hour you can really make time. We flew over the Museum, where I took some Polaroid photographs that I still have. They haven't faded. They served as a guide.

AT: When you started the painting, the LACMA building was just a year or two old. How did people perceive it, as ugly or beautiful?

ER: That building has been redesigned four or five times, it's totally different today from what it was then. A lot of people hammered it for one reason or another; I just found it a part of the facts of life. It was an institution that was like an authority figure. And it looks the part, doesn't it? It has those glorious columns....

AT: Yes, the columns, the beige stone, very authoritative.

ER: I guess I always felt that way about it. The Museum promised big things, it was committed to contemporary art—it was a big development for the city.

AT: LACMA was the first museum to own a painting of yours, I think?

ER: Yes, a collector had donated a painting to them a few years before. It was *Actual Size* [1962], which says "SPAM."

AT: So you were figuratively burning down an institution that was actually friendly to you?

ER: Yes. I had no gripe with this particular institution.

AT: When you saw it from the helicopter and took photographs, did you right away think, Eureka, this has to be a painting? Or were they for something else?

ER: I think I took the pictures with the idea of doing something with them but I had no idea what.

AT: At the time, you would have seen the Museum as a photograph on the cover of the L.A. telephone book.

ER: It was on a telephone book from around '64. I used that telephone book along with my Polaroids to work out the composition. I also went down to the Museum and photographed details when I was back on the ground.

EDWARD RUSCHA.
The Los Angeles County Museum on Fire.
1965–68.
Oil on canvas, 53½" x
11' 1½" (135.9 x
339.1 cm). Hirshhorn
Museum and Sculpture
Garden, Smithsonian
Institution, Washington,
D.C.. Gift of Joseph H.
Hirshhorn, 1972

AT: The drawing could practically be an architectural rendering, it's so clear.

ER: It fulfilled a need I had to do something oblique. An aerial oblique—something seen at an angle from above—is almost like a tabletop if you think about it, and obliques somehow had value to me as an artist. Also, as I've said before, the painting that inspired me here was Millais's *Ophelia* [1851–52], in the Tate Gallery. They're both unfortunate events—the building is on fire, Ophelia is dying—within a more or less serene format. The background is quiet and respectful and the colors are still and quiet. I liked the idea of putting quiet with fire.

> AT: True enough. You have to look at the painting twice to realize the building's on fire.

ER: I like that, it intrigues me. Also, putting an object way off to the side, as though it were trying to escape from the picture—I've done that in other works.

> AT: Ophelia's lying in the water with flowers. At first, looking at that painting, you don't know anything's amiss; you just think, This is lovely.

ER: Yes. Maybe it was a bit of a Romantic period that I went through there. I never felt like painting like a Pre-Raphaelite, but I tried to get the essence of *Ophelia* in this.

> AT: You saw it at the time, or earlier and it stuck with you?

ER: I saw it at the Tate in '61 or so. It's much smaller than it looks in reproduction.

> AT: That's a strange quality about your paintings as well—it's difficult
> to guess their size. With the drawing you have a hint, because you have the
> sense of a piece of paper, but even there, if I'd seen it in a book and you
> told me it was nine feet long, I'd believe you. The other thing that strikes me
> about the drawing and the painting is that they're a fantasy, they're made-
> up scenarios. Your art before then, with few exceptions, had the straightforward
> stance of the record or document. But then here came this image out of your
> imagination, a museum on fire.

ER: Fire was a cold choice on my part. I had no fixation with it, and I didn't think about it as a political statement, or as suggesting any other idea. I wasn't illustrating tragedy. It's kind of a simple device, always changing. I've used it several times, especially in earlier works.

> AT: The *Various Small Fires* book [1964] starts it I guess—

ER: Yes—

> AT: But fire has a great tradition in art history. There's J. M. W. Turner, for
> example, with the Houses of Parliament ablaze.

ER: And then there are some British artists, like Richard Eurich's painting *Withdrawal from Dunkirk* [1940]. That thing's so quiet, yet you look closely and there are these explosions. They look like trees; it's such a restful picture, you think somebody should grab you and put you in front of *Guernica* and say Look, this is what war's like, not this. So the idea of fire in a serene format is what's happening here.

AT: Yes, but I bet a lot of art-history papers have been written about you as the contemporary artist setting fire to tradition, etc.

ER: Well, that thought is always there. It's a voice against authority figures. If people want to take it there that's fine with me.

AT: Where were these first shown?

ER: At the Irving Blum Gallery in Los Angeles—it was that single painting and these little studies.

AT: So you called them "studies" even though they weren't "studies for"?

ER: I probably said studies. They were more afterstudies.

AT: Was the idea of working with stencils something you had in your repertory from the works with letters?

ER: Yes.

AT: It wasn't so ordinary for someone making what would be conceived of as a traditional graphite drawing to use stencils. Of course it went with your background in graphics.

ER: Yes, and the techniques I use all just depend—they're just out of the toolbox.

AT: You've often said you like art that makes you scratch your head.

ER: I suppose I saw some kind of irony in the scene that I wanted to investigate. It's a piece of scenery in a way that my work isn't always; my works with words are a little less atmospheric. Here there's the sky, there's the background….

AT: As you say, it was almost a Romantic phase. There's also a Surreal side, though—Dalí or Magritte.

ER: I was probably more influenced by Dalí. People say my work looks like Magritte, but I was never really that motivated by his work where I saw it coming in at mine….

AT: How did Dalí's work motivate you?

ER: I know I've been influenced by him, but I can't say exactly where. Maybe it's the departure into fantasy, I think my mind goes that way at certain times. Maybe the influence is through the back door.

AT: Another work in the exhibition, *Vanish* [1972; p. 223], is part of the group of paintings you began with after you hadn't painted for two years. It looks like part of a series from before that break, though—you seamlessly took up where you left off. What made you decide to go back to oil on canvas after pronouncing it finished?

ER: I was thinking it was all going to be behind me but I felt myself moving back toward it. I somehow slipped into different clothes. In painting that earlier series, though, I'd worked almost as though I were a robot. I had this robotic left-to-right action—even the backgrounds were left to right—and the words were clinical in a way. They

had a certain ring to them, not just in their definitions but in the fact that they could have been almost any words. They were like little people strung out across the picture plane—little soldiers that had taken their position. Once the painting is completed, I have a feeling that these works are kind of official. You can almost hear the trumpets. But they're behind the picture. I did maybe a dozen or more paintings like this over the years. I'd move away from painting these pictures and then I'd come back to them, and go away, and come back. In some instances I'd paint a background and let it dry for a couple years. So this painting may actually have been begun in 1968, '69, with the earlier ones. Then I would have put the word in last; it was probably 1972 when I painted the letters.

> AT: That makes sense—it's even the same size as the earlier ones. It seems like you must have bought the stretchers at the same time.

ER: Yes, I did. And it was true of a number of them that I'd paint the background first and then come back later and paint the words.

> AT: Would you plan in advance that, say, a certain background would be right for the word "pressures"?

ER: No, but I might say "chemical" is good here, "chemical" is not good there.

> AT: You do these backgrounds with a brush?

ER: This is all done with brushes—fat brushes in the background, and then smaller brushes. I'd use masking tape to mask parts off, paint that area, then go back and play with it.

> AT: Did you use stencils to paint the words?

ER: No, those were all done by hand. It's a typeface I'd used in my books—Beton, if I recall. I got into a habit of drawing them, and no, I didn't use stencils. I might stage them out with a pattern on a piece of paper. Then I'd measure these little figures with a caliper. Then I might use some kind of highly sharpened chalk pencil and draw the letter in and then go back and paint it. If you looked at these letters up close you'd see brushstrokes. The bigger you blew them up, the rougher they'd look.

> AT: Would you see the pencil outline at all?

ER: It's possible that you might.

> AT: But the letters didn't get *too* big.

ER: Actually the technique of making these little tiny figures across a landscape never translated into larger paintings. They were mostly kept within this size.

> AT: The backgrounds feel like landscapes, but the words don't have that kind of atmosphere. "Vanish" may be the one most easily associated with the scenery of some abstract landscape; "Chemical" too, maybe. But you don't seem to have been looking for that connection.

ER: I have an intrigue with words, and especially out-of-context words, where you

pick a word out of the sky and don't make a sentence out of it. Also cold words that have definitions in the dictionary but no usage as such. My usage is to put it in a painting. Then the visual aspect of it is almost like what a fairy does: Bing! Lots of little sparks come out and they're all in order.

AT: How did the word "vanish" come into your head?

ER: It seemed to me like one of those words that have their own magic. Why I pick certain words is difficult to describe, but if we went through a list, I'd be able to tell you which ones appeal to me. I do like these clinical definitions. It's almost like I get a feeling that these paintings could go well in a hospital.

AT: The way the paintings are painted, they almost feel like they're stained. And indeed, those first paintings of the late 1960s seem to have led into your stained works from the early '70s.

ER: Yes, I did start doing the stains soon after those paintings. In 1969 I did a book called *Stains*. On each page there was a single stain of food or another organic material. Then I started making drawings and prints using organic materials. When I did those, I really didn't believe in oil painting. I wasn't painting with acrylic or anything like that either. I think it had to do with the fact that those media were like a skin applied to a support, while the organic ones were more like staining or getting down into the fabric. That's what I wanted to do then. And now I find myself back to putting this skin on the canvas.

AT: Did your thinking on this involve a sociopolitical stance at the time?

ER: The politics of living, how I viewed the world, were secondary to my life as an artist. All I wanted to do was make these pictures. I think I've just gone along as I could, following a blind faith in what I'm doing. At the same time, I'm not painting for an audience; I've chosen to show my work and have it be seen, but I have no target audience in mind. So in a sense the communicative value of these things is uncertain. Everyone's going to react a little differently to them.

AT: *Now Then As I Was About to Say* [1973; p. 225] follows closely upon *Vanish,* but belongs to a body of work where for the first time you're joining words together into phrases.

ER: Yes, broken thoughts. But they're still words, still part of the language.

AT: Was this phrase from a movie or book, or from something you overheard or that someone said to you? It's both commonplace and specific-seeming.

ER: This had to do with everyday conversation, I think. It's like picking a frozen moment out of the conversation of two people in the elevator.

AT: The work is in shellac on moiré rayon. Is the shellac clear, but apparently dark because it's on that purple fabric?

ER: It was clear shellac. The fabric is a synthetic moiré, real shiny. When you move, it

changes radically, and when you look at it sideways the letters shine. I like the idea of shine-on-shine.

> AT: Did you make a lot of paintings with shellac, or was it just one in your body of organic mediums?

ER: I might have done one or two more. I did some paintings on taffeta and on rayon. I found the fabrics at a fabric shop in L.A. In London I'd done a portfolio of rhyming prints of words that sounded British to me: "NEWS," "MEWS," "PEWS," "BREWS," "STEWS," "DUES" [1970, Editions Alecto, London, edition of 125]. These paintings came out of that project. I went to make prints not really knowing what I was going to do, and then I thought, What if I use something else? What if I use cream, what'll happen with cream? I tried cream, and couldn't make it print properly, so I tried axle grease, and that seemed to work pretty well. Then I tried caviar, and blueberry jam, things I used for their own integrity.

> AT: Although you were obviously trying to get outside the traditions of art, it would seem to me that getting the shellac, or blueberry juice, or whatever to do what it had to do must have been tricky. It would have been easier, not harder, to use paint.

ER: Maybe, but the ease of it wasn't a question. Neither was the work's longevity. Things happen. I used blood on one of the works; it was attacked by mites, although you might think blood dries inert. In another work I used blueberry jam, which has sugars in it; you would think insects might attack that, but they never really did—it finally dried out. Salmon roe had a whitish tinge that intensified over time; most colors will fade. Anyway, a good number of those paintings have survived. It's actually their supports—these rayons and taffetas—that are their delicate parts.

> AT: When you chose a substance to paint with, did you experiment with it to get it to work?

ER: I didn't say, I'll paint with carrot juice but first I'll see how carrot juice lasts by putting it out in the sun. I wanted to be immediate. And yes, the works might fade, but so what? In fact a lot of those things have maintained their colors. I'd rub lettuce on paper and it had that chlorophyll look; it still maintains that.

> AT: If it wasn't about ease, could you say what your choices *were* about?

ER: I wouldn't say they *weren't* about ease. I could paint one of these in a day.

> AT: Again, all freehand?

ER: Yes. Here I'd make up letters and position them in back of the canvas, because you can see through this fabric and follow lines. The letters were done without guidelines, at least not drawn ones; the guidelines were behind the canvas in the form of acetate, Mylar, or glassine—more than likely glassine. I'd sketch out the letters on that, making heavy black lines, and then put it in back. I'd have a light source behind it and then I'd just paint the letters.

AT: So these perfect letters were your own.

ER: They follow the pattern of a typeface. Futura Italic.

AT: Would you experiment with the composition of the words? If this had
been a bigger painting, would the letters have been bigger, or the lines longer?

ER: They might have taken a different form. But again, following the notion of blind
faith, I might have just staked this out in a quick sketch. I'd write the letters and then
just feel like, I think I'll make it flush left. I guess I just somehow said to myself, This is
the way this is going to be.

At the same time, I may have felt that one of the important steps in making
a work of art is to be deliberate. Maybe that's part of my approach to making art: to
accept the fact that whatever I do is going to be deliberate. But choices shouldn't be
agonized over.

AT: Or unconscious, to go to the other extreme.

ER: Or unconscious. Otherwise I might paint off the edge of the canvas.

AT: You've spoken about how your initial interest in Pop art had to do
with its being something that had an end, as opposed to a Jackson Pollock–
type idea of just performing until the work was done.

ER: I love Abstract Expressionism, and I love that almost Zen idea of making art by
approaching a blank canvas and somehow effecting something on it that ends up
being a picture. But although I thought many artists did that brilliantly, it was always
a little too vague for me. I went in a different direction; it was my interest in letter
forms and words that somehow guided me into the world of painting. Those things
made me realize that I had to plan. You can't be vague when you start a word paint-
ing. Maybe I'll use the word "suspension," and I'll think, Let's see, you spell that "s-u-
s." My choice is deliberate; I elected to paint this picture of "suspension" and that's
the way it's going to be. At the same time, I don't attempt to illustrate a word's def-
inition. To paint a picture of the word "blue" in blue paint is out of my intention.

AT: Let's jump forward twenty years to The End [1991; pp. 226–27].

ER: For a long time I'd been intrigued by Old English lettering. Tattoo artists and
gangsters in prison use this lettering; I'm amused by that, and by the fact that the
typeface goes way back in history. Its shapes were created by chisels carving in
stone: that little hook is where the chisel lifts up off the stone's surface. That way
they didn't have to clean up the edge, they just drove it forward and hooked it. Then
that became the design. I always found this typeface kind of amusing in that it's
meant to be formal and old and churchlike. The Bible used to be printed this way, and
there are fractured connections with medieval illuminated books and early typogra-
phy. It has a hangover with the past.

AT: Have you seen "The End" written in that typeface? Where it appears in old
black-and-white movies, I always think of it as being in a pretty cursive script.

ER: I'm not trying to illustrate the ends of movies so much as I'm influenced by the ends of movies. Then I'm bringing my own thing to it: I probably chose this lettering because I've done a lot of paintings and drawings with it.

AT: My projection here is not the end of a movie but an apocalypse.

ER: Yes, that's a powerful thing. It's the end—here it is—the end. It's a powerful and final kind of thought. I feel cozy about using that as subject matter.

AT: "Cozy" isn't the word most people would have paired with that idea. But yes, you've done several paintings of "the end."

ER: I've also done maybe forty or fifty drawings of it, though not always in Old English type. But I did think it necessary to use an airbrush: I wanted to eliminate brush-strokes. The edges are all fogged, almost like the picture is out of focus; that's always a question when you're watching a movie, whether it's in focus.

The other interest in *The End* is the idea of watching a movie and seeing a lot of scratches and pops and fizzles and little dingbats. It's a picture full of what moviemakers would prefer to have eliminated. But I always liked seeing the pops and scratches in movies. Scratches from sand or whatever gets into a movie projector.

AT: In the painting, are they actually absences in the oil?

ER: Yes, they are. They're not painted on, they're blocked out.

I suppose you've seen a film get stuck in some sort of out-of-sync mode? In a sense, this painting is an illustration of an out-of-sync mode. Fifty years from now, when there's no such thing as movie projection through celluloid, it will be a head-scratcher—people will say, What do these lines here mean? Today we still have some sense of identity with this picture, but it's not going to be relevant in the future. That could disturb me, but I'm not going to let it.

Robert Ryman

ANN TEMKIN: This untitled work from 1976 [p. 229] was included in Bernice Rose's exhibition *Drawing Now* at the Museum that same year. It was one of a pair of your works in the show.

ROBERT RYMAN: That was how I happened to do them: Bernice was doing that show, and wanted to know if I had any drawings, and I thought I would make some. I don't remember how I happened to choose plexiglass, but I may have been working on paintings on a similar material at the time. I had the plexiglass sand-blasted so that it was translucent, and also so it would have a tooth that would accept pencil and pastel. I was using visible fasteners at the time; these happen to be square steel plates.

AT: What made you call them drawings?

RR: I approached them with line and the surface was in pastel, which I wouldn't have used in a painting. It was all drawing media, not painting media. I sprayed them with a fixative—I don't remember what, but something that would hold them together. I just thought of them as drawings. I approached them that way.

AT: At the Museum, we define drawings by the nature of the support. Drawings are works on paper, so by MoMA standards this work has been called a painting, because it's on plexi. But I'm feeling like it ought to be in the drawings collection, to be true to your intent.

RR: Yes, it really should be. On the other hand I think the Department of Drawings has some paintings. The little *Surface Veil* [1970], on fiberglass with wax paper—I think that's in the drawings department, and that's a painting.

AT: Were you trying to avoid painting a painting on canvas or drawing a drawing on paper specifically to avoid using the traditional vehicles for classifying different mediums?

RR: No, that had nothing to do with it. It was a matter of figuring out how the drawing could just be naked, so to speak, by itself, without glass or anything else.

AT: So it was pragmatic.

RR: Yes. Actually, I wasn't against paper; I would have used paper if I'd known what to do with it. It had to be a hard surface to be put on the wall.

AT: You were asked to do a drawing so you used pencil and pastel. At the time you were doing oil and Elvacite paintings on plexi too.

RR: Yes, though I liked the translucency of the plexi for the pastel. And I'd already started using the visible fasteners—I showed paintings hung that way for the first time in a show at P.S.1 in 1976. I think the first works on plexi were the same year. I don't know how it came out to be plexi; I guess I just liked the softness of it, the translucent quality.

Installation view showing works by Robert Ryman in the exhibition *Drawing Now: 1955–1975*, at The Museum of Modern Art, New York, January 21–March 9, 1976

AT: *Embassy I*, in oil on plexi from 1976, would be one of the paintings you're talking about.

RR: Yes, and it's very similar to the drawings in construction.

AT: The fasteners are steel squares coated with black oxide.

RR: Yes, I did some paintings with black oxide too. I think a couple of the drawings had the steel-color plates and others had the black oxide.

AT: Black oxide is a rust-proofer? It's not really black.

RR: Yes, it's rust-proof, and it's actually a blue. I think they use it on guns and other metal parts to keep the surface from rusting.

AT: It's coated onto the steel?

RR: Yes, I had someone do it, at a place on Broome Street around Lafayette where they'd coat metal with other metals for you. Chrome and so on. I don't think shops like that exist anymore.

AT: Did you buy the steel fasteners?

RR: I had those made to specification. There was another place, on Sixth Avenue just off Fourteenth Street, on an upper floor—he made the metal parts.

AT: You'd bring him a drawing?

RR: I'd bring him a drawing and they would stamp them out.

AT: Did the men at these shops ever ask what your things were for? Did they know they weren't for a machine or something?

RR: They'd usually make things by the thousand, and I'd only want twenty or thirty. I can't remember what I said, but I explained they were for some exhibition thing. I might have said they were for a painting. Anyway they were willing to do it. And it wasn't expensive, they didn't charge me much. They probably did it in their spare time.

AT: Just as an oddity, for a few dollars.

RR: Right. I still have the drawings for the different fasteners I used. They're just fab-

rication drawings to show someone what I wanted, with dimensions.

AT: You couldn't play around with these things in the abstract—you'd just have to have them made, and then you'd see if they worked with the painting.

RR: Well, I had an idea of how I wanted them to look on the work.

AT: Did you usually order them with a specific painting in mind?

RR: Once I started these paintings, I had several different fasteners made. I had some that projected farther off the wall, others, for smaller paintings, that projected less far, and they were different sizes depending on the size of the work. So I had fasteners "in stock" to use if I needed. In fact I still have some.

AT: But you haven't been using them lately?

RR: I last used them a couple of years ago. I hadn't done a painting with fasteners in a long time, and I just thought I would. I did two canvases, one with black-oxide fasteners, the other with steel color. But I had the fasteners already.

AT: You didn't have to find a source.

RR: They were just elements that I could use on a painting if I needed, if I wanted.

AT: But around 1976 you were investigating fasteners more intently.

RR: That's right. At that time all my works had visible fasteners. I just thought, Well, why not see how it's attached. The fastener made the work really part of the wall, which I liked. Then I could use the fastener compositionally, too. I always did that.

AT: The way you paint, the viewer really has to inspect all the different parts of the work. But it's also striking that works of this kind really don't exist until they're up on the wall.

RR: That's right.

AT: If you're lucky enough to be involved with the installation of these things, it's magnificent to get to see something come to life right before your eyes. But it seems to me that you're putting a lot of responsibility into the hands of the installers, unto eternity.

RR: There's nothing you can do about that. It's just the nature of these paintings and these drawings. Someone said of them, A picture is on the wall but these paintings are in a space. That's the difference. Technically, of course, these are on a wall too, but they act differently, because they work with the wall and because they move outward. You don't so much look into each one as perceive the whole.

AT: There's a certain intuitively gauged area around the work—maybe six feet beyond, maybe three feet, I don't know.

RR: Yes. It's within the space. It's an outward aesthetic.

AT: And that has everything to do with why we can't imagine the
paintings framed.

RR: If you put a frame around this drawing, it would just be destroyed.

AT: Like a picture wiped. It would stop its action. Yet aren't you
surrendering a lot of control to the decoration of the room? What if
someone wanted to put the drawing on a colored wall?

RR: That would change it, no question. The drawing being translucent, whatever color
is behind it will activate it. It might be all right on a certain-colored wall, but it would
certainly change it. Another aspect of them is light. They react to real light. There's
no illusion of light painted into the work; it's *real* light. That's crucial also: being in
daylight or low light will change the look and feeling of it. I prefer a low light, as I think
you can see more that way.

AT: Yes, as with a Rothko.

RR: If it's brightly lit, you would think you could see more, but you don't. The lighting is
another aspect that you don't really have control over once the pictures go up.

AT: That's also true of conventional pictures.

RR: Most pictures have an illusion of light painted into them. They can be in almost
any light and you'll still see the picture. But with this drawing—well, if people are sen-
sitive enough to what it is, and what they're looking at, they can try different lights.
They will naturally see it in maybe an evening light, or a light from across the room,
or a light from a lamp, or a light from directly above. It will always look different. In
most rooms, unfortunately, you have windows on one side and then two side walls,
raked by the light that comes in from the side. You usually have just one wall that's
really good—the wall opposite the windows. It's just the way things are.

AT: Did you paint these in a studio without natural light?

RR: Yes, I painted them right here, but that's not so important. I see them in different
lights. I have different light downstairs. Most museums have the lights I do here; a lot
of bulbs yellow as they age, but these stay the same throughout their life.

AT: So having your works seen in natural light isn't so important to you,
just good light.

RR: Right.

AT: Your works especially demand suitable neighbors, I think. So often
I've seen your paintings installed next to really incompatible work; it must
be very frustrating.

RR: Well, that's true. And many times it's Agnes Martin who's next to me. I guess it's
because there's a similar kind of softness or something. But it's a different situation.

AT: Was this drawing made on a flat surface, as most drawings are?

RR: It was made on the wall, because I had to see the fasteners.

AT: So you put the fasteners on first and then worked around them.

RR: Sure. As I remember, I put some tape over the fasteners to keep them clean, but I could stop, take the tape off, and see how the work looked.

AT: When you were looking for plexiglass, did you special-order it the way you described with the fasteners, or did you go to art-supply stores? A lot of the supports you've used aren't found in art-supply stores.

RR: I don't remember where I got the plexi—probably a place selling plexiglass for windows, something like that. I brought it to a place on Bond Street, over by the Bowery, to be sand-blasted. Again I'm sure that place is gone now.

AT: Your mediums and supports are an aspect of your work that people often don't focus on, yet it's clear that they're crucial. What was the attraction of translucent plexi? Isn't it more difficult to work with than canvas?

RR: It had to do with size, partly. I was making a drawing. If I went with a large paper, or even with a small one, then I'd have to have glass or plexiglass over it, or some kind of mounting. And this way I could draw directly on the plexi, which would be strong and tough enough to stand on the wall. I guess I didn't think of metal at the time; I thought of the plexiglass as being almost paperlike, yet I could do it fairly large, in fact almost any size. That's how I think it came about.

AT: Even though you sand-blasted it, I wouldn't have thought that plexi would have been natural to use with pastel.

RR: I couldn't use paint, it had to be some kind of drawing medium. Of course I could use pencil, and ink, chalk, things like that—and pastel. And though years ago maybe I'd done some small pastels on paper, I hadn't worked with pastel much. I thought it would be an interesting challenge. I didn't really know how it would come out.

AT: Did you use sticks of pastel?

RR: Yes, I had a lot of them. I think they were all pretty much the same color. The fixative darkened them a little, but I had to put that on.

AT: Did the fixative cover the plexi, too, or just the pastel?

RR: The whole thing except the fasteners, which I masked.

AT: In the past you've talked about your work as realism. Is that something that you still like to do, or did you say that in reaction to a drift of criticism at a certain moment?

RR: It's not that important. I just thought, Well, these paintings and drawings are real things on the wall. They have to do with real light, and with a real surface that you see. There's no illusion and there's no narrative. I'm not abstracting from something else; it has to do with reality. That's why I thought of it as realism.

AT: Can you explain a little more?

RR: I just thought of my approach as a realistic approach as distinguished from a

representational approach. But that's too confusing. It doesn't matter. It can be abstraction, whatever anyone wants to call it.

> AT: Yes, you're not going to win these battles. But your work is very literal. That's a word I find fair to apply.

RR: Yes, that's right. And it works with real light, the light that's on it.

> AT: Do you ever think of yourself in relation to the specifically American tradition? I'm thinking partly of Duchamp's remark, back in the 1910s, about how America's greatest works of art were its bridges and plumbing.

RR: I don't get into that kind of thing, I just don't think that way. I just think about how I can put something together. It's not "American art" or whatever; it doesn't have to do with any symbolic or biographical meaning. I have a little paper that I had when I first started these drawings and paintings—

> AT: With lists?

RR: Well, just thoughts, about how things could go together. I hadn't thought of it as relating to my painting generally, but it does. It would be the same for whatever I do, although I wouldn't write it out like that.

> AT: [*reading*] "Matte, soft, reflective, hard, smooth, uneven…."

RR: It's just a matter of things that are in painting, things that are visual.

> AT: These are all the variables: "Print to edge, print over the edge"?

RR: That's what there is to work with. I had to have that list as a beginning.

> AT: There are always a thousand options.

RR: Exactly, sure. When I do a painting, I don't know myself just what it's going to be until it's finished.

> AT: But one thing that's consistent in your work, that you don't leave as a variable, is the square format. That's a big constraint.

RR: You know that's funny, it's odd—I haven't even thought of that, but I do end up with a square all the time. I just naturally do that. I don't know, a rectangular space is more like a picture space.

> AT: A stage?

RR: For something to go into. Somehow a square is a natural space for me to work with.

> AT: But you could do a triangle, or a vertical rectangle, or what's sometimes called a "shaped canvas"…

RR: I don't think I've ever done a triangle. There were some circular drawings, actually, some years ago. Done on Chemex papers. Do you remember Chemex?

> AT: Sure, the coffee filters. Readymade circles.

RR: Yes. I don't think I've done any triangles. There were a few rectangles in the early paintings, but mostly the square is what I use.

AT: I'm sure theorists could go on forever about the proportion of the square, its cultural meanings, etc. But again you're not thinking about any cosmic implications?

RR: No, I don't know anything about that at all. A square is just equal sided. It's a place to work.

AT: Do you listen to music in the studio?

RR: Sometimes but not often. Sometimes with painting, music can be all right, because I'm not really thinking. But if I'm doing anything I have to think about, I don't listen to music.

AT: Only when you're working on a rote passage. And then would it be classical music? Of course you were a jazz musician once.

RR: Jazz. Bop or modern jazz. Sometimes classical.

AT: Do you still play?

RR: No, not at all. It would take too long. That was a time and it's passed. I thought years ago that maybe when I got older there'd be more time and I'd get back to it. But there's just less time.

AT: Were there aspects of the creative process of making music that you find similar to those of making art?

RR: Well, with jazz, you have a structure and you improvise, compose, on that structure. So in a sense it's very similar to painting, where you have the rules and you see what can happen.

AT: With classical music that wouldn't be the case. And with other kinds of music you might have the improvisation but not the rules, or the rules but not the improvisation.

RR: Yes, with popular music you mostly hear songs. You hear very little instrumental music in popular music; it's storytelling, and mostly rhythm, with very simple melodies. I equate it with traditional pictures that tell a story: that's what most people like, that's what's most acceptable. Of course, abstraction and the so-called "realism" that I was just talking about are more instrumental.

AT: It's a good analogy, but the way you paint seems to me in one respect different from jazz, in that jazz is usually a team effort and painting is solo.

RR: Well, yes, that is different, definitely. You have to be alone to paint. Looking back, I probably started painting because it suited my personality better—it was something I could do alone, and I didn't have to depend on other people for my work. But I didn't think of it that way at the time. Painting was just something I went into.

AT: As Robert Storr tells it [in *Robert Ryman*, 1993], you bought some paints on impulse. Painting wasn't a premeditated idea.

RR: That's right. It was just a very challenging endeavor that I could try.

AT: You didn't grow up wanting to be an artist?

RR: Oh no. I never thought of it till I came to New York. No, I thought of music. That was interesting to me growing up.

AT: In 1953 you started working as a guard at MoMA—was that before or after you started painting?

RR: I think it was a little after I started to paint, or started to fool around with paint. I didn't know what I was doing; I just wanted to see what I could do. But then I got the job at MoMA and got to see painting on a long-term basis. I lived with all those paintings. So then I took more interest in it.

AT: You still don't paint with assistants, do you? That is rare now.

RR: No, I don't. When Simon Rodia did the Watts Towers in L.A., he was asked if he had any help. And he said, No, I couldn't have any help because they wouldn't know what to do. He also said, Sometimes I don't know what to do myself. I feel the same way. My paintings begin with the canvas, the surface, so I can't have someone else work on that. I do have someone stretch the canvas now, but I couldn't have anyone doing anything else.

AT: Not even a ground layer or something?

RR: No, because it's all in the beginning.

AT: The beginning determines what follows.

RR: Sure.

AT: In the past, you've remarked on how young you feel abstract painting is. When you said this, there was all that rhetoric about the end of painting. Do you still feel that?

RR: Back then there was the feeling that painting is dead, that everything is done. Of course I think that there's much left to do with painting. Even if you're painting a still life or a landscape, it's never the same. If it's a hands-on thing—I'm not talking about a computer process—there can only be one. If you do it again, it's different. That's the wonderful aspect of painting: there's no end, because it can't be repeated. Even these drawings we're talking about, I couldn't do one like that again.

There's so much richness in painting, you just don't know how it's going to develop. New materials have something to do with that; certain things that can be done now could not be done earlier. That alone doesn't mean anything good will come from it; you can't just say, I've got a new material and that's going to be great. But even aside from that aspect, painting is a miraculous endeavor. There's no end to it. Every time, a new rich experience can happen.

AT: So you don't feel that the painters of the last twenty years have merely been repeating things, as some people think?

RR: No. Painters have different approaches to painting. A lot of people paint landscapes, and maybe those landscapes look similar; but there's always an aspect to what each artist will do that makes it unique. Sometimes it doesn't come out very interesting; you could say, Well, I've seen that. That's understandable. But there's always that one that's a little special, and you don't know exactly why. Painting is an open situation. It can develop in ways that you can't know. Younger artists now are doing all kinds of new things; there are so many new materials, new paints, new things you couldn't work with in the past. There are all kinds of possibilities.

AT: It's interesting you should say that, since you're rare as an artist in that there are no drastic changes in your work over forty or forty-five years.

RR: Well, the approach is pretty much the same—or not the approach, but the sensibility. The approach involves different paints and different surfaces, which lead to different results. The paintings I'm doing now are on canvas, and they're done a little differently. It's a traditional surface, a canvas with a stretcher, but the paint is much thinner than before—I generally like to use heavy paint. I wanted to try a different approach because it's more of a challenge for me than just to do what I'm comfortable with, or what I know I can do. I always try to do something where I'm not quite sure how it's going to work out, because then it's more interesting. It has to be interesting for me, or it's no good at all.

Lorna Simpson

Untitled (detail). 1992
Eighteen color instant
prints (Polaroids)
and eighteen engraved
plastic plaques, 7' 6" x
13' 6" (228.6 x 411.5 cm).
The Museum of
Modern Art, New York.
Partial and promised
gift of UBS

ANN TEMKIN: Can you tell me about where this piece [Untitled, 1992; pp. 238–39] fits into your work as a whole?

LORNA SIMPSON: For me that piece was conceptually an end to a body of work that had started in 1985. I don't want to sound corny but it was like a swan song, looking back at the work I'd done up to that point—the way I'd handled gender. The very early pieces spoke about gender, women, race, ethnicity, and sexuality, but what was missing was an idea of sexuality as either amorphous or bisexual. So I wanted to create a portrayal of women that did not conform to the very feminine motif I'd had in earlier works.

In that way the work is very orchestrated. It uses a body of twenty-by-twenty-four-inch Polaroids, and I think the person posing is Diane Allford. I found women's suits that had masculine tailoring, which for me didn't so much say "masculinity" as present a question about gender and artifice—the artifice of gender in terms of social visibility. Below the row of photos showing Diane in a suit you have a row showing men's and women's shoes, which add the suggestion that maybe the figure is more androgynous: this could be a man or a woman.

A lot of my work is like I'm having a conversation with myself, so it becomes very encoded. Here I relied more on a colloquial way of saying things. So the black boxes that appear in the top row, in place of the head—the "black box" records flight data in airplanes, it's like a brain holding information. You see and say "black box" and you should go, Oh! Not that that's a complicated idea, but the boxes are so crisp and orchestrated in the way the piece is put together, you might not get to that.

AT: I wonder if subliminally you do, no matter what.

LS: Yes, the box is in the head's place. I can never judge how people read the work, because when I look at art myself I think I sometimes come to things in an idiosyncratic way. So "Scars, Stories, Lies, Fears, Desires, Habits," the words on plaques on the boxes: those are compartments of the brain, or of memory—what makes up a person. There's a belief that we all live holistically and that everything is integrated,

but I don't think that's the way things work, so each of these words represents a certain part of one's experience. And at the same time there's an idea of pulling away from a very black-and-white portrayal of gender. That's what this piece is about.

The piece is very important as a transition point: after it, the figure left the work. It was like, Lorna, this is the last time you can put the figure in your work. This body of work, which I love—there are things that need to be worked out in the work itself to get to another point. I think I approach all the work like that. So after this the curtain came down, the rule applied, and it was against the law in my universe to use the figure. The next piece was *Wigs* [1994], which is again about gender and appearances—about the societal need to compartmentalize, create boundaries, in and around femininity and masculinity.

AT: That's interesting—do you know what prompted the transition?

LS: I felt I'd gotten the work out there a lot and the audience had gotten familiar with how to read it. What I was doing was formulaic, in the sense that I always set up a particular structure. Now, working in film and video, things work more in terms of process. There's a lot of collaboration in film and video, so things are more active—

AT: There's more seeing what happens and then going from there?

LS: Right, it evolves. Photographic work doesn't really function in terms of process, so it was important to change it, just so that I could do other things as an artist—though I did set parameters as to what those would be. In order for me to make that jump, the next move had to be extreme. It wasn't like I decided to make doodles, but I did say, OK, eliminate the figure.

On the other hand, even though the later work may look very different, in terms of subject there are subconscious things I can't control. You look back and realize that they run through the work. Anyway, this untitled piece is important in that it's the link between the older work and *Wigs*, which began this whole new adventure.

AT: This is a personal reading on my part, but for me the piece addresses a moment maybe fifteen years ago when a woman had to look like a man if she was to be taken seriously in the workplace. In that sense the piece strikes me as being not so much about any ambiguity between men and women as about women.

LS: I remember what you're describing, but I think it was more true in the '80s, when I worked in corporate America, than when I made this piece in 1992. In the '80s you did find that emphasis on a masculine appearance: women wore suits with little ties and short collars. After the stock market crash of the late '80s, though, things got distributed a little differently in terms of the ceilings for women, and in terms of women owning businesses. Before the crash, a lot of corporate offices were highly male-dominated environments, but by the '90s that was beginning to change, because people lost their jobs in the crash and things got restructured. Think of Ally McBeal,

for example, a corporate lawyer on TV: that's a '90s character. Nobody really wore miniskirts that stop at your wrist to work, but the '90s were a time of thinking about how to change. This piece was made more in reference to my earlier work, where the woman wore a scoop-necked shift. You're meant to see that she's now wearing a generic corporate outfit, but you're meant to ignore it, too—it's encoded in a way.

AT: How did you first present this piece?

LS: This came from an exhibition of several pieces at the Josh Baer Gallery in New York, and one of those pieces, *Bio* [1992], I saw as a companion piece. They were both about the abstract parts of one's personality and memory, and I hung them side-by-side. *Bio* is more biological, dealing with the way the body creates history; it contains references to Charles Richard Drew, the inventor who developed new methods of preserving blood plasma, and to the blues singer Bessie Smith, who bled to death after a car accident because she wasn't allowed into a hospital for a transfusion. The untitled piece is more about one's own psychological state and the way the body becomes compartmentalized by race. So it's these conflations of history on the body—the experience of the body socially but also within one's head, a more internal view. *Bio* is a huge piece, so when you see the untitled piece installed with it you get a sense of *Bio* as more about the world, contact, and physicality while the untitled piece follows a more intimate, private, internal logic.

LORNA SIMPSON.
Bio. 1992.
Internal dye diffusion transfer process prints and engraved plexiglass plaques, 8' 2" x 13' 6" (248.9 x 411.5 cm). Museum of Contemporary Art, Chicago. Gift of Maremont Corporation by exchange; purchased through funds provided by AT&T New Art/New Visions

AT: Tell me more about Diane, and about the way you worked together.

LS: Diane Allford is a friend of mine, also a photographer. I'd pay her to come and pose for me. The photographs were shot at the Polaroid studio here in Manhattan, probably in one day or two at the most, because I'd go to the studio beforehand to figure out what I wanted to do. Then when Diane was there it would just be a matter of executing it, so it wouldn't take a lot of her time. I framed the photographs and added the text later.

AT: How collaborative were the poses? Did you work them out together or were you really the director?

LS: It was me. But the poses were fairly simple. As we did them, I'd put the shots on the wall and look at them in combination. Then we might improvise the positioning of the body, but basically I worked it out in advance.

AT: You'd rent the Polaroid studio?

LS: Polaroid had studios in Boston and in Manhattan, on Broadway in SoHo, where they had a gigantic camera with a twenty-by-twenty-four-inch plate. There were technicians to help with the lighting and the exposure and handle the camera, and apart from them you'd have the entire studio to yourself. As an artist, you could rent the

studio for a couple of days in a row. They also had a grant program for artists, where you could make photographs for free. I did the grant thing and I also hired the studio.

AT: And you'd walk home with your product.

LS: Basically, yes—actually the surface had to harden if it wasn't to be damaged, so you'd go back a couple of days later once it was dry. But you could pin it up and see it right away. There was a fee for the studio, and then when you got over a certain number of images they'd start counting what you made and there'd be a fee for that. It was great. They had a commercial application as well. People would come to do portraiture, all sorts of things.

AT: Had you used Polaroid right from the beginning of your career?

LS: I mostly used a regular four-by-five-inch camera, but there are early pieces, like *Stereo Styles* [1988], that were done with Polaroid. I mostly used black and white Polaroids, which are really beautiful, luscious, amazing images.

AT: Polaroid wasn't particularly known as an art medium. Was that part of what attracted you to it?

LS: I loved the idea that it was instant. You could just do it and be done, you didn't have to go develop the film and print it. And I liked the visual quality of Polaroid, whether in black and white or color—a lot of my stuff was either monochromatic or very strong color. And because a lot of that work was compartmentalized or sectioned—it has all these different parts—the Polaroid gave me a format to work with compositionally, these twenty-by-twenty-four-inch segments making up a series that in turn makes up a work.

AT: And that would be different with Polaroid because with other film you'd have more choices to make about the format of the print?

LS: Well, it's all photographic to me, it's just that with Polaroid you go to the studio and you prepare for one day of work.

AT: It's compartmentalized in terms of time.

LS: In terms of time and a way of working. I could also very quickly see exactly what I'd got—when I was done with the photography I basically had to figure out the order of the prints, which ones were the good ones, and then it was off to the framers. Because by the time I was at a shoot I knew what the piece was going to look like. So it sped up the process, I wouldn't have to go through all those different steps.

Being instant is a beautiful quality. It lets you see what you're doing, that your exposures are correct and so on, as opposed to working with regular film. I mean, generally you shouldn't be making mistakes with things like that, but it's nice to be able to say, OK, let's move on, rather than, Let's just take another round of shots to be safe. Seeing the shot as you're working with it facilitates ease. I mean, I love photography, but I don't love being that deep in it. I like taking photographs, I like

being able to make images, but I'm not so interested in going to the darkroom and—

AT: Obsessing over the texture of the print and things like that.

LS: I can't do that. I just want to see it, make sure there's enough information, that it looks good and is of a quality that I can use, and then I can move on to the next thing.

AT: To take that one step further, did you ever have someone else take the photograph?

LS: No.

AT: For a work like this one, would there be rejected images?

LS: Yes, there would. With Polaroids you sometimes get chemical streaks and other flaws, or they get bent, or something might happen in mounting and framing them. So sometimes I'd make extras, partly to have something to play with in terms of order and composition, but also in case of damage. I do have "leftovers" that are good.

AT: Besides shooting Diane, you'd shoot the boxes and the shoes on the same day?

LS: All on the same day.

AT: And is that all the same box?

LS: Yes, I think it's a shoe box that I had at home and that I painted black.

AT: And were the shoes your own, or did you buy them specifically for the piece?

LS: I had this obsession—I don't anymore, because how much stuff can you store—but in the '80s there were amazing thrift shops all over the country. Oh my god, even for a seasoned thrift-shopping New Yorker, in the early '80s California was almost untouched. I bought fabulous furniture, and more pottery than I knew what to do with, and shoes. I didn't buy them to wear, I bought them as objects, as examples of fashion. I have a lot of things like that. Last year I did a piece called *Corridor*, the time-frame was the late '50s or early '60s, and I completely outfitted it with things I'd bought in thrift shops a long time ago.

AT: Plaques are common in your work from that period. They are of course generic, but when you think about it, what is generic?

LS: The idea was to make them generic, and very simple, but also things that label and compartmentalize.

AT: Classifying.

LS: Exactly. Categorizing things in a way that isn't necessary.

AT: The difference between the format of the language—the printing of words like "Lies" and "Fears"—and the words themselves is startling. You're classifying things that are unclassifiable.

LS: You can quantify these things, but they're abstract. At the same time, they're

germane to being human.

AT: Where did you buy the plaques?

LS: I'd go to a little engraver—who is no longer there—in Williamsburg. I'd give them the text and they would engrave it for me.

AT: And the plaques were a standard size.

LS: Yes, they're just plexi with plain ink and foam. The shop had a variety you could choose from.

AT: What's the longevity of the Polaroids?

LS: I remember that being a question, but Polaroid dyes are pretty permanent. They should be behind UV glass. With light and heat the color shifts, so not a lot of light or heat. Then if they're not mounted they may buckle—there are things like that at issue.

AT: In a lot of your work, your strategy is to provide blanks to be filled in by the viewer, so the role of the viewer is a loaded one. Do you find yourself imagining your audience?

LS: I guess I take two positions: I imagine myself as the viewer, but I also take into consideration both a historical sense of photography and the viewer's perceptions, or inclinations to read photographic images in a particular way. The blanks and gaps for the viewers to fill in toy with or tug at the viewers' ideas of what they expect to see, or what information they expect to receive. I engage their habits. I don't expect anyone to interpret the work as I do; the idea is experiential—your experience and the way you define yourself, given your own life experience, or given the way you think about things that happen.

AT: The perception of those mechanisms seems to me crucial to your work.

LS: True, I do try to deal with that. I don't take it for granted that you should just be in rapture with the work because of its beauty. I mean, I do think my photographs can be beautiful—I think I've made beautiful works—but that's not the primary emphasis for me. Maybe I give people what they want, or maybe the piece works by annoying them, or works very starkly; those possibilities are devices I can use. I *can* make the piece beautiful or pleasurable, but that's not where I start.

AT: Beauty plays a complicated role in your work. There's a straightforward attraction to the image of the woman, but attraction happens differently with your words, or with the juxtapositions you set up among words and images.

LS: It's playing a nerve.

AT: It's a friction.

LS: I do like photographic imagery. To make something rub the other way takes just as much effort. A photograph is a narrow reproduction of a particular moment in time, and it's something orchestrated for the camera. There's an attraction, a beauty, just

in that. And then the nostalgia—all that Susan Sontag stuff wrapped in there. Even Joel-Peter Witkin and the grotesque, there's complete beauty in that…. There isn't much photographic work that I think functions purely in the opposite direction, that doesn't have a beauty and a seduction. I think it's inherent in the medium that you don't really escape that, regardless of the subject.

AT: I'd be interested to know how much you saw yourself in a tradition of artists when you were making this piece, or if you thought of yourself more as outside art history.

LS: Well, I guess it's hard to go to undergraduate school and then graduate school—

AT: —and be ignorant! But in retrospect what you've done looks like a particular extension of the work of people like Cindy Sherman and Barbara Kruger.

LS: Well, I went to school in the '70s in New York and then in the '80s in California. There was a big distinction between those places back then, particularly in working with photography and the way it was taught. The most interesting courses I took in New York were film courses, which were all about structure. We looked at French New Wave cinema of the '60s, important Latin American underground films of the '50s and '60s—a series of amazing films. I was interested in a historical point of view in looking at film and being able to read it. So a lot of what I brought to photography really came from history courses in film.

Then in California I was at UCSD [University of California, San Diego] in La Jolla, which was a conceptualist haven, mostly performance related. I hadn't had any of that background in New York, so being there opened up a whole other way of looking at artmaking for me. It wasn't as locked down as many graduate schools may be now, when everybody doing photography has to do it in a certain way, and everybody doing video work knows how video work has to look. It was much more open and freeform. Babette Mangolte taught there, and a lot of people like Michael Snow and Jean-Pierre Gorin would come to talk—people who were working experimentally, and whose careers went back to the '60s and continued on in an experimental way. So I didn't feel I had to conform. Also I traveled: I saw exhibitions from San Diego to San Francisco, and then I'd go back to New York as well. So I was well versed in what was going on at the time, yet I didn't feel that I had to lock down to a particular agenda.

AT: That freedom seems less likely today.

LS: That can happen anyway as generations change, but the expectations of what should happen in classrooms and seminars are much more regimented now than when I was at school. Back then you could float, explore things, talk about ideas, about work. Certainly what was great about UCSD was that people talked about the structure of what you were doing. The emphasis wasn't "How well can you articulate ideas about your work? Can you give a spiel about it?" but "What are you trying to accomplish?" And because it was such a small place, the conversation became intimate in a way. You really just said to yourself, What am I doing? And you were left

alone to figure that out.

San Diego was small but segregated. [The African-American artist] Carrie Mae Weems was there at the same time I was and we were always being confused for one another. Carrie is six feet tall, statuesque, and I'm about five foot six…so there was this environment in terms of race. And traveling back and forth from New York, I'd go thrift shopping in Harlem and buy old photographs and all sorts of things that I'd present in film class, and they'd look at me and say, If we include this material in this way, that means the director is black…. That's the power of that imagery. In that respect I really didn't like the nature and level of conversation that was going on, but I just said to myself, I don't need to do this. I mean, what was I going to get from it? I'd have to explain, I'd have to educate. I just felt, I'm here for me. I don't have time to educate everyone about race. So I kept to myself in terms of figuring out what I wanted to do. And even though in that sense it wasn't the best environment, I really cherished my time there.

But you know, San Diego's no different from Yale. And I still get complaints from graduate students today; this continues to happen everywhere. I think the problem is the Western, American/European idea of art in which the universality of the world only extends to people of European descent. So any time a student of color comes in, there's a reading of race, a negation, an idea that people cannot connect as they ordinarily would with the person or work presented to them. But all students have to make that navigation constantly; that's the way you get to be able to read and learn things about other people's work, by putting yourself in that place. The experience doesn't have to be identical, nor does the person have to look like me.

AT: And it's as much an issue today as twenty years ago.

LS: Of course. That has not changed. But the great thing about graduate school is that you have time to make art. You're given a room and a space, and you don't have to work, or maybe you have to work a little bit but you don't have to work as hard as you might otherwise. You get to be self-indulgent and figure out what you want to do—you get to begin a practice, basically, to build your relationship to your work. When I talk to young people about their schooling, and they start to say, "Oh, I don't like the instructor, and…," I say, "You're missing the point."

AT: Did your experience in graduate school affect your decision to make the issue of race perception an explicit part of your work?

LS: No, by the time I reached college my politics were well formed. They came from the environment that my parents created for me. My mother was a secretary who worked for doctors in Lower Manhattan, and my dad was a social worker. They were very politically active and very involved in the arts. I was constantly taken to the theater, to dance performances, to museums.

AT: They had an interest in cultural life that they transferred to you.

LS: Yes, that's what they gave me. They created an artist, really. As a child I'd go to

Chicago to visit my grandmother and I'd take classes at the Art Institute. My parents loved art, they just loved it. They imparted to me the view of the world that I now have. They saw art in terms of its universality: whether it be dance or music or theater, it could be an opportunity to learn. Being creative was really important.

AT: And race wasn't part of it?

LS: We also went to a lot of things, theater projects for instance, that were completely black. I hardly ever felt self-conscious about race. It was more like trying to define your surroundings and be aware of them.

AT: So when you came into a situation like the one at UCSD, encountering assumptions based on ignorance about race, that came as a surprise?

LS: Yes, I thought people were more sophisticated than that. I thought it was ridiculous. I already knew what it meant, and I didn't see myself as having to need to correct it. Because it was a correction that other people needed to make, not me.

AT: It's interesting you should say that, because something that's often said about your work is that you seem to want to change the way things are. You're challenging assumptions about race; anyone willing to look at your work hard may find the imagery tough to take.

LS: But the work doesn't give you a monolithic agenda. There's not a problem and then a solution. I try to make a picture of the way my own mind works, but also to reflect the way people interpret things and then to pick that apart. There's more than one way of interpreting something, and there are different layers to the experience of interpreting something. So it's not so much a question of right and wrong, or of an agenda that needs to be fulfilled, but more the layers that can be pulled back. Your own interpretation and where that leads you are my interest, not, Here's the dilemma, here's the solution. Because I have no solution, basically.

Christopher Wool

ANN TEMKIN: How did you come to use the phrase "FLOAT LIKE BUTTERFLY, STING LIKE BEE" [p. 255]?

CHRISTOPHER WOOL: "Float like a butterfly, sting like a bee" is of course Muhammad Ali's phrase. Initially I had been drawn to text because I wanted to make a work that was a little more direct, a little louder, that talked a little more directly to the audience, than some of my abstract paintings had, and working with found text often seemed suitable. But I wrote a few of the phrases in my paintings.

The found texts I used were mostly less known than this one. The phrase "SELL THE HOUSE, SELL THE CAR, SELL THE KIDS" is from the movie *Apocalypse Now*. I even titled the painting *Apocalypse Now* [1988]. I did a painting with the phrase "CATS IN BAG, BAGS IN RIVER"; that wasn't well-known at all, but it's a line from the movie *Sweet Smell of Success* [1957]. Sidney Falco, the Tony Curtis character, does a dirty job for J. J. Hunsecker, the Burt Lancaster character, and to tell him he's done the job—they're in the 21 Club so they have to talk in code—he says, "The cat's in the bag, the bag's in the river." Clifford Odets wrote the screenplay, and *Harper's Bazaar* did an article recently about that for which they interviewed Tony Curtis, who said, "When I heard that sentence, it went straight to my brain." It was an important line.

AT: But you picked it out without knowing that.

cw: I loved the poetry—it was a poem. Richard Prince once said that the great contemporary haiku was the advertising line "Raid kills bugs dead"—this perfect line. And "Float like a butterfly, sting like a bee" was also a great multivalent line. You could read it in so many ways.

AT: You've said it had been floating around in your head for a long time before you made the painting—it wasn't something you selected on this particular occasion.

cw: No, I'd even used it for the title of another painting. It was in my mind because I'd seen William Klein's documentary on Ali [*Muhammad Ali, the Greatest*, 1974]. The line was actually written not by Ali but by Bundini Brown, his trainer. They were friends

from the beginning of Ali's career. So in the film, Ali's preparing to fight Sonny Liston and he and Brown just chant this back and forth.

AT: And the phrase stuck with you.

CW: I certainly knew it before I saw the film, but maybe that was the moment when I thought of it in terms of a painting. I actually knew the phrase before I knew its lineage; I'd looked it up in Bartlett's and discovered that it was attributed to Bundini Brown. But Ali made it famous, it certainly wouldn't exist without him. That was the great thing about Ali, he could be seen as a poet as well as a boxer. I think Brown made up the line about him as a description of the way he fought: he was fast and he had sting. I like the idea that the image might do what the text said—that a painting could "float like a butterfly, sting like a bee." Both say it and do it.

AT: How did you arrive at the composition?

CW: I'd been making abstract paintings and word paintings at the same time. When I say I'd been making abstract paintings but had a desire to speak more loudly and directly, I don't mean that I wanted to cancel what I'd been doing with the abstract paintings; it wasn't that they were unfulfilling, there was just a frustration with being unable to speak in another way. So I continued to work on the abstract paintings when I was doing the word paintings. Oddly the abstractions from that time and the "FLOAT LIKE BUTTERFLY" painting are much more similar to each other than either of them is to the abstract work I'm doing today.

Back then, for whatever reason, I felt a need to limit the composition and the color. The abstract paintings had an allover composition, and the word paintings did too; but the fact that the word paintings used text meant they had a certain structure already, the sequence of letters was a given. If I were to change the letter sequence for compositional reasons, I'd give myself other problems: I'd end up with different words! So the fact that there was a sequence of letters that started in the upper left and ran left to right allowed me to drop composition. Not completely, but as far I could—as far as I ever have. The width and height of the letters were the only way to change the composition. I'd work those things out in advance, trying many different forms. There's a drawing for this painting that has a different composition and different dimensions. Sometimes I'd feel that changes in composition really affected the quality of the painting; other times they didn't make as big a difference. So I couldn't absolutely *remove* composition, but I went as far as I could in that direction.

Those issues aren't so important to me today. I still have a certain desire to defy composition, but I do it in a different way now; it's not so much about composition per se as about pushing composition away from traditionally modernist practices, from notions of the proper composition, the good composition. I recently

read a Clement Greenberg essay in which he goes on about the corners of a painting, and how a particular painting fell apart in the corners. That was really interesting to me; for me, paintings often have trouble in the corners, it's something I've noticed in my studio. But for Greenberg to say that paintings live and die by what's done in the corners, though—that was a bit shocking.

> AT: In the paintings you made with rollers or stamps in the mid-to-late '80s, were you looking for a way to minimize the role of the artist's creativity?

cw: Yes. In the same way that I was drawn to text that had already been used in a different context, I found it satisfying to use already given patterns and images. They were tools; the paintings weren't really about them. People seem to have misunderstood what I was doing in those paintings; they thought I was deconstructing painting, making a statement about artmaking. Whereas I felt that I was just making paintings, albeit self-conscious ones. As far as I was concerned all those issues had already been dealt with by other artists.

> AT: Yes, but theorizing about art was so prevalent then that it would have been tough to avoid it.

cw: I just wasn't that interested. And the artists I knew weren't so interested either. Yet when I was working in the studio—and some of this I only realized in retrospect—I found myself facing some of the same issues that were being discussed in critical theory. I may have felt a strong desire to take composition out of painting, for example, and to eliminate a modernist kind of decision-making—but not because I was interested in some way in deconstructing artmaking. It wasn't for a conceptual reason. For me Richard Prince was great because he absolutely summed up all these issues in critical theory but there was nothing theoretical about his work.

> AT: I'm suspicious when new art seems to be fulfilling a preconceived idea of what it should be or do.

cw: I think a lot of young artists think that way. I didn't really go to art school, so I didn't have to unlearn a lot of stuff—I just didn't have it in the first place.

> AT: But I've read you studied with Jack Tworkov?

cw: I went to college for a year, when I was just out of high school, and studied with Richard Poussette-Dart. Then I went to art school for a year and studied with Tworkov. But after that there was no school except some film school.

> AT: Were there other important influences?

cw: I was always drawn to the post-Minimalists more than to the Minimalists or the Conceptualists. And I was drawn to Andy Warhol more than to whoever his contemporaries in Conceptual art would have been.

> AT: Who are you calling post-Minimalist—Richard Serra? Bruce Nauman?

cw: Yes, or even someone like Vito Acconci, whom I don't think of as Conceptual per se.

AT: He dealt more with process.

CW: And for me, as a painter, process was crucial.

AT: That's clear. Yet the interesting thing to me is that process is also identified with a quintessential high-modernist idea of painting. The obvious example is Jackson Pollock, and the romanticized part of gestural action painting that many people associate with him. So your interest in process was taking you into the eye of the storm in a way.

CW: But think about Warhol. With his use of silkscreen and other such, his work was concerned with process also, and was certainly not the ideal of high modernism. And I don't think anyone would say Acconci or Nauman represented an ideal of high modernism. Process has always been important to me. When I made the word paintings, even though I almost always worked out the composition in advance, the process was still important. Even showing that process was important; they had to look hand-painted. I first picked up on this in Brice Marden's monochrome paintings.

I think even Warhol allowed the visual residue of the process of making the painting to be an entrance into the picture, something that pulled your eye in. That was harder to see at the time; it's much easier to see now. It's certainly true about Warhol's use of silkscreen. His rap about wanting to be a machine was undermined a little by that.

AT: At first everyone believed it.

CW: If he was a machine, he didn't care about being a very efficient one.

AT: The story of discovering how much process matters, even, say, in a readymade by Marcel Duchamp, is to some degree the story of the increasing understanding of a work of art. Cases where there first seemed to be no care involved, as in a Warhol silkscreen, are now seen to be laden with care.

CW: Yes, exactly, I guess you could equate visualizing the process of making the work with visualizing the actual inspiration for the work itself. Through the late '70s, the garage-band aesthetic pertained in the idea that it really wasn't important how you did something, it was just important what you did. The how-to was irrelevant. Robert Gober had a great influence on me: seeing that his sinks of the mid-'80s were hand-made—and seeing the relationship of the handmade there to, say, Duchamp's ready-mades—was fascinating to me. Even in my earlier works, the handmade was an issue.

AT: But you did think of yourself as a painter all along, except for that quick break into film in the late '70s? Smelly studio, the whole thing?

CW: Yes. I don't think you could make paintings at that time without being aware of the implications of making a painting—I certainly was—but that's different from just deconstructing a painting.

AT: Did your decision to work on aluminum have anything to do with a desire to resist any conventional stereotype of a painter? Or, putting it another way: what role did the aluminum play?

cw: With the text paintings, for reasons both technical and visual, I really wanted and needed a flat, hard surface. It helped them look like signs. The reason aluminum is used in signs is that it helps make them more visual—stronger. But I became a little uncomfortable with aluminum, and with the fact that it wasn't seen the way a traditional medium might be. It worked visually for me, and it worked technically as a material, but I was never that comfortable with its implications. Now I'm working on linen and finding it very workable. I'm much more comfortable with it as a material that painting is commonly identified with. It's funny: the quadruple-primed linen that I use now is primed by machine, so in some ways it's got an even more industrial look than the aluminum did—but an industrially primed canvas doesn't look like a product of industry.

> AT: Right, we're conditioned to think of canvas as an art material. In the text paintings, what kind of black paint did you use?

cw: The black is always the same but there are different white grounds. I was still putting those on myself at that point, spraying acrylic paint. Later I found someone at an auto body shop to do the grounds, and he sprayed Mercedes Benz primer. (Later I found someone who put on a lot of the grounds.) I used Flashe, which is pretty industrial looking, like auto-body paint, although it does look hand-done if you look carefully enough. The black is a sign-painter's paint. It's a super-high-quality paint, with a lot of pigment. I use the same paint still.

> AT: How did you choose your stencils? On the one hand stencils seem generic, but there are many varieties of stencils.

cw: Absolutely. That's an important issue. Again, I didn't think it out in a critical way; stenciling was just the simplest, most direct way of making these paintings. But to make those big letters I had to draw and cut stencils myself. They had to be cut to size, to fit the painting. You can only get stencils in a smaller size than I wanted, so the alternative would have been fitting the painting to the stencils. So I cobbled this stencil type together. I modeled it after store-bought stencils, but I had to make a lot of changes. Certain letters didn't look the way I wanted them to. So I used a standard commercial stencil as a model and cut my own.

> AT: I notice that the "B" is irregular.

cw: The "B" is odd. I wanted to keep everything symmetrical, and the standard "B" stencil didn't work because the top and bottom weren't the same. It just didn't look right. In a sense I restandardized the stencils, because they weren't so standard-the letters were connected in irregular ways.

> AT: Did the store give you many typefaces to choose from?

cw: I wasn't interested in typefaces, I didn't know type from anything. And I wasn't interested in design. The few times I've tried doing billboards they weren't so successful—for me it was a contradiction trying to make art within an industrial-design

or even a design context. It was the same thing with flowers: when I was using flowers, it was assumed that I was interested in them, or that I was interested in pattern and design. But actually I was interested in the *displacement* of pattern, in putting pattern into painting. I wasn't the first to do it. I wasn't the first to put text into art, either, taking it from the real world and putting it into painting; that displacement was part of the work. So making "word painting" into billboards and putting them back into the real world didn't work.

AT: The effect was neutralized. Would you keep the stencils you made as an inventory for new paintings, or were they for one-time use?

cw: I'd occasionally use them again, if I needed the same-size letter. I took care of them. But I don't think there were many paintings for which I reused stencils.

AT: What were the steps in painting the lettering and the ground? Did you finish the ground and then draw on it with the stencils?

cw: Getting the white on was more of a priming issue than a painting issue. And I didn't draw with the stencils, I actually painted through the stencils. That's what gives you that bleed.

AT: Would you lay out the stencils for the whole painting and then paint?

cw: No, I'd do one letter at a time. That way I didn't have to cut as many stencils—I only needed one "T," for example. There was also a technical concern: I couldn't do all of them at once, because the paper border of the stencil for, say, the "U" in the second line would cover the bottom of the "T" in the top line.

AT: You hand-painted the letters with a brush.

cw: Yes. And I did a pencil grid to use as a guide. You can see it in the paintings, although I did it quite lightly.

AT: In a *Village Voice* review [May 31, 1987] Gary Indiana talked about the "glitches" in your paint surface, which I thought was a great word for them. But this painting seems quite clean.

cw: Some of the paintings are more painterly than others, for expressive reasons. I played with that to a certain extent. If I remember right, this was a particularly inexpressionistic painting.

AT: The degree to which you wanted a work to look "painterly" varied?

cw: Yes. Sometimes for a specific reason, other times for no particular reason. It's interesting with the pattern paintings: some of the more expressive ones are relatively more dry and severe. And when I pushed the elements of process and chance, there was always a point where the painting started to be less interesting and less expressive.

AT: The whole idea of painterliness equating to expression is really a fallacy.

CHRISTOPHER WOOL.
Untitled. 1990.
Enamel on aluminum,
9 x 6' (274.3.x 182.9 cm).
The Museum of Modern
Art, New York. Gift
of the Louis and Bessie
Adler Foundation, Inc.

cw: Yes. At that point I was still just trying to figure out how much expression you could pack into something, or else how little—how much expression you could take out.

AT: Well, along that line, you also removed from this quote two uses of the word "a"—"Float like *a* butterfly, sting like *a* bee."

cw: They didn't fit. Boy, those are difficult issues. I did it also with "CATS IN BAG": the text was "*The* cat's in the bag, *the* bag's in the river," but I dropped the "the's." The issue was always a combination of image and structure. Was the image more direct, more interesting, pared down to its essentials? And how did that affect the composition?

When I was working on the text paintings, it was difficult for me to know how they'd read to someone else. Some of them I broke down so they were harder to read, and I'd often have to invite people into the studio and get them to read them to me. Then I could find out whether they were legible or not.

AT: How would you work out the divisions between the words? With paper and pencil?

cw: Yes, I'd grid them up on sheets of paper, over and over. I'd even cut and paste the paper. Some paintings were more difficult; sometimes that process went on for quite a while before I worked it out. Often I'd have texts that I was playing with, but I couldn't figure out a way of making paintings from them. "CATS IN BAG, BAGS IN RIVER" went through all kinds of permutations. With a few paintings I did a couple of versions in different permutations.

AT: You say that the text paintings were simultaneous with the pattern paintings: did that mean that you'd be working on both types of painting in the studio at the same time?

cw: Absolutely, even on the same day. I thought it was interesting to show them together, too. It was important to me to show that they spoke in different ways about similar kinds of things. It was also useful to call attention to their differences.

AT: You've talked about your interest in the audience's reception of your work. Did that have anything to do with your desire to make paintings louder or more direct than the abstract pattern paintings had been?

cw: As an artist, you never really know how and what people are seeing in a work. I didn't have a sense that the audience saw the abstract work as quiet; I just had a feeling that I was speaking quietly somehow. The idea that I wanted to do something louder—that really came from me, not from some idea about the audience. I always try to be aware of audience response, I think it's important, but I basically work in my studio for myself.

AT: The last word paintings you made were finished about ten years ago, if I'm not mistaken.

cw: The last real group was '95 or '96, and I made a couple more in '97. I never decided to stop making word paintings, I just lost interest—I don't at all rule out returning to them. At some point it would be quite natural to do them again.

RICHARD ARTSCHWAGER
American, born 1923

Seated Group. 1962
Charcoal and synthetic
polymer on Celotex
42 x 60" (106.7 x 152.4 cm)
The Museum of Modern
Art, New York. Partial
and promised gift of UBS

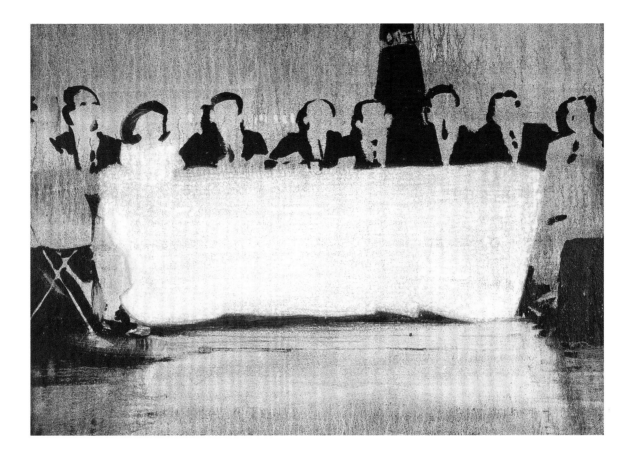

GEORG BASELITZ
German, born 1938

Five Times Titmouse. 1988–89
Oil on canvas
8' 2⅜" x 8' 2⅜" (249.9 x 249.9 cm)
The Museum of Modern Art,
New York. Partial and promised
gift of UBS

JOSEPH BEUYS
German, 1921–1986

Hind. c. 1950
Collage, gold paint, tempera,
watercolor, and brown paper tape on
paper mounted on glass and metal
12¼ x 15½" (31.8 x 39.4 cm)
The UBS Art Collection

Gold Sculpture. 1956
Graphite and gold paint on six
sheets of paper mounted in board
and framed together
30⅞ x 23" (78.4 x 58.4 cm)
The Museum of Modern
Art, New York. Partial
and promised gift of UBS

VIJA CELMINS
American, born Latvia 1938

Drawing Saturn. 1982
Graphite on acrylic ground on paper
14 x 11" (35.6 x 27.9 cm)
The UBS Art Collection

Night Sky #5. 1992
Oil on canvas mounted on wood panel
31 x 37½" (78.7 x 95.3 cm)
The Museum of Modern Art,
New York. Partial and promised
gift of UBS

FRANCESCO CLEMENTE
Italian, born 1951

Perseverance. 1981
Oil on canvas
6' 6" x 7' 9" (198.1 x 236.2 cm)
The Museum of Modern Art,
New York. Partial and promised
gift of UBS

Salvation. 1987
Pigment on linen
6' 4" x 15' 3 ¾" (193 x 466.7 cm)
The UBS Art Collection

144

CHUCK CLOSE
American, born 1940

Large Mark Pastel. 1978
Pastel and watercolor on washed
paper mounted on paper
55¾ x 43¼" (141.6 x 109.9 cm)
The Museum of Modern Art,
New York. Partial and promised
gift of UBS

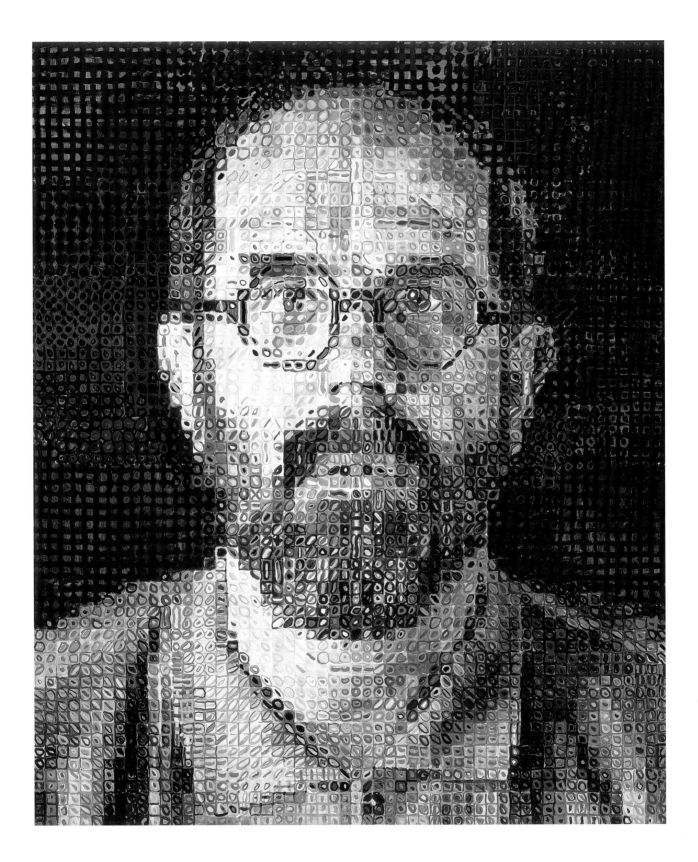

148

Self-Portrait. 1991 [opposite]
Oil on canvas
8' 4" x 7' (254 x 213.4 cm)
The Museum of Modern Art,
New York. Partial and promised
gift of UBS

Self-Portrait. 1995
Pencil, marker, and India ink on paper
60 x 40½" (152.4 x 102.9 cm)
The UBS Art Collection

TONY CRAGG
British, born 1949

Grey Moon. 1985
Gray and white plastic found objects
7' 2⅝" x 52" (220 x 132.1 cm)
The Museum of Modern Art,
New York. Partial and promised
gift of UBS

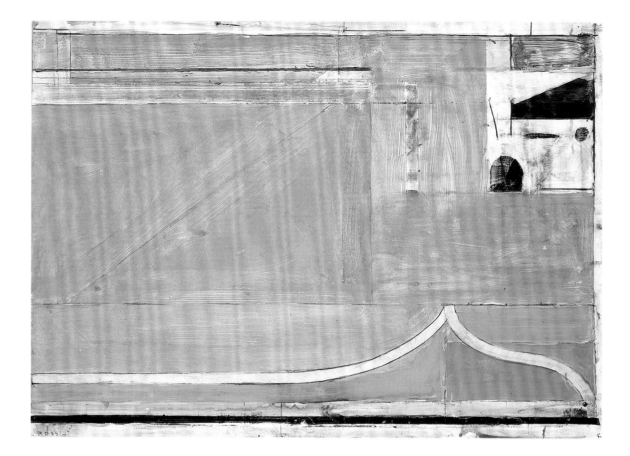

153

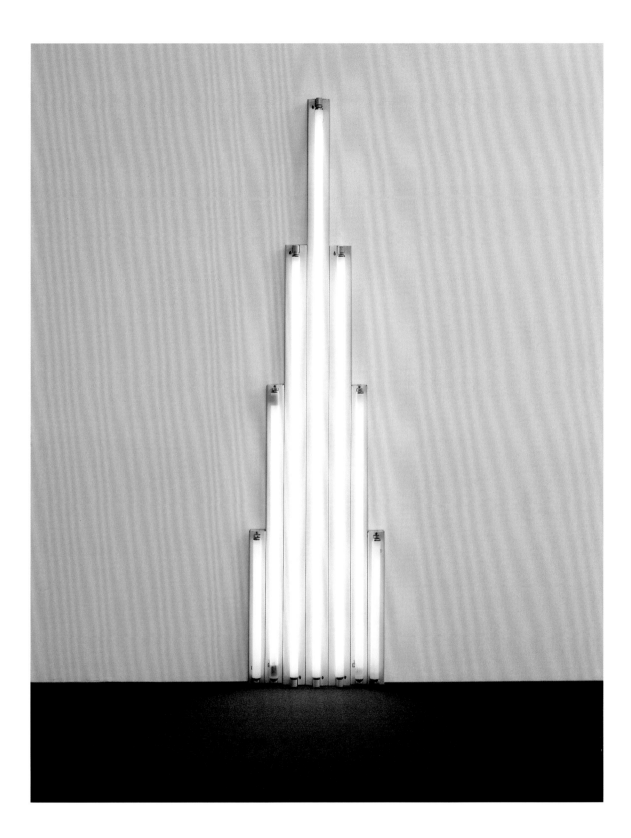

LUCIAN FREUD
British, born Germany 1922

Double Portrait. 1988–90
Oil on canvas
44½ x 53" (113 x 134.6 cm)
The UBS Art Collection

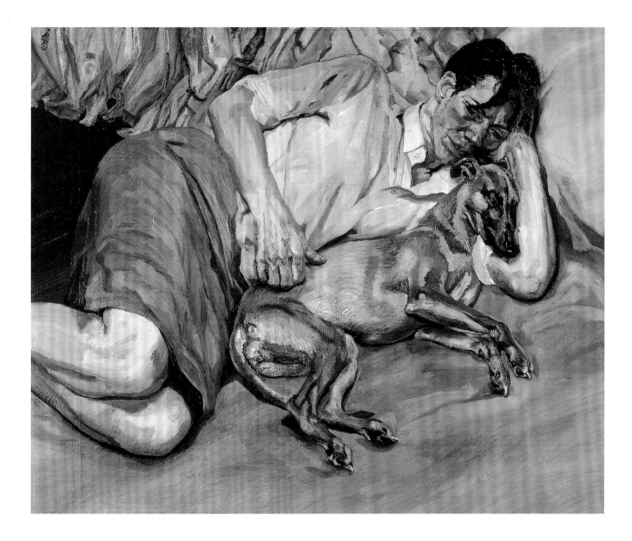

ANDREAS GURSKY
German, born 1955

99 Cent. 1999
Color photograph
6' 9½" x 11' ⅝" (207 x 336 cm)
The UBS Art Collection

PHILIP GUSTON
American, born Canada. 1913–1980

Artist in His Studio. 1969
Charcoal on paper
17¾ x 23⅞" (45.1 x 60.6 cm)
The UBS Art Collection

In the Studio. 1975
Oil on canvas
6' 10" x 6' 7" (208.3 x 200.7 cm)
The Museum of Modern Art,
New York. Partial and promised
gift of UBS

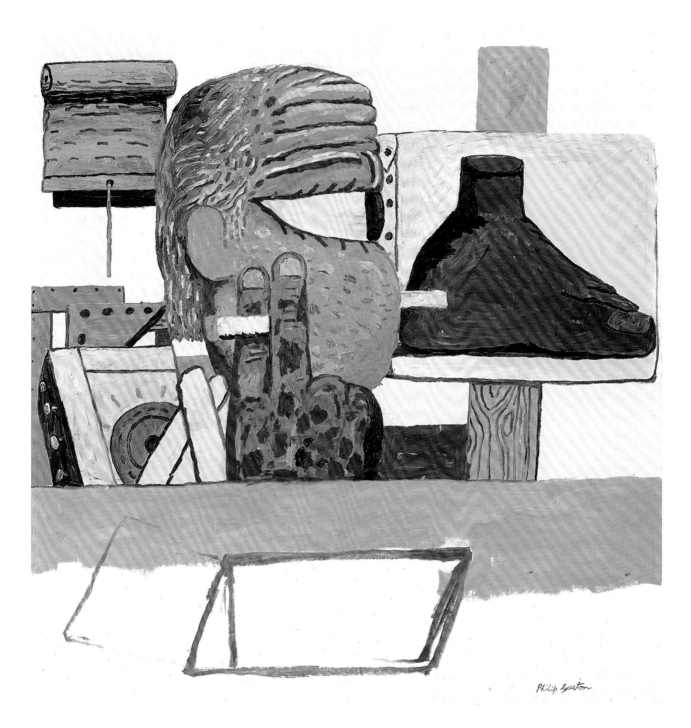

Philip Guston

People Again. 1969
Crayon, gouache, and collage
on photograph
12¼ x 20" (31.1 x 50.8 cm)
The UBS Art Collection

DAMIEN HIRST
British, born 1965

Albumin, Human, Glycated. 1992
Oil-based household gloss
and synthetic polymer on canvas
7' x 9' 8" (213.4 x 294.6 cm)
The UBS Art Collection

*Beautiful Cyclonic Bleeding
Slashing Hurricane
Dippy Cowards Painting.* 1992
Household paint on canvas
7' in diameter
The UBS Art Collection

HOWARD HODGKIN
British, born 1932

In Bed in Venice. 1984–88
Oil on wood in artist's frame
38 ⅝ x 48 ⅞" (98.1 x 124.1 cm)
The UBS Art Collection

SOME DAYS YOU WAKE AND
IMMEDIATELY START TO WORRY.
NOTHING IN PARTICULAR IS WRONG,
IT'S JUST THE SUSPICION THAT
FORCES ARE ALIGNING QUIETLY
AND THERE WILL BE TROUBLE.

BILL JENSEN
American, born 1945

Chord. 1982–83
Oil on linen
24 1/8 x 28 3/16" (61.3 x 71.8 cm)
The UBS Art Collection

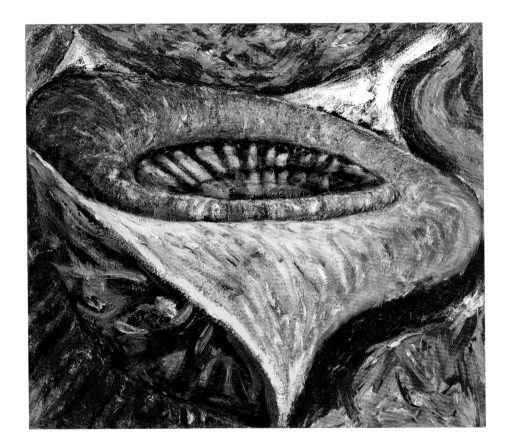

JASPER JOHNS
American, born 1930

Untitled. 1981
Paintstick on tracing paper
21½ x 32⅛" (54.6 x 81.6 cm)
The Museum of Modern
Art, New York. Partial
and promised gift of UBS

Untitled. 1990
Watercolor on paper
38⅝ x 25⅜" (98.1 x 64.5 cm)
The Museum of Modern
Art, New York. Partial
and promised gift of UBS

DONALD JUDD
American, 1928–1994

Untitled. 1967
Lacquer on galvanized iron
5 x 40 x 8¾" (12.7 x 101.6 x 22.2 cm)
The Museum of Modern
Art, New York. Gift of UBS

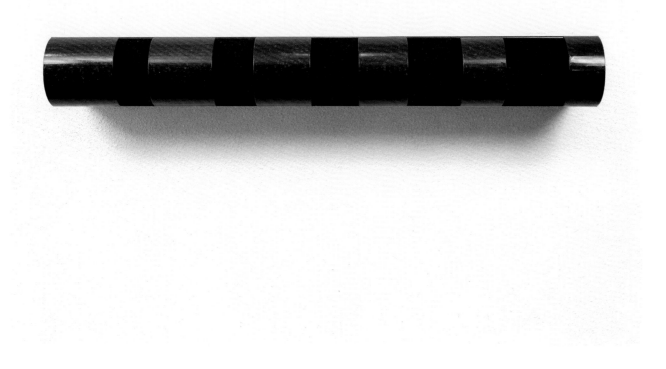

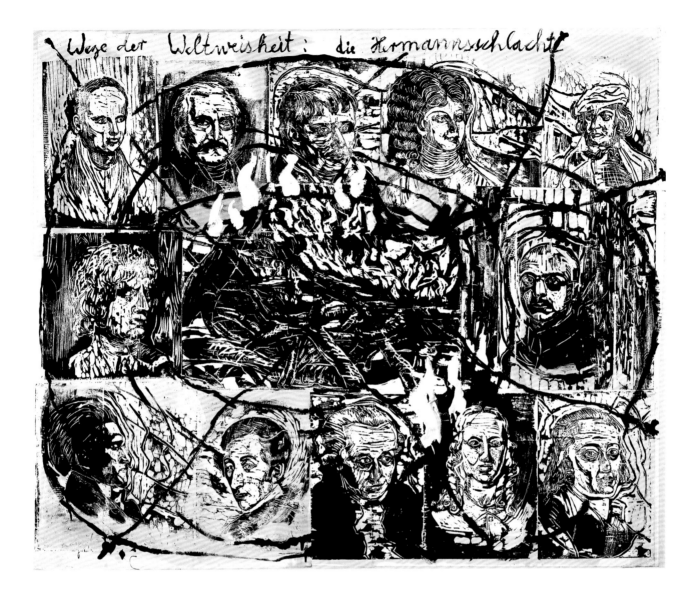

ANSELM KIEFER
German, born 1945

*Ways of Worldly Wisdom:
Arminius's Battle.* 1978
Oil on woodcut on paper mounted
on canvas
6' 5¼" x 7' 10¼" (63.5 x 132.7 cm)
The Museum of Modern Art,
New York. Partial and promised
gift of UBS

To the Unknown Painter. 1982
Watercolor and graphite on paper,
three sheets
25 x 52¼" (63.5 x 132.7 cm)
The Museum of Modern Art,
New York. Partial and promised
gift of UBS

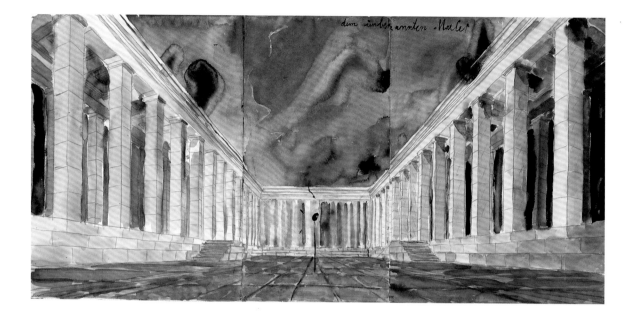

A.D. 1989
Chalk and entrails on treated lead
7' 11⅛" x 51⅞" x 1⅝" (243.1 x
131.8 x 4.2 cm) including steel frame
The Museum of Modern
Art, New York. Gift of UBS

CHRISTOPHER LE BRUN
British, born 1951

Prow. 1983
Oil on canvas
8' 6" x 8' 6" (259.1 x 259.1 cm)
The Museum of Modern Art,
New York. Gift of UBS

ROY LICHTENSTEIN
American, 1923–1997

Crying Girl. 1963
Ink on paper
19½ x 25½" (49.5 x 64.8 cm)
The UBS Art Collection

Mirror #10. 1970
Oil and magna on canvas
24" (61 cm) in diameter
The Museum of Modern Art,
New York. Partial and promised
gift of UBS

Post Visual. 1993
Oil and magna on canvas
8' x 6' 8" (243.8 x 203.2 cm)
The UBS Art Collection

RICHARD LONG
British, born 1945

Untitled. 1987
River Avon mud on paper
44 x 64" (111.8 x 162.6 cm)
The Museum of Modern
Art, New York. Partial
and promised gift of UBS

BRICE MARDEN
American, born 1938

Untitled. 1971
Graphite and wax on paper
22 ⅜ x 30 ½" (56.8 x 77.5 cm)
The Museum of Modern
Art, New York. Partial
and promised gift of UBS

Study II. 1981
Oil and graphite on paper
18 ½ x 39 ½" (47 x 100.3 cm)
The Museum of Modern
Art, New York. Partial
and promised gift of UBS

Chinese Dancing. 1994–96
Oil on canvas
60" x 9' (152.4 x 274.3 cm)
The UBS Art Collection

ROBERT MOSKOWITZ
American, born 1935

Eddystone. 1984
Pastel on paper
9' x 48" (274.3 x 121.9 cm)
The UBS Art Collection

ELIZABETH MURRAY
American, born 1940

Southern California. 1976
Oil on canvas
6' 7⅛" x 6' 3½" (201 x 191.8 cm)
The Museum of Modern
Art, New York. Partial
and promised gift of UBS

BRUCE NAUMAN
American, born 1941

Read/Reap. 1983
Colored chalks, masking tape,
acrylic wash, and paper collage on
paper mounted on canvas
71 x 70 ³⁄₈" (180.3 x 178.8 cm)
The Museum of Modern Art,
New York. Partial and promised
gift of UBS

CLAES OLDENBURG
American, born Sweden 1929

A Sock and 15 Cents (Studies for Store Objects). 1961, dated 1962
Crayon, watercolor, and paper
collage on paper
24 ¾ x 22 ¾" (62.9 x 57.8 cm)
The Museum of Modern
Art, New York. Partial
and promised gift of UBS

*Proposed Colossal Monument
to Replace Nelson Column
in Trafalgar Square—Gearshift
in Motion.* 1966
Crayon, watercolor, and paper
collage on paper
15 ¾ x 22 ¾" (40 x 57.8 cm)
The Museum of Modern
Art, New York. Partial
and promised gift of UBS

gear shift

BLINKY PALERMO
German, 1943–1977

Untitled. 1968
Oil, black chalk, and pencil on canvas
17 ¾ x 37 ½" (50.8 x 61 cm)
The Museum of Modern Art,
New York. Gift of UBS

SIGMAR POLKE
German, born 1941

Untitled. 1985
Dispensing ink and wash
on cardboard
38 ¾ x 29 ¼" (98.4 x 74.3 cm)
The UBS Art Collection

208

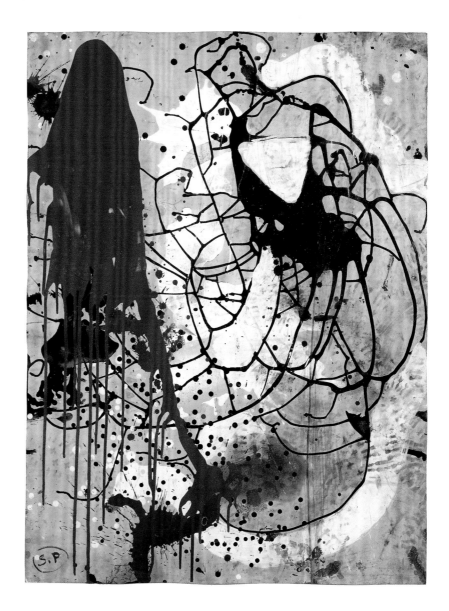

NEO RAUCH
German, born 1960

Wound. 1998
Oil on paper
6' 10¾" x 53" (212.7 x 134.62 cm)
The UBS Art Collection

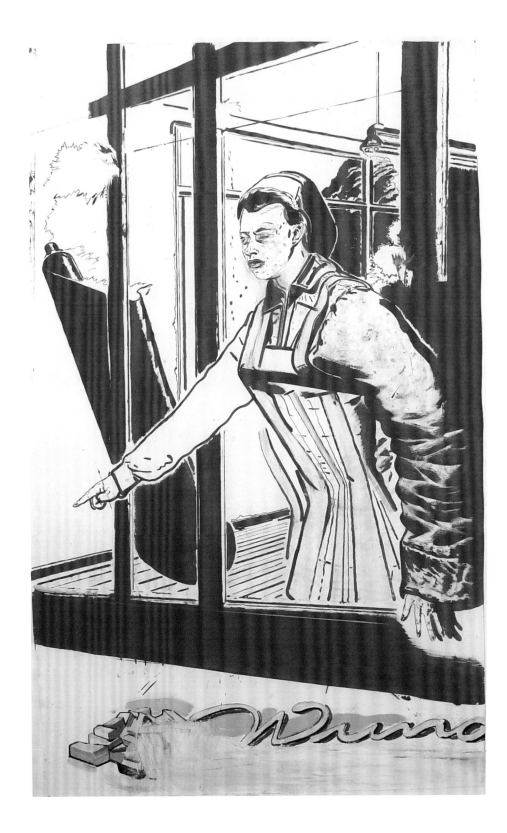

ROBERT RAUSCHENBERG
American, born 1925

Untitled. 1958
Solvent transfer. Watercolor,
gouache, colored pencils, and
graphite on paper
22 ¾ x 29" (57.8 x 73.7 cm)
The UBS Art Collection

GERHARD RICHTER
German, born 1932

Helen. 1963
Oil and graphite on canvas
42 ¾ x 39⅛" (108.6 x 99.4 cm)
The Museum of Modern
Art, New York. Partial
and promised gift of UBS

Confus. 1986
Oil on canvas
8' 6½" x 6' 6¾" (260.4 x 200 cm)
The Museum of Modern
Art, New York. Partial
and promised gift of UBS

214

SUSAN ROTHENBERG
American, born 1945

Biker. 1985
Oil on canvas
6' 2¼" x 69" (188.3 x 175.2 cm)
The Museum of Modern
Art, New York. Gift of UBS.

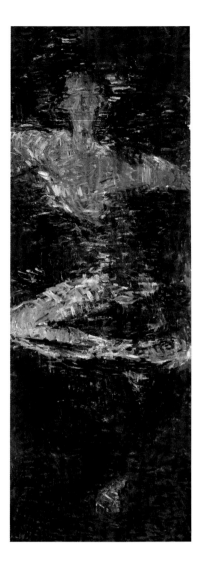

1, 2, 3, 4, 5, 6. 1988
Oil on wood, six panels
Each panel 10' 6¾" x 46⅛"
(321.9 x 117.2 cm)
The Museum of Modern
Art, New York. Partial
and promised gift of UBS

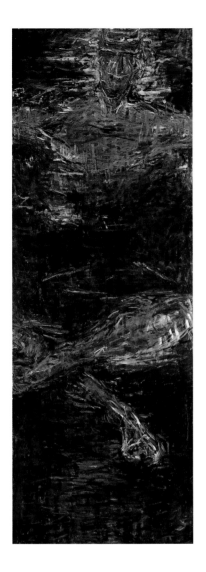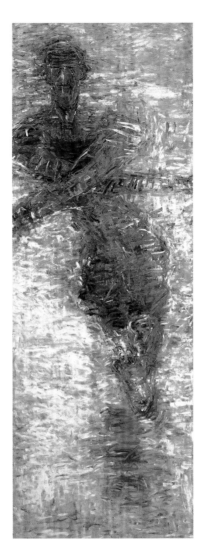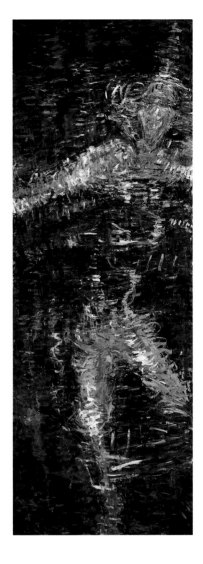

Dogs Killing Rabbit. 1991–92
Oil on canvas
7' 3" x 11' 9" (221 x 358.1 cm)
The Museum of Modern
Art, New York. Partial
and promised gift of UBS

EDWARD RUSCHA
American, born 1937

Museum on Fire. 1968
Graphite on paper
8 x 14 ⅜" (20.3 x 36.5 cm)
The Museum of Modern
Art, New York. Partial
and promised gift of UBS

Vanish. 1972
Oil on linen
20 x 24" (50.8 x 61 cm)
The UBS Art Collection

*Now Then As I Was About
to Say.* 1973
Shellac on moiré rayon
35¾ x 40" (90.8 x 101.6 cm)
The Museum of Modern
Art, New York. Partial
and promised gift of UBS

The End. 1991
Synthetic polymer paint and
graphite on canvas
70" x 9' 4" (177.8 x 284.5 cm)
The Museum of Modern
Art, New York. Partial
and promised gift of UBS

ROBERT RYMAN
American, born 1930

Untitled. 1976
Pastel and graphite on plexiglass
with steel
49 5/8 x 49 5/8" (126.1 x 126.1 cm)
The Museum of Modern
Art, New York. Gift of UBS

DAVID SALLE
American, born 1952

My Subjectivity. 1981
Oil on canvas and household paint
on Masonite in two panels
7' 2" x 9' 4" (218.4 x 284.5 cm)
The UBS Art Collection

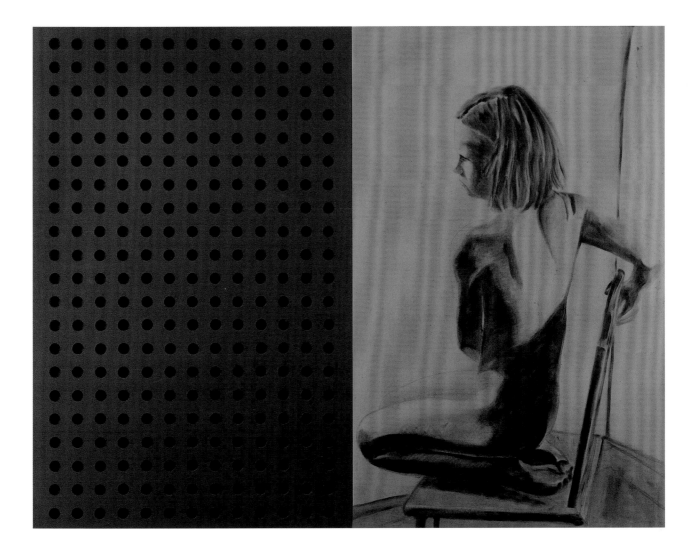

RICHARD SERRA
American, born 1939

No Mandatory Patriotism. 1989
Paintstick on two sheets of paper
7' 9 1/8" x 16' 9 1/8" (236.5 x 510.9 cm)
The Museum of Modern Art,
New York. Partial and promised
gift of UBS

CINDY SHERMAN
American, born 1954

Untitled #122A. 1983
Color photograph
35¼ x 21¼" (89.5 x 54 cm)
The UBS Art Collection

LAURIE SIMMONS
American, born 1949

Walking Camera (Jimmy the Camera). 1987
Color photograph
64 x 48" (162.6 x 121.9 cm)
The UBS Art Collection

LORNA SIMPSON
American, born 1960

Untitled. 1992
Eighteen color instant prints
(Polaroids) and eighteen engraved
plastic plaques
7' 6" x 13' 6" (228.6 x 411.5 cm)
The Museum of Modern Art,
New York. Partial and promised
gift of UBS

238

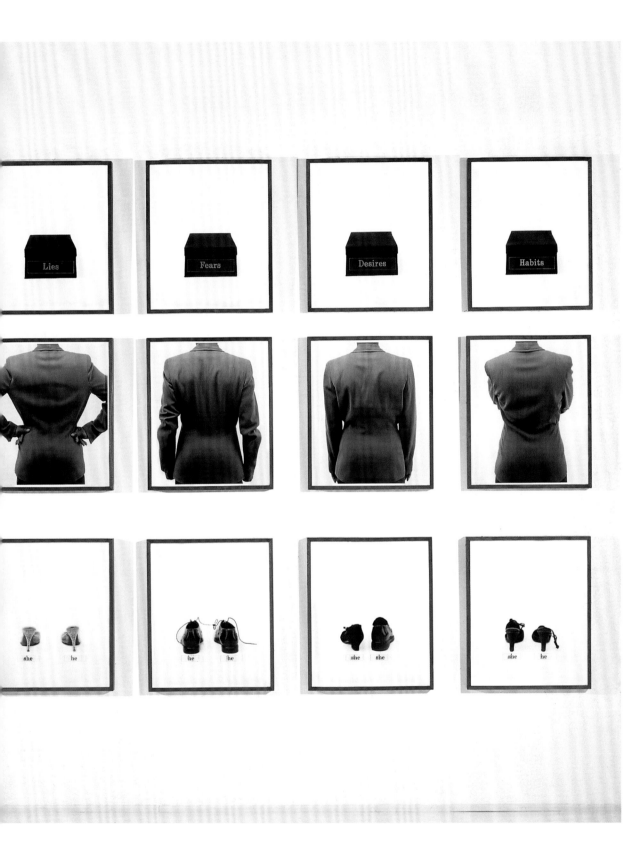

KIKI SMITH
American, born Germany 1954

Identical Twins. 1990
Cast aluminum with metal cords
in four parts
10 x 3⅝ x 2¼" (25.4 x 9.2 x 5.7 cm),
10 x 3¾ x 2½" (25.4 x 9.5 x 6.4 cm),
9 x 4 x 2½" (22.9 x 10.2 x 6.4 cm),
and 10⅝ x 4 x 2¼" (27 x 10.2 x 5.7 cm)
The UBS Art Collection

FRANK STELLA
American, born 1936

The Wheelbarrow (B#3, 2x). 1988
Mixed media on cast aluminum
9' ¼" x 9' 1¾" x 43⅜" (275 x
278.8 x 110.2 cm)
The Museum of Modern Art,
New York. Partial and promised
gift of UBS

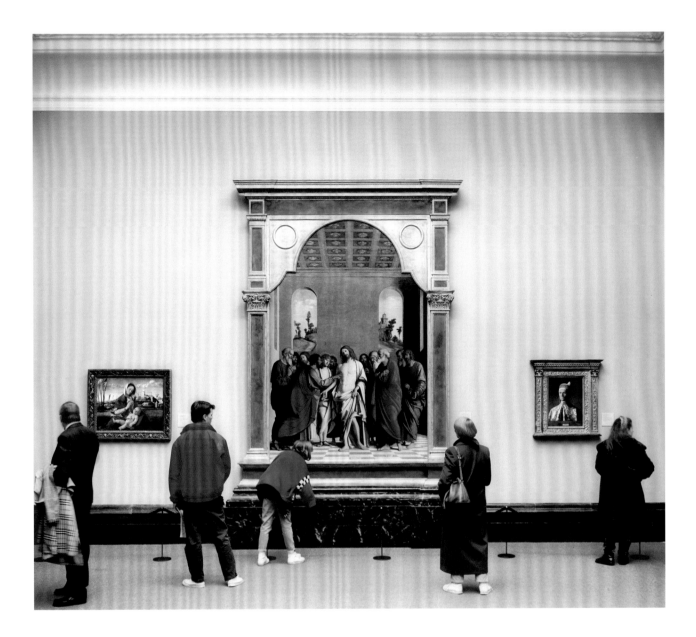

CY TWOMBLY
American, born 1928

Untitled. 1972
Rubber stamp, crayon, graphite,
and ink on paper
61½" x 6' 6½" (69.9 x 100.3 cm)
The Museum of Modern Art,
New York. Partial and promised
gift of UBS

Untitled. 1981
Seven parts, left to right:
pastel on paper, 39½ x 27½" (100.3 x
69.9 cm); tempera on paper, 39½ x
27½" (100.3 x 69.9 cm); tempera on
paper, 39½ x 27½" (100.3 x 69.9 cm);
paintstick, flat paint, crayon, and
tempera on paper, 59½ x 53½" (151.1
x 135.9 cm); paintstick, crayon, and
tempera on paper, 30 x 22¼" (76.2 x

56.5 cm); paintstick on paper, 30 x
22¼" (76.2 x 56.5 cm); graphite on
paper, 30 x 22¼" (76.2 x 56.5 cm)
The UBS Art Collection

TERRY WINTERS
American, born 1949

Conjugation. 1986
Oil on linen
7' 1" x 9' 2" (215.9 x 279.4 cm)
The Museum of Modern
Art, New York. Partial
and promised gift of UBS

CHRISTOPHER WOOL
American, born 1955

Untitled. 1988
Alkyd and Flashe paint on aluminum
7' x 60" (213.4 x 152.4 cm)
The UBS Art Collection

The following selection of texts, primarily published recently and in English, may be of interest to the general reader wishing to learn more about the artists in the exhibition.

RICHARD ARTSCHWAGER

Armstrong, Richard. *Artschwager, Richard.* New York: Whitney Museum of American Art, 1998.

Armstrong, Richard, Linda L. Cathcart, and Suzanne Delehanty. *Richard Artschwager's Theme(s).* Buffalo: Albright-Knox Art Gallery, Philadelphia: Institute of Contemporary Art, and La Jolla: La Jolla Museum of Contemporary Art, 1979.

Artschwager, Richard. *Richard Artschwager: Texts and Interviews.* Ed. Dieter Schwarz. Winterthur: Kunstmuseum Winterthur, 2003.

Clearwater, Bonnie. *Richard Artschwager: "Painting" Then and Now.* North Miami: Museum of Contemporary Art, 2003.

Noever, Peter, ed. *Richard Artschwager: The Hydraulic Door Check.* Cologne: Verlag der Buchhandlung Walther König, 2002.

Richard Artschwager. Gent: Fondation Cartier pour l'Art Contemporain, 1994.

GEORG BASELITZ

Franzke, Andreas. Trans. David Britt. *Georg Baselitz.* Munich: Prestel-Verlag, 1989.

Gretenkort, Detlev. *Georg Baselitz: Paintings, 1962–2001.* Milan: Alberico Cetti Serbelloni Editore, 2002.

Rosenthal, Norman. *Recent Paintings by Georg Baselitz.* London: Anthony d'Offay Gallery, 1990.

Simmel, Georg. *Baselitz.* London: Gagosian Gallery, 2000.

Waldman, Diane. *Georg Baselitz.* New York: Solomon R. Guggenheim Museum, 1995.

JOSEPH BEUYS

Beuys, Eva, Wenzel Beuys, and Jessyka Beuys. *Joseph Beuys: Block Beuys.* Munich: Schirmer/Mosel, 1990.

Borer, Alain. *The Essential Joseph Beuys.* London: Thames & Hudson, 1996.

Rosenthal, Mark. *Joseph Beuys: Actions, Vitrines, Environments.* New Haven: Yale University Press, 2004.

Schnellmann, Jörg. *Joseph Beuys The Multiples. Catalogue Raisonné of the Multiples and Prints.* 8th ed. Cambridge, Mass.: Busch-Reisinger Museum, Minneapolis: Walker Art Center, and Munich and New York: Editions Schellmann, 1997.

Stachelhaus, Heiner. Trans. David Britt. *Joseph Beuys.* New York: Abbeville Press, 1991.

Temkin, Ann, and Bernice Rose. *Thinking Is Form: The Drawings of Joseph Beuys.* Philadelphia: Philadelphia Museum of Art, 1993.

Tisdall, Caroline. *Joseph Beuys.* New York: Solomon R. Guggenheim Museum, 1979.

VIJA CELMINS

Bartman, William S., ed. *Vija Celmins.* New York: A.R.T. Press, 1992.

Lingwood, James. *Vija Celmins: Works 1964–96.* London: Institute of Contemporary Arts, 1996.

Rippner, Samantha. *The Prints of Vija Celmins.* New York: The Metropolitan Museum of Art, 2002.

Tannenbaum, Judith. *Vija Celmins.* Philadelphia: Institute of Contemporary Art, 1992.

Turnbull, Betty, and Susan C. Larsen. *Vija Celmins: A Survey Exhibition.* Los Angeles: Fellows of Contemporary Art and Newport Harbor Art Museum, 1979.

FRANCESCO CLEMENTE

Auping, Michael, Francesco Pellizzi, and Jean-Christophe Ammann. *Francesco Clemente.* New York: Harry N. Abrams, in association with the John and Mable Ringling Museum of Art, Sarasota, 1985.

Dennison, Lisa, ed. *Clemente.* New York: Solomon R. Guggenheim Museum, 1999.

Francis, Mark. *Francesco Clemente: The Fourteen Stations.* London: Whitechapel Art Gallery, 1983.

Percy, Ann, ed. *Francesco Clemente: Three Worlds.* Philadelphia: Philadelphia Museum of Art, 1990.

Rimanelli, David. *Francesco Clemente: Paintings 2000–2003.* New York: Gagosian Gallery, 2003.

Shinoda, Tatsumi, ed. *Francesco Clemente: Two Horizons.* Tokyo: Sezon Museum of Art, 1994.

CHUCK CLOSE

Adrian, Dennis. *Chuck Close.* Chicago: Museum of Contemporary Art, 1972.

Friedman, Martin, and Lisa Lyons. *Close Portraits.* Minneapolis: Walker Art Center, 1980.

Guare, John. *Chuck Close: Life and Work 1988–1995.* London: Thames & Hudson, 1995.

Kesten, Joan, ed. *The Portraits Speak: Chuck Close in Conversation with Twenty-Seven of His Subjects.* New York: A.R.T. Press, 1997.

Lyons, Lisa, and Robert Storr. *Chuck Close.* New York: Rizzoli, 1987.

Pillsbury, Edmund P. *Chuck Close: Works on Paper.* Houston: Contemporary Arts Museum, 1985.

Storr, Robert, Kirk Varnedoe, and Deborah Wye. *Chuck Close.* New York: The Museum of Modern Art, 1998.

Westerbeck, Colin. *Chuck Close.* San Francisco: Friends of Photography, 1989.

TONY CRAGG

Biggs, Lewis, Tony Cragg, Gareth Evans, et al. *A New Thing Breathing: Recent Work by Tony Cragg.* London: Tate Gallery Publications, 2000.

Celant, Germano. *Tony Cragg.* New York: Thames & Hudson, 1996.

Cooke, Lynne. *Tony Cragg.* London: Arts Council of Great Britain and Hayward Gallery, 1987.

Cragg, Tony, and Nicholas Serota. *Tony Cragg: Winner of the 1988 Turner Prize.* London: Tate Gallery & Patrons of New Art, 1989.

Schimmel, Paul. *Tony Cragg: Sculpture 1975–1990.* Newport Beach: Newport Harbor Art Museum, 1990.

RICHARD DIEBENKORN

Buck, Robert T. *Richard Diebenkorn: Paintings and Drawings, 1943–1976.* Buffalo: Albright-Knox Art Gallery, 1976.

Elderfield, John. *The Drawings of Richard Diebenkorn.* New York: The Museum of Modern Art, 1988.

———. *Richard Diebenkorn.* London: Whitechapel Art Gallery, 1991.

Livingston, Jane. *The Art of Richard Diebenkorn.* New York: Whitney Museum of American Art, 1997.

Flam, Jack. *Richard Diebenkorn: Ocean Park.* New York: Rizzoli, 1992.

Newlin, Richard. *Richard Diebenkorn: Works on Paper.* Houston: Houston Fine Arts Press, 1987.

Richard Diebenkorn: Paintings 1948–83. San Francisco: San Francisco Museum of Modern Art, 1983.

DAN FLAVIN

Belloli, Jay. *Dan Flavin: Drawings, Diagrams, and Prints.* Fort Worth: Fort Worth Art Museum, 1976.

Bochner, Mel, Donald Judd, and Brydon Smith. *Dan Flavin: Fluorescent Light, etc.* Ottawa: National Gallery of Canada, 1969.

Flavin, Dan. *Monuments for V. Tatlin from Dan Flavin 1964–82.* Chicago: Donald Young Gallery, 1989.

Govan, Michael. *Dan Flavin.* New York: Dia Center for the Arts, 1998.

Govan, Michael, Brydon Smith, and Tiffany Bell. *Dan Flavin: A Retrospective.* New York: Dia Art Foundation, 2004.

LUCIAN FREUD

Cohen, David. *Lucian Freud: Etchings from the Paine Webber Art Collection.* New Haven:

Yale Center for British Art, 1999.

Feaver, William, ed. *Lucian Freud*. London and New York: Tate Gallery Publications, 2002.

Gowing, Lawrence. *Lucian Freud*. London: Thames & Hudson, 1982.

Hughes, Robert. *Lucian Freud, Paintings*. London: British Council, 1987.

Lampert, Catherine. *Lucian Freud: Recent Work*. London: Whitechapel Art Gallery, 1993.

Russell, John. *Lucian Freud*. London: Arts Council of Great Britain, 1974.

ANDREAS GURSKY

Andreas Gursky. Houston: Contemporary Arts Museum, 1998.

Bradley, Fiona, ed. *Andreas Gursky, Images*. London: Tate Gallery Publications, 1995.

Felix, Zdenek. *Andreas Gursky: Photographs 1984–1993*. Munich: Schirmer, 1994.

Galassi, Peter. *Andreas Gursky*. New York: The Museum of Modern Art, 2001.

Gronert, Stefan, Diedrich Diederichsen, and Ralph Rugoff. *Great Illusions: Thomas Demand, Andreas Gursky, Edward Ruscha*. Bonn: Kunstmuseum, and North Miami: Museum of Contemporary Art, 1999.

Syring, Marie Luise. *Andreas Gursky: Photographs from 1984 to the Present*. Munich: Schirmer/Mosel, 1998.

PHILIP GUSTON

Arnason, H. H., ed. *Philip Guston*. New York: Solomon R. Guggenheim Museum, 1962.

Ashton, Dore. *Yes, but … A Critical Study of Philip Guston*. New York: Viking Press, 1976.

Auping, Michael. *Philip Guston Retrospective*. Fort Worth: Modern Art Museum of Fort Worth, 2003.

Dabrowski, Magdalena, ed. *The Drawings of Philip Guston*. New York: The Museum of Modern Art, 1988.

Feldman, Morton. *Philip Guston, 1980: The Last Works*. Washington, D.C.: The Phillips Collection, 1981.

Storr, Robert. *Philip Guston*. New York: Abbeville Press, 1986.

RICHARD HAMILTON

Field, Richard S. *The Prints of Richard Hamilton*. Middletown, Conn.: Davison Art Center, Wesleyan University, 1973.

Hamilton, Richard. *Collected Words*. London and Stuttgart: Edition Hansjörg Mayer, 1982.

Lullin, Etienne, ed. *Richard Hamilton: Prints and Multiples, 1939–2002. Catalogue Raisonné*. Winterthur: Kunstmuseum Winterthur, and Düsseldorf: Richter Verlag, 2003.

Morphet, Richard, ed. *Richard Hamilton*. London: Tate Gallery Publications, 1992.

Russell, John, ed. *Richard Hamilton*. New York: Solomon R. Guggenheim Museum, 1973.

Schwarz, Dieter. *Richard Hamilton: Exteriors, Interiors, Objects, People*. Stuttgart: Edition Hansjörg Mayer, 1990.

DAMIEN HIRST

Adams, Brooks. *Sensation: Young British Artists from the Saatchi Collection*.

London: Thames & Hudson, in association with the Royal Academy of Arts, 1997.

Burn, Gordon, and Damien Hirst. *On the Way to Work*. London: Faber, 2001.

Hirst, Damien. *Damien Hirst*. London: Institute of Contemporary Arts, 1991.

———. *Damien Hirst: Pictures from the Saatchi Gallery*. London: Booth-Clibborn, 2001.

Morgan, Stuart. *No Sense of Absolute Corruption*. New York: Gagosian Gallery, 1996.

Shone, Richard. *Damien Hirst*. London: British Council, 1992.

HOWARD HODGKIN

Anfam, David. *Howard Hodgkin: Hodgkin's Lyrics. Painting the 'Spots of Time'*. New York: Gagosian Gallery, 2003.

Auping, Michael, and John Elderfield. *Howard Hodgkin: Paintings*. New York: Harry N. Abrams, in association with the Modern Art Museum of Fort Worth, 1995.

Morphet, Richard. *Howard Hodgkin: Forty-five Paintings 1949–1975*. London: Arts Council of Great Britain, 1976.

Serota, Nicholas, and Howard Hodgkin. *Forty Paintings: 1973–84*. London: Whitechapel Art Gallery, 1984.

JENNY HOLZER

Herbert, Lynn M., ed. *Jenny Holzer, Lustmord*. Houston: Contemporary Arts Museum, 1997.

Holzer, Jenny. *Jenny Holzer: Writing*. Ostfildern-Ruitz: Cantz Verlag, 1996.

Joselit, David. *Jenny Holzer*. New York:

Phaidon, 1998.

Schjeldahl, Peter, Beatrix Ruf, and Joan Simon. *Jenny Holzer: Xenon*. Küsnacht: Ink Tree Editions, 2001.

Waldman, Diane. *Jenny Holzer*. New York: Solomon R. Guggenheim Museum, 1989.

BILL JENSEN

Rathbone, Eliza. *Bill Jensen*. Washington, D.C.: The Phillips Collection, 1987.

Wye, Deborah. *Bill Jensen: First Etchings*. New York: The Museum of Modern Art, 1986.

JASPER JOHNS

Bernstein, Roberta. *Jasper Johns*. New York: Rizzoli, 1992.

Crichton, Michael. *Jasper Johns*. New York: Whitney Museum of American Art, 1994.

Francis, Richard. *Jasper Johns*. New York: Abbeville Press, 1984.

Johns, Jasper. *Jasper Johns: Writings, Sketchbook Notes, Interviews*. Ed. Kirk Varnedoe. New York: The Museum of Modern Art, 1996.

Rosenthal, Nan, and Ruth E. Fine. *The Drawings of Jasper Johns*. Washington, D.C.: National Gallery of Art, 1990.

Varnedoe, Kirk. *Jasper Johns: A Retrospective*. New York: The Museum of Modern Art, 1996.

DONALD JUDD

Agee, William C., ed. *Don Judd*. New York: Publishers Printing-Admiral Press, 1968.

Fuchs, Rudolf Herman, ed. *Donald Judd*. Eindhoven: Stedelijk van Abbemuseum, 1987.

Haskell, Barbara. *Donald*

Judd. New York: Whitney Museum of American Art, 1988.

Judd, Donald. *Complete Writings 1975–1986*. Eindhoven: Eindhoven van Abbemuseum, 1987.

Meyer, Franz, and Jochen Poetter. *Donald Judd*. Baden-Baden: Staatliche Kunsthalle, 1989.

Osaki, Sachiko, Gen Umezu, and Marianne Stockebrand. *Donald Judd, Selected Works, 1960–1991*. Saitama: Museum of Modern Art, and Shiga: Museum of Modern Art, 1999.

Serota, Nicholas, ed. *Donald Judd*. London: Tate Gallery Publications, 2004.

ANSELM KIEFER

Arasse, Daniel. *Anselm Kiefer*. New York: Harry N. Abrams, 2001.

Cacciari, Massimo, and Germano Celant. *Anselm Kiefer*. Milan: Edizioni Charta, 1997.

Rosenthal, Mark. *Anselm Kiefer*. Philadelphia: Philadelphia Museum of Art, 1987.

Rosenthal, Nan. *Anselm Kiefer: Works on Paper in The Metropolitan Museum of Art*. New York: The Metropolitan Museum of Art, 1998.

WILLEM DE KOONING

Cummings, Paul. *Willem de Kooning: Drawings, Paintings, Sculpture, New York, Berlin, Paris*. New York: Whitney Museum of American Art, 1983.

Hess, Thomas B., ed. *Willem de Kooning*. New York: The Museum of Modern Art, 1968.

Garrels, Gary, and Robert Storr. *Willem de Kooning: The Late Paintings, the 1980s*. San Francisco:

San Francisco Museum of Modern Art, 1995.

Gaugh, Harry F. *Willem de Kooning.* New York: Abbeville Press, 1983.

Lieber, Edward. *Willem de Kooning: Reflections in the Studio.* New York: Harry N. Abrams, 2000.

Prather, Marla. *Willem de Kooning: Paintings.* Washington: National Gallery of Art, 1994.

Rosenberg, Harold. *De Kooning.* New York: Harry N. Abrams, 1974.

GUILLERMO KUITCA

Becce, Sonia, and Paulo Herkenhoff. *Guillermo Kuitca: Obras 1982/2002.* Madrid: Museo Nacional Centro de Arte Reina Sofia, 2003.

Cooke, Lynne. *Guillermo Kuitca, Burning Beds: A Survey.* Amsterdam: Contemporary Arts Foundation, 1994.

Pacheco, Marcelo, Martin Rejtman, and Jerry Saltz. *A Book Based on Guillermo Kuitca.* Amsterdam: Contemporary Art Foundation, 1993.

Saltz, Jerry. *Guillermo Kuitca.* Milan: Galleria Cardi & Co., 2002.

CHRISTOPHER LE BRUN

Bann, Stephen. *Christopher Le Brun: Paintings 1984–85.* Edinburgh: Fruitmarket Gallery, 1985.

Lynton, Norbert, Bryan Robertson, and Charles Saumarez Smith. *Christopher Le Brun.* London: Booth-Clibborn Editions, 2001.

Lynton, Norbert. *Recent Work: Christopher Le Brun.* London: Marlborough Fine Art, 1998.

Robertson, Bryan. *Christopher Le Brun:*

Paintings 1991–1994. London: Marlborough Fine Art, 1994.

ROY LICHTENSTEIN

Clearwater, Bonnie. *Roy Lichtenstein: Inside/Outside.* North Miami: Museum of Contemporary Art, 2001.

Cowart, Jack. *Roy Lichtenstein.* Basel: Fondation Beyeler, 1998.

Lichtenstein, Dorothy, Leo Castelli, et al. *Roy Lichtenstein: Interiors.* New York: Hudson Hills Press, in association with the Museum of Contemporary Art, Chicago, 1999.

Rose, Bernice. *The Drawings of Roy Lichtenstein.* New York: The Museum of Modern Art, 1987.

Sylvester, David, and Avis Berman. *Roy Lichtenstein: All about Art.* San Francisco: San Francisco Museum of Modern Art, 2004.

Waldman, Diane. *Roy Lichtenstein.* New York: Solomon R. Guggenheim Museum, 1993.

Waldman, Diane, ed. *Roy Lichtenstein, Drawings and Prints.* New York: Chelsea House Publishers, 1969.

RICHARD LONG

Codognato, Mario, and Maria Grazia Tolomeo, eds. *Richard Long.* Rome: Fatonigrafica, Elemond Editori Associati, 1994.

Friis-Hansen, Dana. *Richard Long: Circles, Cycles, Mud, Stones.* Houston: Contemporary Arts Museum, 1996.

Giezen, Martina. *Richard Long on Conversation, Bristol 19.11.1985.* Noordwijk, the Netherlands: MW Press Box, 1985.

Moure, Gloria, ed. *Richard Long: Spanish Stones.* Barcelona: Ediciones Polígrafa, 1998.

Perdriolle, Herve, ed. *Dialog: Richard Long, Jivya Soma Mashe.* Cologne: Verlag der Buchhandlung Walther König, 2003.

Seymour, Anne. *Richard Long: Walking in Circles.* London: South Bank Centre, 1991.

BRICE MARDEN

Codognato, Mario. *Brice Marden: Works on Paper 1964–2001.* London: Trolley Ltd., 2002.

Corrin, Lisa G. *Brice Marden.* London: Serpentine Gallery, 2000.

Kertess, Klaus, and David Whitney. *Brice Marden, Paintings and Drawings.* New York: Harry N. Abrams, 1992.

Lee, Janie C., ed. *Brice Marden Drawings: The Whitney Museum of American Art Collection.* New York: Whitney Museum of American Art, 1998.

Serota, Nicholas. *Brice Marden: Paintings, Drawings, and Prints, 1975–80.* Amsterdam: Stedelijk Museum, 1981.

Wylie, Charles. *Brice Marden. Work of the 1990s: Paintings, Drawings, and Prints.* Dallas: Dallas Museum of Art, 1998.

SARAH MORRIS

Bourriaud, Nicolas. *Sarah Morris: Sugar.* Paris: Galerie Philippe Rizzo, 1996.

Bracewell, Michael, and Jan Winkelmann. *Sarah Morris: Modern Worlds.* Oxford: Museum of Modern Art, 1999.

Burgi, Bernhard. *Sarah Morris: 7/6–13/8/2000, Kunsthalle Zurich.* Zurich: Kunsthalle Zurich, 2000.

Jones, Ronald, ed. *Capital.* Cologne: Oktagon, 2001.

ROBERT MOSKOWITZ

Ammann, Jean-Christophe, and Margrit Suter. *Robert Moskowitz.* Basel: Basler Kunstverein, 1981.

Kline, Katy. *Robert Moskowitz: Paintings and Drawings.* New York: Blum Helman Gallery, 1986.

Rifkin, Ned. *Robert Moskowitz: A Retrospective, 1959–1989.* Washington, D.C.: Hirshhorn Museum, Smithsonian Institution, 1989.

ELIZABETH MURRAY

Graze, Sue, and Kathy Halbreich, eds. *Elizabeth Murray: Paintings and Drawings.* Dallas: Dallas Museum of Art, 1987.

King, Elaine A., ed. *Elizabeth Murray: Drawings 1980–86.* Pittsburgh: Carnegie Mellon University Press, 1986.

Prose, Francine. *Elizabeth Murray: Paintings 1999–2003.* New York: PaceWildenstein, 2003.

Storr, Robert. *Elizabeth Murray.* Tokyo: Gallery Mukai, 1990.

BRUCE NAUMAN

Benezra, Neil, Kathy Halbreich, et al. *Bruce Nauman.* Ed. Joan Simon. Minneapolis: Walker Art Center, 1994.

Bruggen, Coosje van. *Bruce Nauman.* New York: Rizzoli, 1988.

Hilty, Greg, and Marisa Culatto, eds. *Bruce Nauman.* London:

Hayward Gallery, 1997–1998.

Koepplin, Dieter, Coosje van Bruggen, and Franz Meyer. *Bruce Nauman: Drawings 1965–1986.* Basel: Kunstmuseum Basel, 1986.

Kraynak, Janet, ed. *Please Pay Attention Please. Bruce Nauman's Words: Writings and Interviews.* Cambridge, Mass.: The MIT Press, 2003.

Morgan, Robert C. *Bruce Nauman.* Baltimore: Johns Hopkins University Press, 2002.

Simon, Joan, and Nicholas Serota. *Bruce Nauman.* London: Whitechapel Art Gallery, 1986.

Storr, Robert. *Neons Sculptures Drawings.* New York: Van de Weghe Fine Art, 2002.

CLAES OLDENBURG

Baro, Gene. *Claes Oldenburg: Drawings and Prints.* New Jersey: Well eet Press, 1988.

Celant, Germano, Marla Prather, Mark Rosenthal, et al. *Claes Oldenburg: An Anthology.* New York: Solomon R. Guggenheim Museum, 1995.

Celant, Germano, ed. *A Bottle of Notes and Some Voyages: Claes Oldenburg, Coosje van Bruggen.* Sunderland: Northern Centre for Contemporary Art, and Leeds; Henry Moore Centre for the Study of Sculpture, 1988.

Haskell, Barbara. *Claes Oldenburg: Object into Monument.* Los Angeles: Ward Ritchie Press, 1971.

Lee, Janie C., ed. *Claes Oldenburg Drawings in the Whitney Museum of American Art.* New York: Whitney Museum of American Art, 2002.

Rose, Barbara. *Claes Oldenburg*. New York: The Museum of Modern Art, 1970.

BLINKY PALERMO

Blinky Palermo. New York: Dia Art Foundation, 1987.

Palermo, Oeuvres, 1963–1977. Trans. Eliane Kaufholz. Paris: Centre Georges Pompidou, 1985.

Moure, Gloria, ed. *Blinky Palermo*. Barcelona: Museo d'Art Contemporani de Barcelona, 2002.

Werner, Klaus. *Blinky Palermo*. Stuttgart: Edition Cantz, 1993.

SIGMAR POLKE

Caldwell, John, ed. *Sigmar Polke*. San Francisco: San Francisco Museum of Modern Art, 1990.

Hentschel, Martin, ed. *Sigmar Polke: The Three Lies of Painting*. Ostfildern-Ruitz: Cantz Verlag, 1997.

Lane, John, and Charles Wylie. *Sigmar Polke: History of Everything. Paintings and Drawings, 1998–2003*. Dallas: Dallas Museum of Art, and New Haven: Yale University Press, 2003.

McEvilley, Thomas, Judith Nesbitt, and Sean Rainbird. *Sigmar Polke: Join the Dots*. London: Tate Gallery Publications, 1995.

Rowell, Margit, ed. *Sigmar Polke: Works on Paper, 1963–1974*. New York: The Museum of Modern Art, 1999.

NEO RAUCH

Cantz, Hatje, ed. *Neo Rauch*. Maastricht: Bonnefantenmuseum, 2002.

Maren Roloff & Neo Rauch. New York: Goethe House, 1995.

Neo Rauch: Arbeiten auf Papier 2003–2004. Ostfildern-Ruitz: Hatje Cantz, 2002.

Seemann, E. A. *Neo Rauch*. Leipzig: Museum der Bildenden Künste, 1997.

Wagner, Thomas, Bernhart Schwenk, and Harald Kunde. *Neo Rauch: Randgebiet*. Leipzig: Galerie für Zeitgenössische Kunst, 2000.

ROBERT RAUSCHENBERG

Alloway, Lawrence, ed. *Robert Rauschenberg*. Washington, D.C.: National Collection of Fine Arts and Smithsonian Institution, 1977.

Hopps, Walter. *Robert Rauschenberg: The Early 1950s*. Houston: Menil Collection and Houston Fine Arts Press, 1991.

Hopps, Walter, and Susan Davidson, eds. *Robert Rauschenberg: A Retrospective*. New York: Solomon R. Guggenheim Museum, 1977.

Joseph, Branden W., ed. *Robert Rauschenberg*. Cambridge, Mass.: The MIT Press, 2002.

Mattison, Robert S. *Robert Rauschenberg: Breaking Boundaries*. New Haven: Yale University Press, 2003.

GERHARD RICHTER

Obrist, Hans-Ulrich. *Gerhard Richter: 100 Pictures*. Ostfildern-Ruitz: Cantz Verlag, 1996.

Rainbird, Sean, and Gerhard Richter. *Gerhard Richter*. London: Tate Gallery, 1991.

Richter, Gerhard. *The Daily Practice of Painting: Writings and Interviews 1962–1993*. Ed. Hans-Ulrich Obrist. Trans. David Britt. Cambridge, Mass.: The MIT Press, 1995.

Schwarz, Dieter. *Gerhard Richter: Drawings 1964–1999. Catalogue Raisonné*. Düsseldorf: Kunstmuseum Winterthur, 1999.

Storr, Robert. *Gerhard Richter: Forty Years of Painting*. New York: The Museum of Modern Art, 2002.

———. *Gerhard Richter: October 18, 1977*. New York: The Museum of Modern Art, 2000.

SUSAN ROTHENBERG

Auping, Michael. *Susan Rothenberg: Paintings and Drawings*. New York and Buffalo: Albright-Knox Art Gallery, 1992.

———. *The Paintings of Susan Rothenberg*. Monterrey: Museo de Arte Contemporáneo de Monterrey, 1997.

Bruvtan, Cheryl A. *Susan Rothenberg: Paintings from the Nineties*. Boston: Museum of Fine Arts, 1999.

Maxwell, Rachel Robertson. *Susan Rothenberg, The Prints: A Catalogue Raisonné*. Philadelphia: P. Maxwell, 1987.

Rathbone, Eliza E. *Susan Rothenberg*. Washington, D.C.: The Phillips Collection, 1985.

Simon, Joan. *Susan Rothenberg*. New York: Harry N. Abrams, 1991.

EDWARD RUSCHA

Benezra, Neil, and Kerry Brougher. *Ed Ruscha*. Washington, D.C.: Hirshhorn Museum and Sculpture Garden, Smithsonian Institution, 2000.

Livet, Anne, ed. *The Works of Edward Ruscha*. New York: Hudson Hills Press, in association with the San Francisco Museum of Modern Art, 1982.

Marshall, Richard C. *Ed Ruscha*. London and New York: Phaidon, 2003.

Poncy, Pat, ed. *Catalogue Raisonné of the Paintings, Volume I*. New York: Gagosian Gallery, 2003.

Rowell, Margit. *Cotton Puffs, Q-Tips, Smoke and Mirrors: The Drawings of Edward Ruscha*. New York: Whitney Museum of American Art, 2004.

Ruscha, Ed. *Leave Any Information at the Signal: Writings, Interviews, Bits, Pages*. Ed. Alexandra Schwartz. Cambridge, Mass.: The MIT Press, 2002.

Wolf, Sylvia. *Ed Ruscha and Photography*. New York: Whitney Museum of American Art, 2004.

ROBERT RYMAN

Bois, Yve-Alain. *Robert Ryman, New Paintings*. New York: PaceWildenstein, 2002.

Garrels, Gary. *Robert Ryman*. New York: Dia Art Foundation, 1988.

Spector, Naomi. *Robert Ryman*. London: Whitechapel Art Gallery, 1977.

Spector, Naomi, ed. *Robert Ryman*. Amsterdam: Stedelijk Museum, 1974.

Storr, Robert. *Robert Ryman*. London: Tate Gallery, and New York: The Museum of Modern Art, 1993.

Waldman, Diane. *Robert Ryman: Exhibition of Works*. New York: Solomon R. Guggenheim Museum, 1972.

DAVID SALLE

French, Sarah, and Wayne Koestenbaum. *David Salle: Immediate Experience*. Milan: Gabrius S.p.A., 2002.

Kardon, Janet, and Lisa Phillips. *David Salle*. Philadelphia: Institute of Contemporary Art, University of Pennsylvania, 1986.

Mignot, Dorine, and David Salle. *David Salle: 20 Years of Painting*. Gent: Ludion, 1999.

Pandiscio, Richard, David Whitney, and Lisa Liebmann. *David Salle*. New York: Rizzoli, 1994.

Schjeldahl, Peter, and David Salle. *Salle*. New York: Vintage Books, 1987.

RICHARD SERRA

Ferguson, Russell, Anthony McCall, and Clara Weyergraff-Serra. *Richard Serra: Sculpture 1985–1998*. Los Angeles: Museum of Contemporary Art, 1999.

Foster, Hal, and Gordon Hughes, eds. *Richard Serra*. Cambridge, Mass.: The MIT Press, 2000.

Krauss, Rosalind. *Richard Serra/Sculpture*. Ed. Laura Rosenstock. New York: The Museum of Modern Art, 1986.

Serota, Nicholas, and David Sylvester. *Richard Serra: Weight and Measure*. London: Tate Gallery, 1992.

Serra, Richard. *Writings/Interviews*. Chicago and London: The University of Chicago Press, 1994.

Serra, Richard, Dirk Reinartz, and Hal Foster. *Richard Serra: Torqued Spirals, Toruses and Spheres*. New York: Gagosian Gallery, and Göttingen: Steidl Verlag, 2002.

CINDY SHERMAN

Bronfen, Elisabeth, and Cindy Sherman. *Cindy Sherman: Photographic Work 1975–1995*.

London: Schirmer Art Books, 1995.

Cruz, Amada, and Elizabeth A. T. Smith. *Cindy Sherman: Retrospective.* London: Thames & Hudson, 1997.

Krauss, Rosalind. *Cindy Sherman, 1975–1993.* New York: Rizzoli, 1993.

Schjeldahl, Peter, and Michael Danoff. *Cindy Sherman.* New York: Pantheon Books, 1984.

Schjeldahl, Peter, and Lisa Phillips. *Cindy Sherman.* New York: Whitney Museum of American Art, 1987.

Sherman, Cindy. *The Complete Untitled Film Stills.* New York: The Museum of Modern Art, 2003.

Steiner, Rochelle, and Lorrie Moore. *Cindy Sherman.* London: Serpentine Gallery, 2003.

LAURIE SIMMONS

Cameron, Dan. *Laurie Simmons.* San Jose: San Jose Museum of Art, 1990.

Charlesworth, Sarah. *Laurie Simmons.* New York: Art Resources Transfer, Inc., 1994.

Howard, Jan. *Laurie Simmons: The Music of Regret.* Baltimore: Baltimore Museum of Art, 1997.

Schorr, Collier. *Laurie Simmons: Photographs 1978/79.* New York: Skarstedt, 2002.

Squiers, Carol, and Laurie Simmons. *Laurie Simmons: In and around the House, Photographs, 1976–78.* Buffalo, N.Y.: CEPA, 1983.

LORNA SIMPSON

Gili, Marta. *Lorna Simpson.* Salamanca: Consorcio Salamanca, 2002.

Jones, Kellie, Thelma Golden, and Chrissie Iles. *Lorna Simpson.* New York: Phaidon Press, 2002.

Rogers, Sarah J., and Lorna Simpson. *Lorna Simpson: Interior, Exterior, Full, Empty.* Columbus: Wexner Center for the Arts, 1997.

Willis-Thomas, Deborah. *Lorna Simpson.* San Francisco: Friends of Photography, 1992.

Wright, Beryl J. *Lorna Simpson: For the Sake of the Viewer.* Chicago: Museum of Contemporary Art, 1992.

KIKI SMITH

Ahrens, Carsten. *Kiki Smith: All Creatures Great and Small.* Hannover: Kestner Gesellschaft, 1998.

Gould, Claudia, and Linda Shearer. *Kiki Smith.* Williamstown: Williams College Museum of Art, 1992.

Lampert, Catherine, ed. *Kiki Smith.* London: Whitechapel Art Gallery, 1995.

Posner, Helaine. *Kiki Smith.* Boston: Bullfinch Press, 1998.

Weitman, Wendy. *Kiki Smith: Prints, Books & Things.* New York: The Museum of Modern Art, 2003.

FRANK STELLA

Leider, Philip. *Stella since 1970.* Fort Worth: Fort Worth Art Museum, 1978.

Reinhardt, Brigitte. *Frank Stella, Moby Dick Series: Engravings, Domes and Deckle Edges.* Ostfildern-Ruitz: Cantz, 1993.

Rubin, Lawrence. *Frank Stella: Paintings 1958–65. A Catalogue Raisonné.* New York: Stewart, Tabori & Chang, 1986.

Rubin, William. *Frank Stella.* New York: The Museum of Modern Art, 1970.

———. *Frank Stella: 1970–1987.* New York: The Museum of Modern Art, 1987.

THOMAS STRUTH

Belting, Hans. *Thomas Struth: Museum Photographs.* Munich: Schirmer/Mosel, 1993.

Ichikawa, Masanori, and Rei Masuda. *Thomas Struth: My Portrait.* Tokyo: National Museum of Modern Art, 2000.

Pfab, Rupert. *Thomas Struth: Landschaften Photographien 1991–1993.* Düsseldorf: Achenbach Kunsthandel, 1994.

Sennett, Richard. *Thomas Struth: Strangers and Friends. Photographs 1986–1992.* London: Institute of Contemporary Art, Toronto: Art Gallery of Ontario, Boston: Institute of Contemporary Art, Munich: Schirmer/Mosel, and Cambridge, Mass.: The MIT Press, 1994.

Wylie, Charles. *Thomas Struth: 1977–2002.* Dallas: Dallas Museum of Art, 2002.

CY TWOMBLY

Barthes, Roland. *Cy Twombly: Paintings and Drawings, 1954–1977.* New York: Whitney Museum of American Art, 1979.

Bastian, Heiner. *Cy Twombly: Catalogue Raisonné of the Paintings.* 4 vols. Munich: Schirmer/Mosel, 1992–1995.

Bastian, Heiner, and Suzanne Delehanty, eds. *Cy Twombly: Paintings, Drawings, and Constructions, 1951–1974.* Philadelphia: Institute of Contemporary Art, 1975.

Lambert, Yvonne. *Catalogue raisonné des oeuvres sur papier de Cy Twombly.* Milan: Multhipla, 1979, 1991.

Szeeman, Harald, ed. *Cy Twombly: Paintings, Works on Paper, Sculpture.* Munich: Prestel-Verlag, 1987.

Varnedoe, Kirk. *Cy Twombly: A Retrospective.* New York: The Museum of Modern Art, 1994.

ANDY WARHOL

Bastian, Heiner. *Andy Warhol Retrospective.* London: Tate Gallery Publishing, 2002.

Bourdon, David. *Warhol.* New York: Harry N. Abrams, 1989.

Coplans, John. *Andy Warhol.* Greenwich: New York Graphic Society Ltd., 1970.

Francis, Mark, and Dieter Koepplin. *Andy Warhol: Drawings 1942–1987.* Pittsburgh: Andy Warhol Museum, 1998.

Frei, Georg, and Neil Printz, eds. *The Andy Warhol Catalogue Raisonné.* New York: Phaidon, 2002–4.

McShine, Kynaston, ed. *Andy Warhol.* New York: The Museum of Modern Art, 1989.

Michelson, Annette, ed. *Andy Warhol.* Cambridge, Mass.: The MIT Press, 2001.

Warhol, Andy. *The Philosophy of Andy Warhol: From A to B and Back Again.* New York: Harcourt Brace Jovanovich, 1975.

———. *POPism: the Warhol '60s.* New York: Harcourt Brace Jovanovich, 1980.

TERRY WINTERS

Phillips, Lisa. *Terry Winters.* New York: Whitney Museum of American Art, 1991.

Plous, Phyllis. *Terry Winters: Painting and Drawing.* Santa Barbara: University Art Museum, and Seattle: University of Washington Press, 1987.

Rosenthal, Nan. *Terry Winters: Printed Works.* New York: The Metropolitan Museum of Art, 2001.

Sojka, Nancy, and Nancy Watson Barr. *Terry Winters Prints: 1982–1988, A Catalogue Raisonné.* Detroit: The Detroit Institute of Arts, 1999.

CHRISTOPHER WOOL

Caldwell, John. *Christopher Wool.* San Francisco: San Francisco Museum of Modern Art, 1989.

Christopher Wool: Works on Paper. New York: Luhring Augustine Gallery, 1990.

Goldstein, Ann, ed. *Christopher Wool.* Los Angeles: Museum of Contemporary Art, 1998.

Pontegnie, Anne. *Christopher Wool: Crosstown Crosstown.* Dundee: Dundee Contemporary Arts, 2003.

ACKNOWLEDGMENTS

This publication and the exhibition it accompanies owe their existence to the great generosity of Donald B. Marron, who initiated the gift that they celebrate. I join Glenn Lowry and John Elderfield in thanking Don for everything he has done, and continues to do, on behalf of The Museum of Modern Art. He has been unfailingly thoughtful in our discussions about this project, and has offered help in myriad ways during the course of preparations.

I warmly thank the UBS Art Collection Project Team for their steadfast support of this landmark gift to The Museum of Modern Art. Petra Arends, Executive Director, The UBS Art Collection, has been an enthusiastic and sensitive partner over the course of the past year. Particular thanks must go to Stephanie Hodor, Divisional Vice President, The UBS Art Collection, upon whose encyclopedic knowledge of the collection and inexhaustible spirit of cooperation we have constantly relied.

I gratefully acknowledge many people inside the Museum who have been involved closely in this project since long before I arrived, in 2003. Director Glenn D. Lowry championed this initiative from the start, and has guided it through an unusually long gestation period. I thank him too for the wonderful interview with Donald Marron included in this book. The late Kirk Varnedoe, former Chief Curator of Painting and Sculpture, thoughtfully crafted the selection for the gift and the exhibition. Former Curator of Painting and Sculpture Robert Storr and former Chief Curator of Drawings Margit Rowell also offered advice as the project was taking shape. My sincere thanks go to John Elderfield, The Marie-Josée and Henry Kravis Chief Curator of Painting and Sculpture, for extending the opportunity of taking up this project soon after I joined the Department of Painting and Sculpture.

An exceptionally dedicated and hardworking team has produced the exhibition and catalogue over the last year. Alexandra Schwartz, curatorial assistant in the Department of Painting and Sculpture, has been nothing short of heroic in her assumption of countless responsibilities, all of which she has handled with great alacrity and intelligence. Jane Tschang, administrative assistant, has provided outstanding organizational and research assistance with her typical resourcefulness and grace. Intern Marika Knowles provided valuable help with research and the bibliography for this catalogue. David Frankel, Managing Editor, expertly shepherded this book through to publication in the midst of many other urgent deadlines related to the Museum's reopening. Elisa Frohlich, Associate Production Manager, handled a difficult challenge with enormous skill and patience. Barbara Glauber, Sarah Gifford, and Beverly Joel of Heavy Meta designed the catalogue with great sensitivity under much pressure. David Hollely designed the handsome installation, confidently venturing into uncharted territory for the first exhibition to take place in the new International Council of The Museum of Modern Art Gallery. Jennifer Russell, Deputy Director for Exhibitions and Collection Support, has overseen the organization of this exhibition with great wisdom and cheer. Stephen Clark, Associate General Counsel, has been an invaluable advisor

during the planning process.

I also thank for their help and advice in various ways Ruth Kaplan, Deputy Director, Marketing and Communications; Michael Margitich, Deputy Director of External Affairs; Michael Maegraith, Publisher; Mary Lea Bandy, Deputy Director of Curatorial Affairs and Chief Curator of Film and Media; Deborah Schwartz, Deputy Director for Education; Gary Garrels, Robert Lehman Foundation Chief Curator, Department of Drawings, and Curator, Department of Painting and Sculpture; Peter Galassi, Chief Curator, and Susan Kismaric, Curator, Department of Photography; Deborah Wye, Abby Aldrich Rockefeller Chief Curator, and Wendy Weitman, Curator, Department of Prints and Illustrated Books; and Jerome Neuner, Director of Exhibition Design and Production.

I would also like to thank, in the Department of Registrar, Terry Tegarden and Sydney Briggs; in Art Handling and Preparation, Pete Omlor, Rob Jung, Steve West, and the superb staff of preparators; in Conservation, Anny Aviram, Lynda Zycherman, Karl Buchberg, Michael Duffy, and Lee Ann Daffner; in Education, David Little, Laura Beiles, Sara Bodinson, and Heather Maxson; in the Department of Development, Mary Hannah, Rebecca Stokes, and Marcie Muscat; in the office of the General Counsel, Jane Panetta; in Imaging Services, Erik Landsberg, Roberto Rivera, and the wonderful staff of photographers; in the Library, Jenny Tobias; in the Archives, Tom Grischkowsky and Michelle Harvey; in Marketing and Communications, Kim Mitchell, Daniela Carboneri, Peter Foley, and Mark Swartz; in Digital Media, Allegra Burnette and Shannon Darrough; and Gael LeLaemer, Steven Wheeler, and the entire staff of CEMS.

I extend special thanks to Matthew Armstrong, Curator, Lightyear Capital, for his gracious advice and expertise. Orcutt & Van Der Putten provided much of the photography for the catalogue, and Big Spaceship developed the excellent website design. I also thank Philippa Polskin, Karen Hughes, and Amy Wentz of Ruder Finn Arts & Communication Counselors.

Finally, I am most grateful to the artists and their representatives for their cooperation in the preparation of this exhibition and catalogue. I extend special thanks to those artists who generously agreed to be interviewed, in many cases despite a strong reluctance to speak about their work in public. No matter how successful an individual artist now may be, the path he or she has chosen is a difficult one. We thank them all for the inspiration they offer, and for enriching the lives of others with the work they do.

—AT

© 2004 Artists Rights Society (ARS), New York/DACS, London: 163

© 2004 Artists Rights Society (ARS), New York/VG Bild-Kunst, Bonn: 138, 139, 158–59, 207

© 2004 Richard Artschwager/Artists Rights Society (ARS), New York: pp. 26, 28–30, 32, 135. Courtesy the artist: 28, top; 29. Courtesy Gagosian Gallery: 32

© 2004 Georg Baselitz: 137

© 2004 Vija Celmins: 34, 36, 40, 140, 141. Courtesy McKee Gallery, New York, photo John Bigelow Taylor: 40

© 2004 Francesco Clemente: 44, 46, 143–45. Courtesy Gagosian Gallery: 46

© 2004 Chuck Close: 147–49

© 2004 Anthony Cragg: 151

© 2004 Estate of Richard Diebenkorn: 153

© 2004 Estate of Dan Flavin/Artists Rights Society (ARS), New York: 155

© 2004 Lucian Freud: 157

© 2004 The Estate of Philip Guston: 160, 161

© 2004 Damien Hirst: 54, 61, 164, 165. Photo J. Fernandez: 61

© 2004 Howard Hodgkin: 66, 68, 74, 167. Courtesy Gagosian Gallery: 68, 74

© 2004 Jenny Holzer/Artists Rights Society (ARS), New York: 169

© 2004 Bill Jensen: 171

© 2004 Jasper Johns/Licensed by VAGA, New York: 172, 173

© 2004 Anselm Kiefer: 176, 177, 179

© 2004 The Willem de Kooning Foundation/Artists Rights Society (ARS), New York: pp. 16, 181

© 2004 Guillermo Kuitca: 183

© 2004 Christopher Le Brun: 185

© 2004 Estate of Roy Lichtenstein: 186, 187, 189

© 2004 Richard Long: 76, 79, 80, 82, 191. Courtesy the artist: 79, 80, 82

© 2004 Brice Marden/Artists Rights Society (ARS), New York: 192–95

© 2004 Succession H. Matisse, Paris/Artists Rights Society (ARS), New York: 89, top. Photographs © The Barnes Foundation

© 2004 Sarah Morris: 2, 197

© 2004 Robert Moskowitz: 199

© 2004 Elizabeth Murray: 201

Photographs by The Museum of Modern Art, Department of Imaging Services: 109 top, 158–59. John Wronn: 26, 76, 86, 106, 126

© 2004 Bruce Nauman/Artists Rights Society (ARS), New York: 203

© 2004 Claes Oldenburg: 204, 205

Photographs by Orcutt & Van Der Putten: 2, 16, 34, 44, 54, 66, 96, 126, 135–38, 140–57, 160–235, 238–55

© 2004 Neo Rauch: 211

© 2004 Gerhard Richter: 58, 214, 215. Courtesy Gerhard Richter and Marian Goodman Gallery, New York: 58

© 2004 Susan Rothenberg/Artists Rights Society (ARS), New York: 86, 88, 92, 217–19, 221. Courtesy The UBS Art Collection: 88, 89, bottom. Courtesy Sperone Westwater Gallery: 92

© 2004 Edward Ruscha: 96, 98, 222, 223, 225–27. Photo Lee Stalsworth: 98

© 2004 Robert Ryman: 106, 109, 229. Digital image courtesy The Museum of Modern Art, New York: 108. Courtesy Raussmüller Collection: 109, bottom

© 2004 David Salle: 231

© 2004 Richard Serra/Artists Rights Society (ARS), New York: 232, 233

Courtesy Cindy Sherman and Metro Pictures Gallery: 235

© 2004 Laurie Simmons: 237. Courtesy of Skarstedt Fine Art

© 2004 Lorna Simpson: 116, 119, 238, 239. Photograph © Museum of Contemporary Art, Chicago: 119

© 2004 Kiki Smith: 241

© 2004 Frank Stella/Artists Rights Society (ARS), New York: 243

Thomas Struth: 245. Courtesy Marian Goodman Gallery, New York

© 2004 Thomas Struth: 245. Courtesy Marian Goodman Gallery, New York

© 2004 Cy Twombly: 247–49

© 2004 Andy Warhol Foundation for the Visual Arts/Artists Rights Society (ARS), New York: 250, 251

© 2004 Terry Winters: 252, 253

© 2004 Christopher Wool: 126, 128, 132, 254. Courtesy the artist and Luhring Augustine, New York: 128